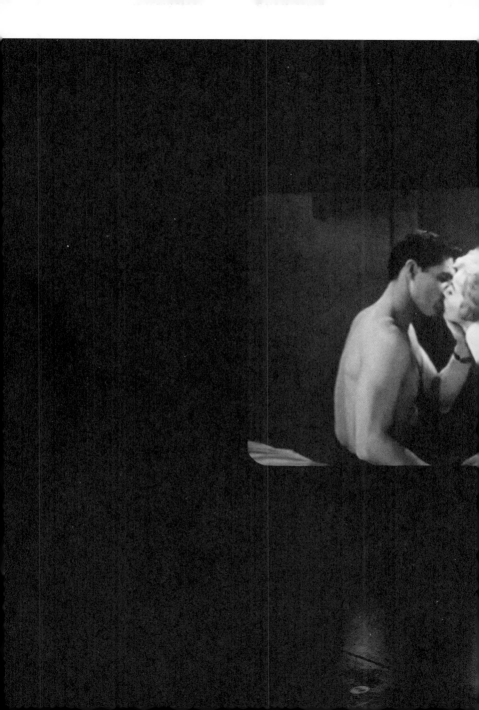

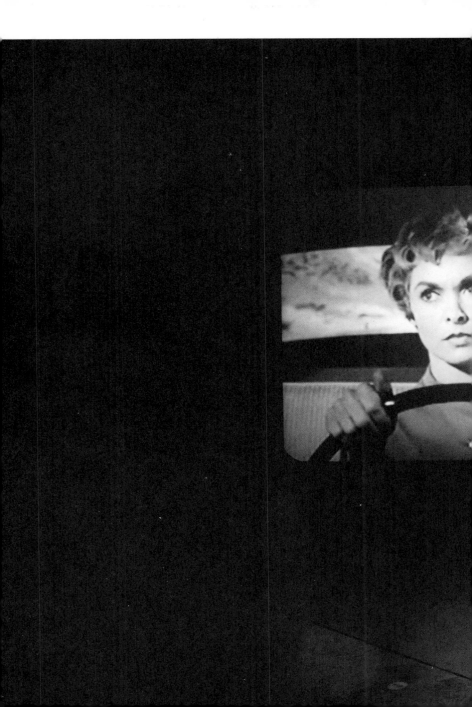

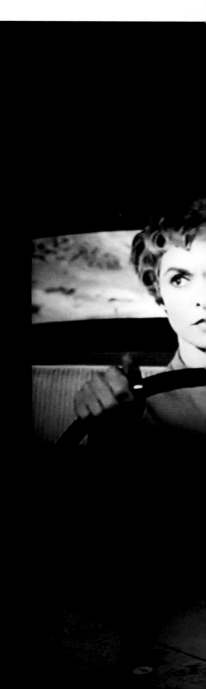

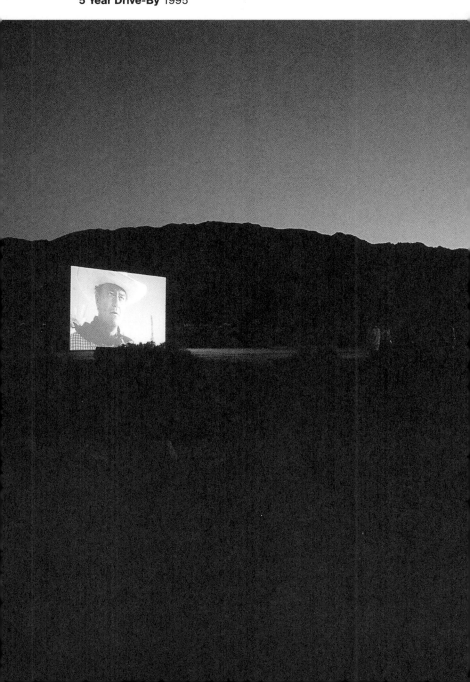

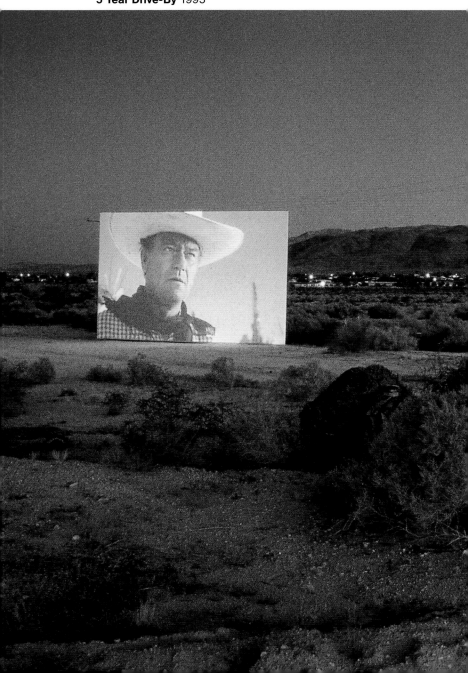

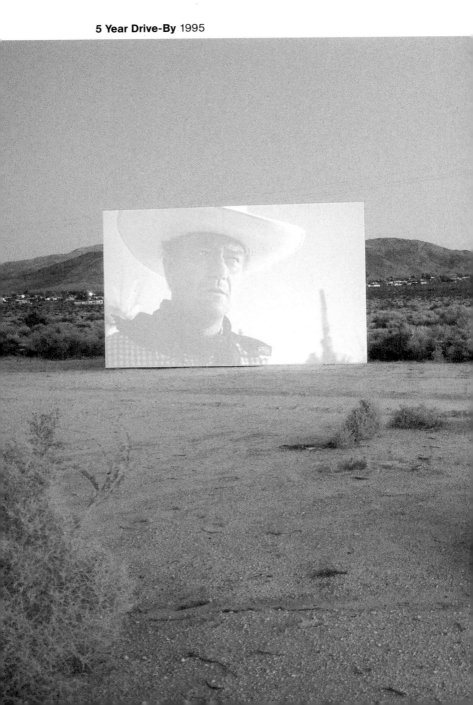

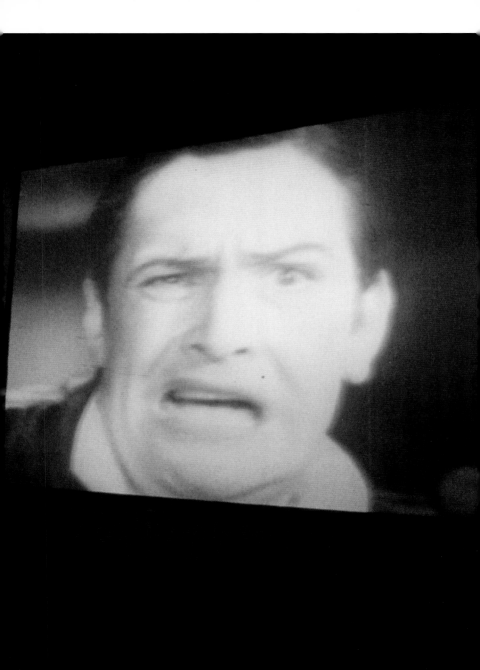

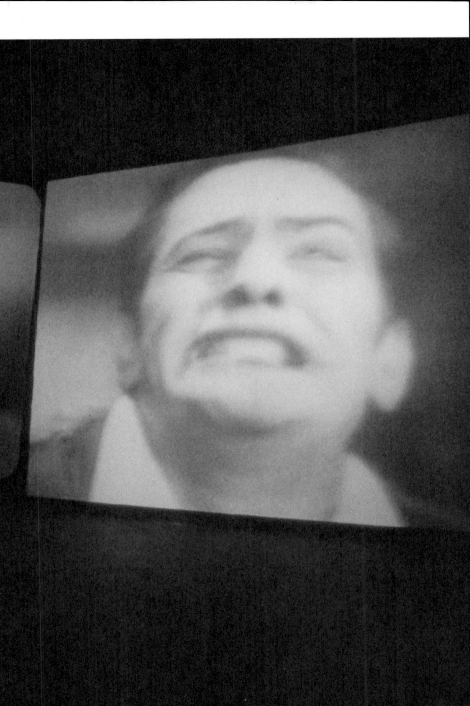

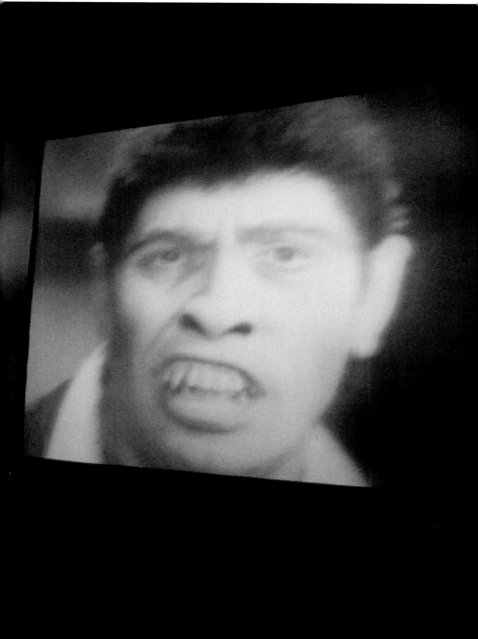

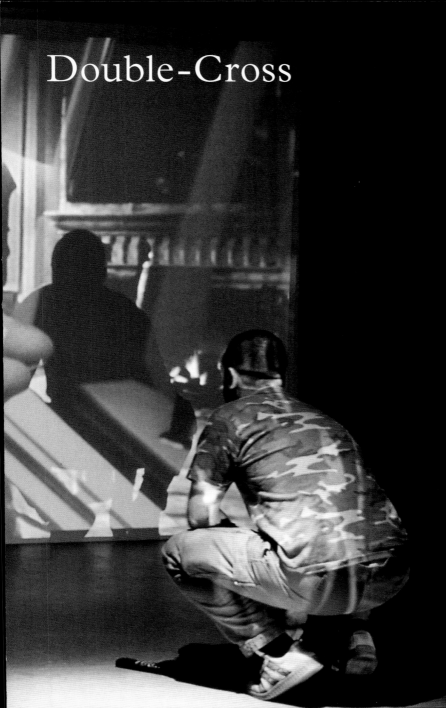

Double-Cross

Double-Cross
The Hollywood Films
of Douglas Gordon
Philip Monk

**The Power Plant
and Art Gallery of York University**

The Power Plant
Contemporary Art Gallery at Harbourfront Centre
231 Queens Quay West, Toronto, ON, Canada M5J 2G8
www.thepowerplant.org

Art Gallery of York University
N145 Ross Building, 4700 Keele Street, Toronto, ON, Canada M3J 1P3
www.yorku.ca/agyu

National Library of Canada Cataloguing in Publication

Monk, Philip, 1950-
 Double-cross : the Hollywood films of Douglas Gordon / Philip Monk.

Co-published with Art Gallery of York University.
ISBN 0-921047-96-7

1. Gordon, Douglas, 1966- 2. Video art. 3. Hitchcock, Alfred,
1899-1980 — Film and video adaptations. 4. Film noir. 5. Film
adaptations. I. Gordon, Douglas, 1966- II. Power Plant (Art gallery)
III. York University (Toronto, Ont.) Art Gallery IV. Title.

N6797.G67A4 2003
709'.2 C00-932067-9

The Power Plant Contemporary Art Gallery at Harbourfront Centre is a
registered Canadian charitable organization supported by Harbourfront
Centre, the membership of The Power Plant, private donations, the City of
Toronto through the Toronto Arts Council, the Ontario Arts Council, and the
Canada Council for the Arts.

The Art Gallery of York University is supported by York University, the
Canada Council for the Arts, the Ontario Arts Council, and the City of
Toronto through the Toronto Arts Council.

Edited by Alison Reid
Designed by Bryan Gee
Printed and Bound in Canada by Acme Litho, Montreal

Available through D.A.P./Distributed Art Publishers
155 Sixth Avenue, 2nd Floor, New York, N.Y. 10013
Tel: (212) 627-1999 Fax: (212) 627-9484

Contents

Acknowledgements

Commenced at The Power Plant following my exhibition of the same name of Douglas Gordon's projections, this book was completed at the Art Gallery of York University. Originally, this publication would not have been possible without the generous financial assistance to The Power Plant of Jay Smith and Laura Rapp and Stephen and Lynda Latner.

At the Art Gallery of York University, co-publication has been fully supported by a generous contribution from Sandra Simpson. My appreciation is owed to these patrons not only in enabling the publication of a challenging book on contemporary art but also in ensuring the high quality of its production.

For the exhibition at The Power Plant, September 23–November 19, 2000, the following artworks where graciously lent: *24 Hour Psycho* by a private collector, courtesy of the Lisson Gallery, London; *Feature Film*, from the collection of Eileen Cohen, New York; and *through a looking glass*, courtesy of Astrup Fearnley Collection, Oslo.

Lisa Mark was an enthusiastic supporter of this project when it was a mere lecture. Louise Bak has been both encouraging and tolerant through its long process.

I stood already committed to a profound duplicity of life.

— **R. L. Stevenson**
The Strange Case of Dr. Jekyll and Mr. Hyde

Preface
Duplicitous Signatures

An exhibition does not appear transparent to the work of its artist. It is countersigned, behind the back of the artist, so to speak, with the name of the curator. The curator knows the worth of this signature, vis-à-vis the artist's, and does not complain of his own obscurity — because the curator's name is imprinted more securely when he publishes a book as a text by an author. Douglas Gordon, too, signs his name to another's work when he takes Alfred Hitchcock's *Psycho* and makes new art from its popular entertainment. Sometimes he signs his name; at other times he holds it back, as in his anonymous telephone calls. Or he acts through the signature of another when he designates a "friend" as author of "A Short Biography," a published text presumably of Gordon's own fabrication.

Right from the start, signalled by a play of signatures and countersignatures, the question of duplicity strikes at the heart of any interpretation of Gordon's work. So for an artist who is best known for his interventions into popular Hollywood films, we might wonder whether a *literary* double is actually more essential than an aside to his work. Might we rather treat Douglas Gordon for what he is not, or, rather, not thought to be — as an author as well as an artist? Gordon's visual art would only be the false face he presents for another activity, while the question of authorship could only be considered under the sign of this duplicity. Nothing, as we shall see, is as it seems in Gordon's works.

If nothing is as it seems, Gordon's video projections must present themselves as something other than they are. Yet they only repeat another's work. Dependent though they are

on the films of others, his projections are neither as plagia-
ristic nor as parasitic as some think. "Borrowed" or "kid-
napped" are words Gordon himself uses to describe his
appropriations. But when the original work is returned,
something is out of place in our perception.

Although Gordon operates through the work of another,
paradoxically he acts as an independent author. He exposes
his own themes through those of his host by means of a dou-
bling that is not mere repeating. Collectively, his works com-
pose a fictional whole. A fictional unity might not be imme-
diately apparent, but themes cohere throughout. Each new
piece by Gordon makes us reread his previous works, inte-
grating the former into larger themes that were not necessar-
ily apparent earlier to us as subject matter. This whole is a
world — a moral world, in fact, as all noir worlds are. Of
course, in this world, everyone is guilty.

Gordon's interventions into Hollywood films have the sec-
ondary effect of making us read his themes of fate, guilt,
trust, and the madness of the double into his source films
where they may function more obliquely. (In this book, I dis-
cuss only Gordon's projections based on Hollywood films.)
If at times I begin to analyze the host films themselves, it is
because, as happens in Jorge Luis Borges's story "Pierre
Menard, Author of Don Quixote," they are now part of Gor-
don's oeuvre, even though they exist separately and prior to
it. Gordon's interventions are strictly formal, but they allow
us to talk about the content of these films in new ways.
Dependent and independent, his projections are artworks
that are also critical interpretations of their film subjects.

Gordon's work is not just a collection of derived themes. Through the subtle manipulation of an extant film's formal characteristics, he creates new artworks from film's material base. Perhaps the most surprising deception of Gordon's work would be my claim that he makes experimental films in the guise of Hollywood narrative cinema. Gordon takes narrative film as the subject and object of his analysis, but in so modifying film's presentation he creates another subject — the image in time. He mines his films' temporal potential so that time is not an abstraction but rather the means of fulfillment of the very themes that he draws from his source films. Like trust that turns in the fateful moment of a double-cross, so, in Gordon's projections, time is the fateful figure where, in the chiasm[1] of their becoming, guilt turns to madness and duplicity inexorably leads to the double.

The question of authorship cannot be answered through the work's themes alone. If authorship is dissembled in Gordon's work, it is because, after all, duplicity issues from the *image*. Gordon's practice crosses media. He is best known for his video projections, but sometimes his works take form solely as texts, other times as photographic images. When analyzing his work as a whole, we must chart the intersections of its crossovers as images pass over to texts and texts slip into images. The invisible non-place of this crossroads, which is the site nonetheless of a manipulative duplicity, is the locale of the double-cross. I play on this phrase "double-cross" to refer to the betrayal so much a theme of American film noir, which is the tradition to which most of Gordon's source films belong. The term also identifies the formal and

temporal operations of Gordon's work that the figure of the chiasmatic X signifies, operations that this book attempts to describe. Can Gordon's work be trusted, made as it is of the double-cross?

Introduction
Author!

What can we know of a man? A few facts. A few facts that a man has told us about himself or that have been supplied by the testimony of his biographer. In the case of Douglas Gordon, can we rely on this testimony since the author of "A Short Biography," identifying himself as a "friend," seems to be Gordon himself, acting as his own doppelgänger?[1] At its supposed source in the person of the artist, the issue of trust makes us hesitate before Gordon's work. We begin to think perhaps that this literary flourish is not so secondary to his visual art, and that its minor deception points to a larger duplicity informing his work as a whole.

Gordon doubles himself through the agency of authorship. This division splits his work at its origins into literary and visual modes — although the former is not visible in the light of the latter. Is Gordon's literary doppelgänger the necessary other, the verbal respondent to the visual emphasis of his work? Does it restore his work to a whole that his reliance on the art of others fractures, in that, dependent as his projections are on others, his work does not speak for itself? We have no reason to believe that texts offer explanations for images, for which, after all, Gordon is better known, and which themselves already exist as commercial films. Language is no analytical key to unlock the meaning of these images that now exist through Gordon's interventions as if in a dream. For language speaks to and from these images, even in their silent projection, as if emanating from the unconscious. To be an other disguised to the self — like Gordon's doppelgänger "friend" or the hypnotized automatons or amnesiacs that people film noir — does this not make the

subject unconscious? If language and image cross-communicate, which then is the unconscious of the other? Continually displaced from one medium to another, the unconscious settles in a non-place between them.

When Gordon projects a film, does the unconscious issue from a gap between the original and its return as his work of art? Is film's unconscious the mystery Gordon unravels? Or is it Gordon who offers himself for our analysis? Neither, exactly. Something changes in film's return upon itself. Although Gordon's projections are based on existing works, the original is altered through the manipulation of the flow of its images. Something is hidden even though floating on the surface. A fictional gesture, an unconscious trace, or a criminal act, this revealing concealment marks a deep duplicity in his art. *Nothing but deception is the motive, appearance, and function of this work.*

If duplicity parades itself as the operation of the unconscious but only hides in the image, we might join a lay science of psychoanalysis to fictional crime detection in order to question the images that are given to us in Gordon's films. We would be only repeating a collaboration already found in film noir plots. Our scrutiny would mimic the legal interrogations or psychiatric examinations that already play a role within Gordon's source films, which are mainly film noir or derivatives of that tradition. In the institutional quest for certainty and the need to know of their protagonists, the plots of film noir maintain a thin line between normality and criminality, sanity and insanity. Is Gordon criminally insane? Or does the need to know invert itself in *our* gaze as our own

small madness? For duplicity functions much like the role of the femme fatale in film noir — as the enigma through which the investigative plot is deflected and complicated and the private dick equivocally implicated. "Woman" is the detour through which man passes to arrive at the truth of his desire. This is why we are deeply implicated, too, if we persist in the film's unmaking, which over time — the time of presentation in Gordon's projections — is also our own.

Duplicity does not make Gordon's work an enigma to unravel, as if a mask behind which the truth of the work or the intentions of the artist are exposed. We need not overly identify the work with the mystery of the artist, even though Gordon has fabricated a Mabuse-like mystique about himself. At times he seems a character in the plot of his work, or, at other times, since he does not necessarily figure in it, he shows himself as the shadowy presence of a criminal author. A case in point: for an exhibition in 1997, Gordon drilled a hole from the apartment where he was then residing in Hannover to the exhibition space directly below; he took his old-fashioned noiresque rotary telephone off the hook, threaded the wire through the hole, and exhibited the ominously dangling handset under the title *Dead Line in Space*. For the period of the exhibition, he could not be reached. Gordon acts here as scenarist of a crime vignette that implicates him in his own orchestrated disappearance. Yet for one who himself is so difficult to contact, he has flaunted his accessibility as criminals sometimes taunt the police. In a catalogue of his work, the notoriously difficult-to-reach Gordon published his e-mail address laid over a photograph of the open pages

of a critical introduction to James Hogg's *The Private Memoirs and Confessions of a Justified Sinner*. The address assumed the name of Hogg's protagonist, Robert Wringhim — the other to the sinister double, a "friend."[2]

Here are a few facts that we know about Douglas Gordon. He was born in Glasgow in 1966. He attended art schools in Glasgow and London; then returned to Glasgow; was involved there with the artist-run Transmission Gallery; then in 1993 made *24 Hour Psycho*, based on Alfred Hitchcock's *Psycho*, for Glasgow's Tramway. The rest is history, as they say. He travels frequently, is hard to reach. He has exhibited widely and has won a number of prestigious prizes. Although he was born in Calvinist Scotland, his mother converted to Jehovah's Witnesses when he was six. From an early age, he was forced to think about the devil, fate, guilt, and trust.[3]

Gordon has worked these untimely notions, his heritage from a repressive culture, into his art. But he has brought this heritage and reaction to it to bear within artifactual simulacra both forbidden by that puritanical, iconoclastic culture and frowned on by an equally iconoclastic, moralist modernist practice. He has had to carry out a double deception, which marks every aspect of his work, in using artifacts of popular culture as the basis of his own art. On the one hand, he tracks the Calvinist themes of fate, guilt, and trust through film noir plots. On the other hand, as his most masterful stroke, he creates experimental film from Hollywood movies, using the narrative structure of a debased popular entertainment to make what we could reasonably call, given its effects, abstract temporal art. Even though Gordon's

works operate in separate domains devoted to language or the image, they uniquely bridge oppositional worlds — Calvinism's culture of the word and entertainment's culture of the image. Whatever the etiology of deceit in Gordon's character stemming from his origins is not our concern; nonetheless, dissemblance is a fundamental operation in his work, where language and image function to screen each other's deception.

This relation between language and image clues us to a larger fictionalizing enterprise constructing Gordon's oeuvre. Given the absence of sound in the first of his projections, we might be surprised to learn that half Gordon's work is language based. Since we do not have his projections in front of us here, we might take a detour through some of these language works that assume the form of tattoos, wall inscriptions, correspondence, and telephone calls, to uncover mechanisms that also operate in his other, visual, production. Even in the absence of images, we hear the echo of film noir in his language works. These works marry the ambiguity of that genre, which makes any communication potentially a life-or-death situation, with the commanding authority of Calvinist self-interrogation, where "every thought, being an index of damnation or salvation, [is] in itself an extreme situation."[4]

Here, then, are four random samples of language use in Gordon's works:

Can we trust the man whose arm is shown in the photograph *Tattoo* (1994)? It is Douglas Gordon. The tattoo on his arm reads "trust me." Can a man be trusted who needs to say it? Calvinism says trust no one, keep your trust exclusively in

God. Yet Gordon has decided to have these words indelibly inscribed on his own body, the double of his soul. "Trust," the word he keeps close to him, I suggest, is the oblique subject of his work. But also guilt. And the breach between the two when fate intervenes. And the madness that issues from that breach. Trust is the figure that turns in a breach — as it betrays or is betrayed — fate to guilt or guilt to fate.

In Gordon's 1997 *Tattoo (for Reflection)*, the word "guilty" has been tattooed in reverse now on a friend's back and reproduced together with its mirror image as a photograph. What is this man guilty of? We cannot know. But we do know that looking is implicated. The tattoo is made for him, but the photograph places the work in our realm. The reflective, doubling nature of photography reproduces for us what the subject sees only in part; but we do not have his self-splitting knowledge — his glancing back in the mirror as if with second thoughts on an undisclosed, sinful act. Is this man guilty, or does something already doubled in him, rather than a fateful act, make him guilty? How does the self split itself in order to become guilty? At one time this was predominantly a religious issue before it became a psychoanalytic one.

Another text, a 1994 wall drawing inscribed with the dice-thrown typography of Mallarmé's great poem, confesses "I remember nothing."[5] And what if you had committed a crime, a murder perhaps, and you remember nothing? Here is a popular film noir theme. You wake up somewhere, not knowing how you got there, beside a dead body. How would you know you had not committed the crime? Who would

believe you? Whom would you trust? What explication would not implicate you further in a (self-)presumed guilt? The words one keeps close to the body in the form of the memory-trace of tattoos are no use. Gordon's subjects are unable to link their bodies' actions to memory-images. Body and image are disjoined from one another, each left in limbo split from its doppelgänger, one acting unaware of the other.

A spoken text now instructs: "From the moment you hear these words, until you kiss someone with green eyes." *Instruction, Number 3b* (1993) is one of a number of verbal works in which an anonymous telephone call is placed by a curatorial collaborator to a recipient in a bar. Out of the blue, I receive this injunction. I might ask by what authority I receive the order. Or I might take it as a threat. Then I might just wonder who has made this call and subsequently forget it. The statement does not have an immediate effect, yet it intervenes decisively in my life. It remains latent until the sight of someone with green eyes makes me suddenly remember the call's injunction and I perform its instruction. The sentence is a pronouncement of fate. I am captured by the utterance, then made complicit by an ensuing action, in a beginning and an ending that is the temporal expression of the work.[6]

An ending in a kiss might be only a new beginning. The kiss, this chance juncture between two individuals that entwines them in only the briefest of touch and transfer of trust or deceit, is a motif that steals surreptitiously through Gordon's works. In 1994–95, Gordon supposedly dusted his lips with truth drugs and had himself photographed kissing friends at gallery openings, putting himself and his friends to

the test. The kiss not only secretly links a number of his works, it also allies them to those by other artists, for instance, to Andy Warhol's 1963 Underground film *Kiss*. What if *Instruction, Number 3b* was made not only with his own future works in mind but, moreover, referred to a parallel universe of films that predates his own work? I am thinking of the importance that Marion Crane and Sam Loomis's intimate kisses in the opening scene of *Psycho* seem to represent in Gordon's documentation of his *24 Hour Psycho*. I can't help also thinking that the kiss between Scottie Ferguson and Madeleine Elster that climaxes the first half of Hitchcock's *Vertigo* and that between Scottie and Judy Barton masquerading as Madeleine that climaxes the second were part of Gordon's work long before Hitchcock's film became the subject of Gordon's Artangel project, *Feature Film*, in 1999.

What if the first one you see with green eyes is not who he or she seems to be, and your kiss sets off another chain of events that ensnares and condemns you? We know of poor Scottie Ferguson's fate in *Vertigo*. What of green-eyed Madeleine Elster/Judy Barton, played by Kim Novak? Her downfall was that she fatefully fell in love with her dupe, blue-eyed Scottie, played by James Stewart. Gordon's complementary *Instruction, Number 3a* ("From the moment you hear these words, until you kiss someone with blue eyes") could symmetrically be applied to Judy Barton. This symmetry binds Scottie Ferguson and Judy Barton to a common fate, turning each towards the other, each one doomed and guilty in turn.

We can imagine Gordon's admiration for the exemplary

formalism of Hitchcock's *Vertigo*, which entraps its characters in repeated symmetrical patterns. Gordon's own work is modelled on structures of reversibility and repetition, on mirrorings and doublings; but he achieves his formalism — linked as his technical interventions are to the themes or, rather, the words and images of another that compose a film — not just through the script but the whole of another's work, Hitchcock's, for instance. The films Gordon "adapts" are closed systems that his interventions open to a temporality that exceeds that of their origins. We have already experienced this temporal opening when we fell victim to Gordon's telephone call in *Instruction, Number 3b*. As receipt of his calls or letters is our fateful turn, so Gordon's intervention is the fateful event that befalls a film.

We would be mistaken to think that as examples of verbal expressions, Gordon's language works merely *state* the themes of fate, guilt, or trust. They themselves are *effective* — performative, as this class of language acts is known to be: they command us to act, even against our will. Once we receive the command issued by Gordon's language works, we cannot escape them, as if we were under their hypnotizing influence. If Gordon's text works are language acts, then the condition that makes them effective (in the strict definition of this type of utterance), their ability to intervene so decisively, must be a receptivity on our part that perhaps we can only interpret as guilt.[7] Not by chance are we Gordon's destined victims.

We just witnessed the strange concurrence and intersection of possible worlds, of verbal instructions issued by tele-

phone and the kisses represented in film. Gordon's language works are more than models for us to understand his video projections. They perform operations that have temporal effects, eliciting responses similar to those that derive from the temporal medium of Gordon's projections. Even though seeming clichés drawn from film noir scenarios, they have a threateningly engaging presence: they act on us and we on them. Similarly, even though the films Gordon appropriates are well known, his interventions have decisive effects on our viewing that we cannot calculate beforehand. Gordon's intervention in his film source is a fateful event that demands and produces the performative act of our viewing. Descriptions of these interventions — "he extends Hitchcock's *Psycho* to a twenty-four-hour projection"— do not suffice. Gordon's interventions are the subtlest of events, simple in their construction yet complex in their consequences, not the least of which is that both film and viewer fall victim to an act that mutually implicates them but that we cannot know is deceptive.

Strange fate of an intervening event where "nothing will ever be the same" yet little remains touched except by a motion of time.[8] Strange fate to be condemned by a fateful act for which we are already guilty. How can the purely abstract form of Gordon's slight technical intervention have such real, profound, and fateful consequences? His acts are timely interventions that operate outside our normal concept of time — a time that is now divided in itself and "distributed unequally on both sides of a 'caesura.'"[9] What concept of time can accommodate an event that emerges from

an atemporal, reversible structure yet engages a performative temporality with a beginning and an end but which may not ultimately have a sequential or chronological order? No other structure, perhaps, than the turn of the chiasm. This abyssal time of the chiasm both engenders and fractures an "I." We might mistake the operations that occur there for those of the unconscious. Perhaps the unconscious is performative — or at least the one that issues from the chiasmatic trap where our guilt is presaged in a fateful event that is beyond our control. We are helpless before this event, in part because the chiasm invaginates the outside and the inside and the past and the future, in part because it exists only as a deception the artist insinuates. Gordon surreptitiously signs his name as author of this trap. But he is only signatory in relation to the unconscious he opens up in the viewer through our so easily falling prey to his deception. Strange that the stamp of the signature maintains a deferred temporality within it, that the signature itself is a performative event that links author and audience.

Whether we choose to interact fully with Gordon's projections or not, whether we walk in or out of them, engaging or dismissing them, they intervene decisively in our experience, enfolding our trust in the duplicity of the artist. We are intimately bound to the artist through a deception we do not, at first, apprehend. Gordon betrays our trust in what we take for granted in the work of art: its undissembled communication. For the deceptive Gordon, the three-fold relation of artist, work, and viewer is rather one of dissembler, dissembled, and dupe. The viewer is essential to the deceit of his work.

Duplicity and guilt: are these not the premises for every film noir? Indeed, from each of these phrases derived from Gordon's text pieces discussed above, or any other, I could compose a film noir scenario. Gordon precedes me. A fictional system already forms his work as a whole. Each of these texts is independent; yet Gordon has linked them strategically to other texts and images in and outside his work.[10] The themes of fate, guilt, trust, and the madness of the double that we derive from this system, however, are subject to an overall operation of dissemblance. They are, as well, a disguise for this operation taking place or a lure to distract us from the real crime.

Such dispersement of a fictional strategy throughout a diverse body of work that also crosses media initially forestalls our attempt to find an overall author whom we could traditionally identify. Gordon further compounds this problem since he is an author who presents his first false face by working through the art of others. This fact immediately bring us to a halt before a theft; Gordon's work is nothing but the repetition of another's work. The unsuspected links between language and image, between works of different media, and between different authors or artists in Gordon's work suggest, on the one hand, a trail of deceit consisting of a proliferating web of implication of authors and works in one another but, on the other hand, a pervasive thievery on Gordon's part, a kleptomania rather than mere appropriation. Gordon flouts convention and authority by such criminal artistic activity. He respects neither the integrity of the artwork nor the identity of the author. The fundamental rep-

etition that constitutes his work, which results in a thing that is both the same and other, instead questions the "unique and self-identical" nature of the artistic text as his theft undermines the legitimate or legal authority of authorship.[11] He does not merely sign his name to a work of another. The picture he offers, fragmented though it is through his works, is that of a fictional, false self, a protagonist played by an "Author" Douglas Gordon. Behind every mask in his work, we find another mask *ad infinitum*.

Gordon builds his fictions on the border of his borrowed Hollywood films, both outside by linking the director's themes to those of his own fictional system and inside by intervening in the film's frame structure. The border is a tightrope performance where Gordon is both present and absent, a character within and author to its production.[12] Obviously, he chooses films suitable for this strategy, those that in some way are already doubled in themselves, those that bear a madness either in their structure or in the flawed characters of their protagonists. These pre-existent divisions allow Gordon to surreptitiously inhabit the films to his own advantage. His sleight-of-hand insinuation only succeeds, however, because we are too willing accomplices or dupes to his duplicitous ways. Is this because we are already guilty? Yes, trust me.

1. The Split of the Unconscious

24 Hour Psycho

Douglas Gordon gained notoriety in 1993 with his *24 Hour Psycho*, a D.I.Y. work in which he stretched Alfred Hitchcock's 1960 horror-thriller classic *Psycho* to a twenty-four-hour silent video projection. The procedure was simple: he took a commercially available VHS tape of Hitchcock's film and played it through a deck that had the capability to slow play extremely. Gordon's act was no mere novelty appropriation of a pop-cultural artifact; his intervention unleashes powerful effects, but not in ways we demand. For many, Hitchcock's film is symbolized by the iconic footage of its lurid shower scene. The temporal dilation of *24 Hour Psycho* works against such symbolic condensation to deny the pleasure of this sight: it takes too long to reach this "climax."

Gordon's *24 Hour Psycho* allows us to scrutinize any particular moment of Hitchcock's *Psycho* — the actors and the details of the set but not so much the movement of action — in excruciating slow motion. For instance, the one-minute cut-and-thrust of Janet Leigh's shower scene rolls on for ten banal minutes in *24 Hour Psycho*. Although sound is suspended, we don't seem to need the dialogue; as familiar as Hitchcock's story is to us, we recall its narrative from past viewings. The hypertrophy of sight at the expense of sound only reinforces our attention in a way that perhaps is special to film in the first place — it plays to our fascination with the image. Gordon recruits us as guilty accomplices to Hitchcock's camera's moralizing scrutiny, which is made all the more dominant in slow motion. He allows our voyeurism to be indulged freely.

While we know the film already, and thus can anticipate

the action, we are nonetheless frustrated by its delay. Because of the extreme slowness of the drama in Gordon's projection, we seem expelled from the film, never quite registering our sense of time with the plot's. We are always out of sync with the time of the action, which sunders our experience. The past (our memory of Hitchcock's film), our present viewing, and our anticipation of future action, which is too slow to arrive, can never link up. Moreover, the projection continues for hours after we have left its screening. Gordon's intervention diverts us from the usual patterns of watching movies, where real time is nullified in the spectacle; he infinitely postpones the catharsis associated with this genre of entertainment. Instead of returning us after viewing to our humdrum lives, Gordon uneasily complicates our sense of time. What seemed a scant appropriative art strategy has more the inaugural status of a philosophical act.

This dissociation between the spectator and the original work serves to split the viewer from the projection, with the counter-effect of slow motion that Gordon's film is now enclosed in its own near-static universe. Gordon's intervention seems instead to subject the characters of Hitchcock's *Psycho* to a celluloid prison where they are condemned to attend their fate in a slow-motion trap. Now, in every moment of the twenty-four-hour projection, their fate and guilt hang heavily on them.

Perhaps film is a prison house. In the last moments of *Psycho*'s opening credits, the horizontal stripes of Saul Bass's graphics switch to vertical bars briefly superimposed over the opening scene, as if to imply the prison its characters inevita-

bly inhabit. Film is a trap no less apparently for its real life actors. Marion Crane and Norman Bates converse about their "private traps" in *Psycho*, but only Anthony Perkins was ensnared career-wise by his persona in Hitchcock's film.[1] As these bars lock into place in the credits, they signal a closure, like a curtain — a shower curtain, perhaps — coming down between the antecedent text and the succeeding images. This closure separates an outside from an inside, which Hitchcock's camera then proceeds to breach, passing through the hotel window to witness a clandestine meeting. As spectators, we are let in on the seemingly sordid scene through the camera's thrust, a complicity that makes us guilty as voyeurs (and that prefigures our participation in the murder of the shower scene).

Presenting the scene to view, Gordon delays our entry into this space. His installation reasserts the thin divide of the screened image that separates the space and time of the virtual action from the time and space of our actual participation. Slow motion has already expelled us from film time. By being displaced by the double context of presentation in his installation — moving from movie theatre to art gallery and from film to video projection — we are physically freed of the constraints of usual viewing. Liberated from plot time, we are also free to walk around the image since the film is rear-projected on a double-sided screen hovering in space like a knife blade.

The content of Hitchcock's film is not suspended in favour of Gordon's manipulation of the apparatus; it is exaggerated. In general, the artist's formal interventions into his host films

exacerbate the dissociation of a guilty conscience, or they intensify the life-or-death predicament that a fateful event imposes on the protagonist. These are eminent film noir themes, both present in *Psycho*, which, with its black-and-white, made-for-television style, could be called a late version of the genre. Gordon's modification in *24 Hour Psycho* simulates the psychological disturbance of the film's protagonist and allows us to see it.[2] Hitchcock's film shows us the madness of his character; Gordon's intervention actualizes it: he makes madness otherwise visible. Gordon's intervention focuses our attention, first perceptually, through an initial distraction where our expectations of the original film are not met, then conceptually as we fully enter the perceptual and psychological distortion that the projection plays out. This dissociative effect links all Gordon's interventions and binds formal structure to thematic intent. Often these interventions strategically involve only one operation that does not necessarily touch upon the editing or plot structure of the film, such as here slowing the speed of Hitchcock's film.

Splitting sound from image in *24 Hour Psycho* restores the conditions of the psychotic state by an overemphasis of the scopic drive. At the end of *Psycho*, we learn from the psychiatrist that Norman's psychosis has its origin in his witnessing the primal scene as a boy and his murder of his widowed mother and her lover that resulted. If Norman's madness was the consequence of this sight, his incitation to new violence seems to have been caused by seeing Marion Crane naked. Deleting sound, Gordon accomplishes what Hitchcock perhaps intended as a cinematic trope: to *show* Norman's mad-

ness by sight, not sound, purely by means of film alone, not its scripted narrative. After all, the shower scene completes what was introduced at the onset: from the moment we pass through the hotel window we enter a space of madness. (Our voyeuristic complicity in the camera's movement at the closure of the credits entails our leaving behind the outside and with it language.) This is not yet Norman's madness, which the shower scene has still to rend in the full scopic violence of his lacerating psychosis, only a little madness, the folly of Marion and Sam's illicit rendezvous, which will lead to Marion's crime.

And yet, or as the psychiatrist at the end of *Psycho* says to a too hasty explanation of Norman's cross-dressing, we might similarly reply, "ah, not exactly" to the standard scopic interpretation of Norman's madness that seems fulfilled in Gordon's projection. Gordon's interventions are also interpretations of his host films. They allow us to look at the originals in new ways. In reviewing *Psycho* through Gordon, we must follow the artist's perversion of origins by deviating in turn from what *24 Hour Psycho* supposedly accomplishes through its deletion of sound. We must read *Psycho* anew through the language that Gordon deletes. We must pass between Hitchcock's *Psycho* and Gordon's *24 Hour Psycho* in order to read between a man's words and the images of his acts. Between one and the other works words disappear, displaced by images. Our reading must then proceed backwards through a series of screens: from the pure visuality in which madness presents itself; to a division of language that sites the unconscious in the image; back even to a madness

residing in language. The case for origin of Norman Bates's disturbance in language calls for a contrary reading of *Psycho*: Norman's madness is revealed in what he says, not in what he sees. We will need to (re)locate this place of saying in the wordless *24 Hour Psycho*.

The shower scene seems to be the locus of Norman's madness in Hitchcock's film, but it may only be a lure for us. The shower scene cuts the film in two, or rather links one film to another — the end of Marion Crane's film to the beginning of Norman Bates's. This division solves the problem of the end of a film answering to its beginning, so that the psychiatrist's concluding analysis explains the murder partway through, not the lovers' tryst in the hotel room that opens the film. Since the two conclusions are in parallel, we might look to the first ending — Norman and Marion's conversation in the parlour — for an explanation of Norman's disturbance. We should linger in the parlour where Norman wanted to stay, not in the shower where he was driven to go. Marion Crane stems Norman's loquaciousness in the parlour. The shower scene silences it.

Norman's madness is supposedly the result of his disturbing witness to a primal scene. This original sight buries the language of memory in him and speech henceforth can only be expressed through the ventriloquism by which he converses with his "mother." The murderous rage this sight provoked is repeated in the shower scene after Norman is aroused by Marion Crane's disrobing. (Her nakedness reproduces the primal scene, which is signalled in what we, not he, saw at the opening of the movie, where we spied on

Sam and Marion's lovemaking.) Substituting for Norman's original horror, Marion's screams act as if to repress memory in the unconscious so that thereafter only vision remains functional. This is why Marion Crane's eye and scream, the latter relayed by the slashing staccato shrieks of Bernard Herrmann's music, play such a symbolic role in the film's reenactment of Norman's traumatic event. After this loss of voice, the scream of the next murder victim, the private detective Milton Arbogast, is consequently unheard, masked by the music.

A divide between the two films, the shower scene severs vision from speech. The dissociation of Norman's psyche is enacted by the separation of the functions of eye and mouth, vision and speech. Repression displaces their effects to Norman's transvestism and ventriloquism.

The shower scene completes the passage from language to image that was initiated with the close of the credits. The scene's fetishizing impact on the popular imagination has given it an iconic value, a shock value Hitchcock intended in order to suppress language to convey a psychosis that mutually binds protagonist and spectator. Through this repression of language, *Psycho* makes us mad, a madness from which we have yet to recover. I believe Norman's madness is only compounded by sight and can rather be traced to a language disturbance. Words bridge action, just as talk transfers guilt. To cure Norman and to free ourselves, we need to restore what the shower scene set asunder.

Something in Norman's psychosis is triggered by his conversation with Marion Crane. Norman says, "We all go a

little mad sometimes. Haven't you?" to which Marion Crane, posing as Marie Samuels, answers to her situation, "Yes, sometimes just one time can be enough." Norman goes mad (again) soon after this exchange because of something that the double character Marion Crane/Marie Samuels says, not because of what she does. Norman's madness is a consequence of witnessing words and acts mismatching. His attack follows from what he sees as women's duplicity and doublespeak, confirmed when Marion — her decision to return just made — unconsciously slips back to her real name at the end of their conversation. Marion unsuspectingly provokes Norman's psychotic reaction by words, not flesh. My resort to a linguistic explanation of madness here is not the same as that which the psychiatrist offers at the end of the picture for Norman's vicious attack: that it resulted from his sexual desire for the disrobed Marion Crane and the consequent denial of this desire in the psychotic complications of his doubling of character through an introjected motherly disapproval. In the psychiatrist's words, "The mother killed her." After his conversation with Marion, Norman calmly observes that the mismatch of her name to the false guarantee of her signature in the motel register is a lie, a "fal...fal...fal...falsity," as he otherwise earlier stutters to Marion. As Norman tells the investigating Arbogast, Marion Crane could fool him — not that she was trying — but not his "mother," his other self, who murders her. Norman displaces to a female series the responsibility for crime and victimhood: Norman's "mother" murders Marion who had already signed her death warrant with her

false signature.[3] What gives Norman the right to act is Marion Crane's duplicity, her denial of trust of the openness of their conversation, a breach that repeats his mother's betrayal. On the contrary, Norman does not lie about his mother; everything he says about her to Marion Crane, in fact, is true about the stuffed dummy she is, but we don't realize this until the end of the film.

When Norman says, "My mother — what is the phrase? — she isn't quite herself today," the veracity of the statement, and consequently the question of trust in the speaker, cannot be settled. Either we take the statement at face value as Marion Crane would have, or, having now seen the movie, we know its meaning to be either "my mother is not quite herself, that is, she is dead," or, "my mother is other than herself, namely, she is me." Ambiguous but true, literality and duplicity inhabit the same statement as the sentence's own little madness. Norman is not being ironic; actually, irony doubles up on him. He himself must take the phrase literally; moreover, he cannot see his own deceit, only that of others — or, rather, only his "mother" can read others' deceit. (Norman must delegate to his mother the right to decide who is being deceitful, for reasons that we will see.) Norman must have recourse to what is already a phrase —"what is the phrase?"— to express ready-made what he cannot acknowledge to himself: his divided self. The doubling of language keeps the subject doubled within it and maintains ready-made a little death in life.

Who and what made Norman double and a victim of language use? A different, linguistic explanation of Norman's

disturbance would make him a candidate for the double bind theory of schizophrenia worked out in California in the years immediately preceding *Psycho*'s release in 1960. Is it a happy coincidence that the author of this theory is named Bates-son, Gregory Bateson?[4]

Norman's mother had made him psychotic ("he was already dangerously disturbed," according to the psychiatrist), and she naturally became the first victim of it. The double bind theory recognizes the child as a victim of the mother. There is no single traumatic event, only a disturbed pattern of communication that the mother sets up and controls. Schizophrenia is a meta-communicational dysfunction in which the child is unable to distinguish message types. A primary negative injunction is accompanied by a secondary negative injunction of a higher order conflicting with the first, both enveloped within a tertiary negative injunction that forbids questioning the double bind and thus escaping it. Norman kills Marion Crane as revenge upon his mother because of a trap of language. His conversation with Marion portrayed the background of his psychological disturbance; but it was a conversation with this other woman, not with his mother, that provoked his violence anew. Marion calls this violence on herself. Acting like the mother, she silences Norman's speech in the parlour.

If language makes Norman mad, we need to briefly examine its dynamic within his conversation. A pure example of the double bind is found in Norman's contradictory phrase "if you love someone, you don't do that to them [i.e., put his mother in an institution], even if you hate them." Other

expressions that show evidence of Norman's suspicion of language and the motivations behind it revolve around substitutive meaning, in itself a deceptive act for Norman, such as "people always call a madhouse 'someplace,'" or issues of truth and falsity, mismatches between statements and reality, such as "I hear the expression 'eats like a bird' is really a fal...fal...fal...falsity." (We should be alerted through the psychopathology of the stutter that the unconscious is speaking here and recognize that the unconscious may be both formed and speak through a deception.) Truth and falsity are logical terms for what is really a question for Norman of the veracity or deceit of a speaker. Problematically, veracity must be decided through a statement that is, at one and the same time, both literal (that is, seemingly true) and deceptive.

A statement can be true or false in relation to a state of affairs, but not both at once. A deception, however, inhabits the literal phrase and is indistinguishable from it. Norman's problem is that he must operate on the literal level while his "mother" manipulates him through the duplicitous level. Within every enunciation is a trap; behind every statement is a deception. The former is Norman's dilemma; the latter is the inquisitorial position Norman's mother commands. Norman must continuously monitor both in whatever he says. Having absorbed his mother within himself, he must maintain this contradictory dichotomy; he is bound by its trap. Everything he says makes sense in the universe he inhabits. His madness does not derive from his need to erase the crime from his mind, as the psychiatrist claims, but to continue to deal with his mother's contradictory injunctions, even after her death.

Coming at the conclusion of the film, the psychiatrist's explanation of Norman's split personality is sometimes seen as an external solution, as a verbal add-on. But this linguistic reflex is necessary. To slice language off the image, as if with a censor's scissors, is only to displace it elsewhere. We otherwise know this to be the unconscious. The psychotic unconscious has its neurotic parallel in the extemporizing of internal speech that we know as guilt. The neurotic Marion Crane could acknowledge her guilt; the psychotic Norman Bates must repress his.[5]

The split-off voice has an essential role in *Psycho*, where it functions as a traditional voice-over but also as an index of degrees of madness, major or minor. A fixture of film noir, the voice-over is only sparingly, and thus pointedly, used here: seemingly as a narrative device of plot furtherance, the two times Marion Crane, speeding away from her crime, imagines the dawning realization on those whom she has fled that she has stolen $40,000; and again at the conclusion of the film when, fully absorbed into the mother half of himself, Norman's "mother" talks — and smiles — to "herself." Talking to oneself may be a sure sign of psychosis. Norman talks to himself through the ventriloquistic displacement of his mother's dummy. Is *Psycho* suggesting that Marion Crane is also a little mad when she talks to herself in voice-over? Is it, moreover, Marion Crane's *pleasure* that makes her mad — and, like his mother, Norman's deserving victim — when smiling to herself (the only time during the voice-over of her anxious flight), she imagines the duplicitous outrage of the lascivious oilman whose money she stole? Through the stra-

tegic device of the voice-over, Hitchcock conflates the two madnesses of Norman and Marion and opens the film to an unconscious space that is other than scopic.

We all go a little mad sometimes. *Our* madness is the pleasure that the master of suspense, Hitchcock, manipulates as a suspension of language in vision. That Gordon exaggeratedly repeats Hitchcock's "censorship" does not mean that there is not an unconscious of the voice as well as an unconscious of the image operating in *24 Hour Psycho* as much as in *Psycho*. If censorship is displacement, the transvestism of sight then is only a screen for the ventriloquism of sound. The doubling of character — Norman/mother — is only a mask for the doubling of language in Norman himself. We think we see Norman's madness displayed in his transvestism but we hear his ventriloquistic displacement of voice more fully instantiated in ourselves. Interpretations of *Psycho* that persist in suppressing language in favour of Norman's scopic disorder are still caught in Norman's madness, a madness that Hitchcock, we now know, extends to his viewers. Remarkably, the silent *24 Hour Psycho* is not one of these.

Yet it remains that Gordon *has* deleted *Psycho*'s soundtrack. This deletion means that the story as a whole, including the explication by the psychiatrist that frees us from the mystery that still imprisons Norman, is suppressed. Gordon's primary gesture repeats for us both Hitchcock's device and the event that made Norman mad in the first place. Am I reading too much into this gesture of censorship, in that the deletion of *Psycho*'s soundtrack is a technical consequence of the deceleration of the image necessary for Gordon to

accomplish the temporal extension of *24 Hour Psycho*? But has Gordon not treated sound and image in similar if opposite ways? For these two components of film, he has established a ratio of extremes, exaggerating one and diminishing the other. The absence of sound does not then mean its simple disappearance, only its displacement. To where? As spectators, we restore what we want of the dialogue in our minds, a ventriloquism we substitute as voice-over to the silent images. Our "hearing" is just as much a madness as our seeing is. Like Norman's, our unconscious, too, speaks to the image.

We find that this long digression from Gordon's silent *24 Hour Psycho* is not so gratuitous. Our rereading of Hitchcock's *Psycho* was only made possible by tracing Gordon's seemingly censorious gesture back into the function of the voice-over in *Psycho*. Both Hitchcock and Gordon seem to overemphasize the visual by debasing language but do so in order to open a space of madness to spectatorship. Such an operation, however, is only a sleight-of-hand lure to draw us into the space of the unconscious, which is not devoid of language but, as has been famously declared, is structured like it. The spectator is the site of the return of the repressed of language displaced from Hitchcock's film in *24 Hour Psycho*.

The unconscious manifests itself through the little madnesses of forgetfulness and psychopathologies such as slips of the tongue or stutters. With its arrest of motion, is *24 Hour Psycho* not one long stutter? Perhaps one long "fal...fal...fal... falsity"? Such a "stutter" would be the outcome of the traumatic event that suppresses language in Gordon's proj-

ect: slow motion. If this is so, then perhaps not only Norman's madness is made visible through Gordon's intervention; something of the unconscious of film presents and speaks itself, however falteringly. Maybe we witness something as well of Hitchcock's unconscious. Or is it Gordon's that dilates before us? I don't want to lay Gordon on the psychoanalytic couch of the projectionist's booth since it is Gordon's fixation with Hitchcock that we must question. One writer has suggested, "Gordon's attraction to Hitchcock — isn't it like some sort of fixation about childhood?"[6] In turn, we flatly ask, is it Oedipal? Doesn't Gordon repeat Norman's displaced Oedipal gesture, killing his mother and lover? How else can we interpret Gordon's knife-like intervention slicing sound from image other than as an attack on the father Hitchcock? But any sundering of sound and image is also an attack on the mother. Isn't Gordon's appropriation — dressing in the work of another — fundamentally an act of transvestism? Norman's dual displacements of seeing and hearing are carried over into *24 Hour Psycho* by Gordon's disguised transvestism and our displaced ventriloquism.

I want to delay discussion of Gordon's relation to Hitchcock partly because I do not think we can psychoanalyze him through the lacunae in his works since he placed them there as lures in the first place. If the dream is not the unconscious but only the workings of its condensations and displacements, then the manipulated images of Gordon's projections analogously cannot be the unconscious of film. In the final analysis, it is not film's, Hitchcock's, or Gordon's unconscious on display, but what is put into operation through

Gordon's projection — ours alone. Gordon's intervention links the closed world of the protagonist to our own through a temporal cut into our consciousness.

Gordon's projection opens a gap in our experience that, at one and the same time, is the site of our perception of film and the place where our unconscious operates. This gap is not that between our knowledge of Gordon's source film and our experience of his manipulated projection. His manipulation allows us to see and experience the protagonist's dissociation, but we ourselves must not just mimic it. We dispose a corrective luxury that the psychotic protagonist does not, in that we can witness our own dissociated consciousness. Yet in that rupture, lured by our fascination, we are stirred by something that we do not completely, rationally command because the gap is a "between perception and consciousness" in which the unconscious moves.[7]

If we needed a screen image for the unrepresentable space-time of the chiasmatic gap in which unconscious lurks visible but obscured within our perception, it would be the figure of suspension. Everything is suspended in *24 Hour Psycho*. The image is suspended before us: it hangs in space and is detained in time. As we unconsciously speak to this image so language is suspended in a dream-like vision. Just as at the language source of Norman's self-splitting subjecthood duplicity disguises itself within literality, inseparable from it, so language in *24 Hour Psycho* is sustained displaced and disguised within sight, seemingly censored only by the slow-motion deletion of sound. Silent, without a voice of its own, *24 Hour Psycho* dwells within Hitchcock's film like the

mother who is absent within *Psycho* yet who determines the ongoing language structuring of its victimhood.

In contrast to the division of speech and vision or sound and image, literality and duplicity function inseparably in *24 Hour Psycho*. In this projection, the duplicity of content cannot be separated from the literality of presentation. Herein precisely lies the duplicity of the work. From the start, even before we experience the effects of the work, appropriation already is the deceitful inhabitation of another's work, reproducing the literal and the duplicitous within a disguised screening. At any one moment, Gordon's projection inhabits *Psycho,* the two screenings playing as one, its slow motion operating as a distending delay — a fal...falsity — within the literal temporality of *Psycho*.[8] It is not just that the images remain the same but not their timing: *24 Hour Psycho* fatefully insinuates itself into *Psycho* as if death moved in the images. Slow motion is the image of the unpresentable. If we wanted to find an emblem other than time for this duplicitous inhabitation of the literal, it would be the smile that disguises the skull beneath the skin. Death taciturnly smiles in the image. The same smile — Marion's during her flight from her crime and Norman's "mother"'s during his detention — joins her minor folly to his major madness. At the end of the film, Norman's wicked, duplicitous smile immediately exposes his mother's superimposed skull through which death finally "speaks" in the image.[9] As if to drive the point home, the skull unites Marion's and Norman's fatal acts to their voice-over madnesses. Like the anamorphically distorted skull floating in the foreground of Hans Holbein's

painting *The Ambassadors*, the slow-motion suspension of the skull in *24 Hour Psycho* functions as a vanitas emblem. But now the *temporal* anamorphosis of slow motion is an obscure emblem and the means of our "madness" at the same time.

If slow motion brings about a change in perception where the unconscious abides, its enduring temporal disruption must also adjust our relation to the host film in adapting its tempo so drastically. Slow motion so radically distends the narrative construction of the film that another reality imposes itself. Gordon's intervention opens a space of madness to view but, more important, it drastically reshapes our experience of time. The slow motion of *24 Hour Psycho* places us in a different temporal universe where there are no privileged moments. In Gordon's version, the shower scene — the epitome of montage in *Psycho* — is no more significant than any other. In fact, "scene" makes no sense when plot construction dissipates and montage is elided through protraction. Montage is the first victim of slow motion; the naturalistic duration film fictionally promotes is the second. With no privileged instances, *24 Hour Psycho* reproduces the double-bind space of no single traumatic event. But it also installs us in the reality in which the psycho strikes in the heart of the everyday, in the banality of what Gilles Deleuze calls the "any-instant-whatever."[10]

When we chance to enter Gordon's projection we are already in the space of madness of the film's protagonist. It exists before our participation and will subsist once we leave it. A crime has been committed; the guilty mind's consciousness has irrevocably forever changed. We enter this space

through the rent Gordon has opened in the universe of the protagonist by means of the violence of his own cut into the work of another artist. Only through such a violation does Gordon make madness visible, but it is achieved — before we witness its effects — at the cost of repeating the violence of another.[11] As spectators, we do not repeat this act but we suffer its consequences. As befits its dependency on the double film *Psycho*, *24 Hour Psycho*'s effects are dual but undecidable. We register these effects alternating between the madness of Norman Bates and the victimhood of Marion Crane. Playing a double role both inside and outside the film, Gordon, however, is neither Norman nor Marion but rather ... the mother. Gordon deceptively rejoins the sound and image he sundered in the process but only through enfolding the spectator in the madness of the film. He allocates to the father Hitchcock the obvious role of playing the audience through the visuality of "pure film." Gordon retains for himself a more subtle, devious determination. Like Norman's mother, he duplicitously manipulates us through a language disorder that had already maddened and incited Norman. Split between contrary seductions and injunctions, we reproduce Norman's dilemma while perpetually suffering the blows of his mad act.

Contrary to the seductions of the visible, the first effect on us, of complicity, belongs to the disavowed domain of sound. The second, of victimhood, belongs to the visible domain of sight. The first invisibly commands Norman to act within the realm of the second, the same realm we first experience in Gordon's projection. Yet, this authority is disavowed and

disappears through the deletion of sound in *24 Hour Psycho*. The gendering of the components of film, with sound standing for the mother and image for the father, curiously reverses the founding origins of Western culture, where the commanding authority of the voice represents the invisible, absent father and the seduction of the visible simulates the mother, one standing for the "good" and the other for the "bad."[12] Curious, because, as we shall discover in Gordon's projections, the instituting factor of the separation of sound and image, with sound's consequent deletion, means that images alone seem to rule. Yet in *24 Hour Psycho* Gordon seems to align himself only to Hitchcock in this zone of male mastery as an accomplice within the visible, whereas the real effects of his work are deviantly disguised in his becoming one with the silent mother.

2. The Calculations of Time

5 Year Drive-By

To the year he was born (1966), Gordon has devoted two works. Typically, as he would in many of his other works, dividing the senses of the ear and eye between them, the works present the sounds and images he subliminally might have experienced while in his mother's womb.[1] Given Gordon's strict religious upbringing, we might interpret these works as the artist's wish to deny his maternal heritage through the transgressive artifacts of popular culture and to ally himself to the good taste of the avant-garde of the popular arts. For while *Words and Pictures (Part I and II)* (1996) projects all the movies that played in Glasgow during the period of his gestation (December 20, 1965, to September 20, 1966), *Something between my mouth and your ear* (1994) is more selective in editing and playing the top fifty music hits of this classic year in popular music.

In appropriating for himself something of the avant-garde of popular culture, Gordon might have had in mind, as well, a recovery of the spirit of an artistic avant-garde from which he was so distant, temporally and spatially: the American film Underground in its halcyon period 1965–66 corresponding to his gestation and birth. In an early example of artistic appropriation, key figures of that scene such as Jack Smith, Kenneth Anger, and Andy Warhol took the popular music of their day as unauthorized scores for their experimental films, while making the glamour of thirties and forties Hollywood the camp subject of their own film productions — a subject that they then proceeded to debase. These artists made avant-garde films using the ostensible content or formats of past films, particularly the movies of

their adolescence that had begun to resurface on television just prior to their own parodic productions. Gordon, likewise, uses the films he watched on television while young, the difference being that he uses the actual films themselves to make his own.

Analogy alone cannot make Gordon's projections experimental in the sense of the innovative Underground works of the 1960s. Comparison must bear on Gordon's particular interventions into the material of film and the effects of the film apparatus on our perception. Gordon's own differ fundamentally in that they are not films per se but video projections of films. But both the younger and older experimentalists use the medium of projection to address, however differently, the issue of film time. Nowhere is this affiliation more evident than in *5 Year Drive-By* (1995), whose impossible experience is at the opposite extreme from that unlikely remembrance of the installations *Words and Pictures (Part I and II)* and *Something between my mouth and your ear.*

Because hitherto it has been unrealizable in full as a project since it exceeds the norm of any possible viewing, Gordon's *5 Year Drive-By* might be interpreted as an extended footnote to *24 Hour Psycho.* Gordon has proposed to stretch John Ford's 1956 classic Western, *The Searchers*, to the length of the film's narrative. The resulting five-year projection would thus literalize Ethan Edwards's obsessive search for his abducted niece.[2] To the problems of realization (it has been shown only in part), Gordon would further add the difficulty of audience participation. He conceives the work as drive-by cinema set in Utah's Monument Valley, the location

of *The Searchers'* outdoor scenes, so that the viewer him- or herself must engage in a quest to see the work.[3]

By coincidence, *24 Hour Psycho*'s presentation adheres to the Aristotelian unity of tragic action, unfolding over a day, although the events in *Psycho* take about a week. On the contrary, *5 Year Drive-By* is an epic, defined as a story with no necessary limit to its action. The length of *24 Hour Psycho* is determined by a limit of its playback technology; *5 Year Drive-By*'s surpassing of technological thresholds matches the relentless, inhuman drive of the film's protagonist. The absurdity of Gordon's project is that in slowing the speed of the film to this extent, he ends up with a set of stills. Each frame of the film is held for about sixteen minutes, and thus each second of film time takes about a working day to project. Unavoidably durational, *5 Year Drive-By* results at any moment in a still image. A cinema of the still also recuperates the still arts. The slow passage of images reproduces the genres of painting — alternately landscape, history, and portraiture. It also mimics the conditions of advertising since its title indicates that the situation of viewing is no different from that of a billboard: drive by, not drive in, it states.

Ideally set in the grandeur of the desert, Gordon's projection is a memorial to the site and to the grand obsession of the story set there. Given the extravagance of its proposal, we should rather conceive it as a monument to time. Not so incidentally, it also memorializes one of Gordon's earliest reminiscences of film. On seeing *The Searchers* as a child, he was puzzled by the story's length, as well as by the lack of action typical of a Western. Grown up, he realized the problem:

It's quite simply a question of time. How can one film, which lasts
only 2 hours, possibly convey the fear, the desperation, the heart-
ache, the real "searching and waiting and hoping" that my father
had tried to explain to me when I was younger? How can anyone
even try to sum up 5 miserable years in only 113 minutes? Now, it's
important to say that this is not a criticism directed at John Ford,
nor the motives behind the making the movie. But, for me, it does
open up the gap in the way we experience the experience of
cinema; and this is the basis of my proposal.[4]

Gordon's dilemma is not that of the child he was, who want-
ed less narrative and more action or who perhaps wanted plot
to supplant the empty time of the search. Gordon seems to
want both more narrative and, contradictorily, less action. His
problem with film (*The Searchers* stands in as a generic exam-
ple) seems to stem from the difference of order that exists
between the time of an event and the time of its telling. In lit-
erature, an obvious difference exists between the order of
events and the order of words. In film, the problem is other-
wise. There, action, or movement, and time already co-exist in
the image. A story is told through linking these units of move-
ment in time. Montage, the name of that early invention, set
cinema on its narrative path, which rapidly achieved its classic
form in Hollywood film. In the history of film, montage and
narrative are synonymous. Montage links by cutting; a narra-
tive cuts up time; and that "lost" time — the gaps that compose
the artificiality of narrative — is signified by the splice of the
edit. Attracted to Hollywood film, Gordon stubbornly refuses
the very basis of its fictional representation.

Gordon's corrective proposal elides the difference be-

tween narrative and event, film and narrative. He does not say, however, that he wants film to reconstitute the event, believing that he can naively close the gap between the representation and its extratextual reference, but to manage an equivalent within the representation that film is. Gordon maintains that the problem pertains to *our* experience of film in the way we experience the *experience* of cinema. To close the gap would mean either to reduce or to expand the role of narrative, to get rid of it altogether or to extend it excessively by means of reconstituting its elisions. Gordon proceeds by excess.

To deny narrative's cutting up of time in telling a story would entail telling a story another way. It would mean moving from a mode of action (which the genre of the Western exemplifies) to a mode of time. Such a shift would make the viewer the subject of the film in his or her subjection to film time. Displacing action would mean moving from the inside of a film's plot construction to the outside of its screening. To close the gap would be to restore real time to cinema — but not to film's recording. Narrative would have to accommodate itself to the real time of cinematic screening.

Gordon's proposal returns Hollywood film to the field of experimentation. His intervention into film, however, seems no more than glorified home viewing, no different from handing the remote controlling the video player to the viewer. Fast-forwarding, reversing, pausing, slowing down: video playback parodies experimental film. Such a strategy would seem to lend authority to the viewer, except that Gordon imposes excessive temporal constraints on us.

If it was only a matter of the direct recording of action in time, two routes explored in the past might be taken: either return to the conditions of primitive cinema or detour through experimental film. Gordon has chosen the second route, but with a difference in that he persists in using existing narrative film as the basis of his work. So the solution to his problem cannot merely be a matter of getting rid of fiction altogether. Narrative is essential for Gordon's enterprise because only through the shorthand of consequential action can the idea of time normatively be constituted, and then through his manipulations that time be experienced differently. Critically, Gordon's projections are not just an analysis of the image but of the narrative image — of the image in time. Following the example of experimental film, in *5 Year Drive-By* Gordon seems to subvert narrative by making a work that lives in the perpetual present of the still image.

Since Gordon works only with the ready-made commercial product available as VHS tape, he modifies the material of film after the fact of shooting and editing when the narrative is set in place. His problem: he must restore the lost time excised by the edit without any new film material. Thus, in *5 Year Drive-By*, he fills in the hollow of lost time within the narrative that the plot elides by holding each frame for a requisite time. Structural film achieved the same effect by the optical printing of a freeze frame or, as Michael Snow did in *One Second in Montreal* (1969), by filming still photographs.

Uniquely combining two opposing genres, Gordon has turned a commercial Hollywood movie into an experimental

film of a type affiliated with the Underground's own monument to duration, Andy Warhol's epic *Empire*. In *Empire* (1964), Warhol trained a stationary camera on an equally unmoving Empire State Building for an overnight eight-hour period. (The connection between Warhol and Ford, between experimental film and Hollywood spectacle, between the duration of one and the narrative of the other is not fortuitous since Gordon made a bootleg copy of *Empire* recorded surreptitiously during a theatrical screening of Warhol's film and subsequently exhibited it under the title *Bootleg (Empire)* (1995) with *5 Year Drive-By*.)[5] In *5 Year Drive-By* Gordon mimics the overall characteristic of the unedited *Empire*, which is also one of the features of structural film: the equivalence between shooting and projecting.[6] Making the length of filming and the length of screening equivalent gave structural films their anti-narrative and, therefore, anti-illusionistic character. Gordon's twist on this trait makes the screening equivalent to the real time of the narrative, not the real time of shooting.

Sixties experimental film evoked a presence that, according to P. Adams Sitney, "Warhol must have inspired, by opening up and leaving unclaimed so much ontological territory, a cinema actively engaged in generating metaphors for the viewing, or rather the perceiving, experience."[7] This experience was grounded in the immediacy of a viewing that outstripped our expectations: Warhol "was the first filmmaker to try to make films which would outlast a viewer's initial state of perception. By sheer dint of waiting, the persistent viewer would alter his experience before the sameness

of the cinematic image."[8] Due to the excessive lengths of its "shots," some of the same effects of experimental film's single takes are reproduced in *5 Year Drive-By*. Our presence in front of *5 Year Drive-By*, though, is the site of a quandary that does not exist in past experimental film. The very characteristics that unite *5 Year Drive-By* to experimental film set it apart at the same time. These pertain to shooting and screening. Now that we locate an equivalence between narrative — not shooting — and screening, the shot in *5 Year Drive-By* must be considered in relation to the new whole of the film corresponding to the "real" time of its narrative as well as to our momentary perception of its screening. At any moment, though, the resulting static film still seems to contradict these conditions or to set them up as impossible extremes. We can neither fathom the relation of an unmoving image to the whole nor can we imagine the consequences of our perception of the still.

Even more so than the slow-motion images of *24 Hour Psycho*, the static images of *5 Year Drive-By* break altogether with the action of its source film. The concatenation of past, present, and future is rendered null in the perpetual, it seems, present of the image. But the still image does not restore an ideal presence to projection because it is now the site of a conflict absent from experimental film. Although we can never necessarily anticipate the outcome of a shot in experimental film (it plays with this failure of expectation), somehow we settle into the film moment and its duration. Sometimes the termination of a shot, though not its timing, is given to us in advance, as in Michael Snow's *Wavelength*

(1966–67), which concludes its unwavering forty-five-minute zoom, shot through a loft space, in a photograph pinned to the back wall. The overarching concept of Snow's shot, nonetheless, is dissolved in the drama of our perception of duration and the tension between the moment and the anticipated conclusion. In *5 Year Drive-By*, the plot of Ford's film sets the length of Gordon's proposed projection, but we cannot comprehend this temporal limit in our experience of the unchanging images of Gordon's projection.

In spite of our tangible experience of the screening, there is something fundamentally abstract about our understanding of *5 Year Drive-By* that distinguishes it from the aesthetics of presence of sixties film. We must think the idea of Gordon's proposal through our seeing of his work. That is, we must not only directly perceive the image, we must also conceptualize the *whole* of the work that we cannot experience at the same time. Gordon does not just tamper with Ford's film as he slowed Hitchcock's *Psycho*. He must conceive a new whole consisting of a near-infinitely extended series of stills. First, he must calculate the time of each frame's duration. So in a letter proposing the project, Gordon converts cinema time into real time:

The original film runs for 113 minutes and we need to stretch this to 5 years. The sums are as follows:

113 minutes of cinema time : 5 years in real time
so, converting this to days…
113 minutes of cinema time : 5 x 365 (days) + 1 (day for a leap year)
 = 1826 days

and converting this to hours...

113 minutes of cinema time : 1826 x 24 (hours) = 43824 hours

and, converting this to minutes...

113 minutes of cinema time : 43824 x 60 (minutes)

 = 2629440 minutes

so,

113 minutes of cinema time equates to 2629440 minutes in real time.

It follows that,

1 minute of cinema time : 2629440 ÷ 113

1 minute of cinema time : 23269.38 minutes in real time.

and further,

1 second of cinema time : 23269.38 seconds in real time

 = 387.823 minutes in real time

1 second of cinema time : 6.46 hours in real time. [9]

Since it is only modified, like *Psycho*, by elongation, Gordon
seems to respect the integrity of *The Searchers*' internal struc-
ture. But, since we see no movement, we cannot really call
this slow motion. Gordon's calculations radically constitute
a new form of intervention into the frame structure of
the film. So my earlier comment that *5 Year Drive-By* is a
footnote to *24 Hour Psycho* is wrong; *5 Year Drive-By* insti-
tutes another experience of time than that opened by the
slow motion of *24 Hour Psycho*, one that would be fully
exploited, though treated differently, in later projections.

Calculated, the still is a factor of number and thus an
abstract fragment; experienced, it has a qualitative duration
that is whole. As a single frame held in time, the still is both
an instant and a duration, as well as part of the film while
being a temporal whole in itself. In the screening, this whole

must be experienced outside its temporal present by a whole larger than it is — the complete project — or, contradictorily, the larger whole must be experienced within the smaller unit of the still. As viewers, we typically seem to experience the moment of the temporal present as something full and the idea of the whole, on the contrary, as something abstract. In Gordon's projection, we are problematically split between our present experience of the image and our knowledge of the new narrative and temporal conditions (now one and the same) that the artist imposes on this film. This new whole proposed by his project (a five-year screening) is incommensurable with our experience and possible viewing, but we must, at the same time, conceive it. In *5 Year Drive-By*, we experience neither the bliss of unencumbered presence manifested by experimental film nor the assurance of narrative closure of Hollywood film.

Deleuze has compared the relation between shot and whole to Kant's notion of the mathematical sublime.[10] Its temporal effects calculated, might the incommensurability of *5 Year Drive-By* also be experienced as sublime? How do we go from Gordon's arithmetic calculation to a sublime experience beyond the apprehension of our senses that is calculation's result? ("The sublime is that, the mere ability to think which shows a faculty of the mind surpassing every standard of sense.") Kant's analysis of magnitude provides the way. If the sublime is that which is "great beyond all comparison," it has no measure larger than it to judge its magnitude. Yet the understanding provides the concept of number for the progressive measure of any magnitude, the

imagination proceeding even to infinity. There comes a point, however, when imagination falters: it cannot adequately present the concept of magnitude when reason demands at once the idea of totality (i.e., its *comprehension* in one intuition, not a progressive *apprehension* by a series of units of measures). The resulting sublime is the supersensible effect of the mind where reason violently pushes imagination past its limits. We take pleasure in this unbounded discord brought about by an imagination inadequate to the ideas of reason. Reason's demand "does not even exempt the infinite (space and past time) from this requirement [of comprehension]; it rather renders it unavoidable to think the infinite (in the judgement of common reason) as *entirely given* (according to its totality)," a consideration pertinent to the extended duration of *5 Year Drive-By*.[11] This demand to *think* infinite space and time tells us that the sublime is not "to be sought in the things of nature, but in our ideas"; that it is not a matter of our perception, even though "rude nature" may provide the intuition for the mind's feeling of the sublime. Even though we witness Gordon's projection in nature, our experience of *5 Year Drive-By* exceeds it. The discord between our apprehension and comprehension, between our perception of a frame from *5 Year Drive-By* and our understanding of the work's totality, would engender in us this feeling of the Kantian sublime that rends our experience of film, experimental or narrative.

While *The Searchers* and *5 Year Drive-By* share in the sublime, our experience of incommensurability is not that of Ford's persistent searchers in the sublime landscape of the

American West. If the notion of the sublime could be misap-
plied to human actions, Ethan Edwards's discordant rage
that obsessively outstrips human purposiveness would be
defined by Kant as monstrous, even as he pursues his aim
through the sublimity of the desert landscape.[12] However
much it surpasses Ford's film, Gordon's temporal interven-
tion, nonetheless, would seem to reconstitute Ford's story in
the perpetual present of its agony, of its "searching and wait-
ing and hoping" rent by knowledge of its impossible task. Yet
5 Year Drive-By differs just as much from the presence of
Westerns as it does from that of American experimental
film.[13] Ethan Edwards's impossible search is exhausted by
the VistaVision vastness of the landscape of Ford's film.[14]
The spatial continuity implied by the out-of-frame land-
scape and the movement of the camera itself through this
space are foreclosed in *5 Year Drive-By*, however. In *5 Year
Drive-By*, the enclosed space of the shot of the still opens
only to a temporal continuity. (The effect of slow motion on
the image makes it seem as if it was shot by a fixed camera.
There is no movement in or out of the frame. Likewise,
space does not exist outside the shot. In the screening of *5
Year Drive-By*, only real space exists outside it.) In Gordon's
project, Ford's spatial sublime is supplanted by a temporal
sublime. Since the spatial sublime corresponds to the narra-
tive space of action, the temporal sublime must render nar-
rative otherwise. We presume narrative to be linked to
action, to movements in time that editing connects and con-
denses; this action depicts time through space. On the con-
trary, in Gordon's projection, time no longer supervenes

space but displaces it. Our search for sense in *5 Year Drive-By* is analogously frustrated by this new endless temporal vista and the impossibility of any action or narrative therein. Abrogating montage through the extension of the still, Gordon, it seems, must dispense with narrative altogether. But montage and narrative are no longer necessarily synonymous. Narrative no longer expresses a mode of action but rather is a mode of time.[15] Turning narrative time thereby against itself, Gordon complicates the fictional construction of temporality that editing reproduces. A film without montage would mean that time no longer is in the edit but in the image. Gordon's project would extend the duration of the search so much, though, that it would seem to have no beginning or ending — no happy ending, at least. Is the meaning of *5 Year Drive-By*, then, the impossibility of the search? Or must we instead now assume that the search is time itself? Gordon transfers the responsibility to us for what only *we* can experience: we experience temporally what Edwards experienced spatially.

Inverting the effects of space and time through the still point of his intervention, Gordon establishes a new relation between inside and outside the film. These inverting, reciprocating relations are typical of Gordon's manipulation of film. By means of them, Gordon actualizes a condition that was only represented in the original. We experience directly what was only thematic in the film: in other words, we experience the experience of it, an excess of the original film that determines all the elements of it. Narrative, for instance, has passed from the culmination of editing to the conditions of

viewing, from the inside of film's making or prior production to the outside of its viewing or present consumption. In effect, Gordon turns Ford's film inside out and opens it to our ongoing temporality. As such, he resituates the temporal within the spatial that he had just sundered — in the here and now of our viewing.

This is the second relation the still establishes. Not only must we relate the still image to the whole of the new temporal conditions of screening (five years) but to the immediate whole of our experience of its screening (right now). The real time of the screening, however, is not that of a darkened theatre as a laboratory of experimental effects; my experience of 5 Year Drive-By was outdoors in the California desert.[16] In the interest of suggesting the abstraction necessary to conceive the idea of the sublime within Gordon's projection, I have delayed describing my experience of its screening. Situated in the desert, set in a valley between mountain ranges and projected on a specially constructed, scaled-down drive-in screen, 5 Year Drive-By, surprisingly, is a highly romantic work. Environmental light and weather, the flight of birds or the call of coyotes ply our perception of the work and play uncannily upon motifs and scenes in The Searchers. At any one moment, the image is static but the screening enters into a dynamic with its setting. At sunset when darkness falls, the real landscape disappears while the brilliant image of another landscape eventually appears, slowly exposing itself before our eyes like a Polaroid photograph. At sunrise (the overnight period repeating Warhol's Empire), the two landscapes cross over again as the image inversely dissipates, as if

symbolizing the fleeting search of the film's protagonists. During the day, the image hides in the light, and even when we are not there, it is.[17]

By exposing film to its outdoor conditions of screening, Gordon makes the viewer subject to these new material effects of the cinematic apparatus. The variations that reside inside experimental film now appear outside in *5 Year Drive-By*. By means of this inversion, Gordon has converted a Hollywood movie into an experimental film. Moreover, he has restored real time to cinema — how "we experience the experience of cinema"— through this process. Gordon has not restored real time to cinema by turning *The Searchers* into a non-narrative experimental film; he has made an experimental film from a Hollywood film — but it has taken a narrative to make it so.

This is the crux of the misunderstanding and critique of Gordon by experimentalists and cinephiles alike, both of whom object to his practice — the former with it having all been done before and the latter with an artist's irreverent messing with the masters. What these critics fail to realize is that Gordon's appropriation of film is also its deconstruction. Perhaps their misrecognition of his work's effects is wilful; perhaps it is a result of the dissemblances of a work whose appropriations are other than they appear. What transpires in Gordon's appropriation is a double displacement of themes that he is thought only to repeat. To use his word, Gordon kidnaps the themes and binds them to his own strategies but only through a technical intervention that is an abstraction of the means of film, and not its themes, and that

radically re-inflects these themes through the viewer's enact-
ment. Gordon's simple appropriation is anything but. By
an adjustment of a film's projection — that is, through re-
projection *alone* — all sorts of never before seen complexities,
articulations, and analyses arise from interventions thought
to be appropriation's mere repetition. This repetition both
divides film into its basic components and brings forth new
temporal realities.

What analysis of film does Gordon's intervention in *The
Searchers* perform in *5 Year Drive-By*? The analysis results
from the calculations necessary for the work's effects. Gor-
don not only inverts the conditions of space and time through
the stasis of the still. Starting with the still — that is, with the
basic unit, the frame — Gordon foregrounds all the compo-
nents of film. They are only foregrounded, however, through
projection, not construction. Gordon's analysis specifically
pertains to the perception of the shot in time. This is a con-
dition of screening demanding the presence of the spectator.
Gordon's calculation takes film apart, but screening the
"recut" film puts its elements back together again in a recon-
stituted relation, within a reordered temporality, even in the
seeming disappearance of some of its components, such as
movement and sound. (The separation of sound and image,
I will continue to stress, is the instituting factor in all Gor-
don's projections.) Sound, however, reappears in *5 Year Drive-
By*, displaced outside the film but not its screening, because
the desert site now supplies the ambient soundtrack. Pre-
figured in *24 Hour Psycho* by the distension of slow motion,
the dissolution of montage is fully achieved in *5 Year Drive-By*

through the still. Abrogating montage in *5 Year Drive-By* paradoxically makes the relation between the shot and the whole primary to our experience of film. The smallest unit of the work isolated by an intervention other than montage leads to the incommensurable effects that overwhelm our viewing.

<p style="text-align:center">* * *</p>

In 1998, a few years after proposing *5 Year Drive-By*, Gordon installed a permanent public work on the side of a building in Glasgow — a vertical sign reading EMPIRE. Doubly articulated, with its backwards letters reflecting into a mirror to which it was attached, this work immediately was presumed to refer to the green neon hotel sign from Hitchcock's *Vertigo* that it mimics in reverse.[18] The sign obviously also advertises Warhol's *Empire*, thereby signalling the twofold nature of Gordon's film work that uniquely synthesizes Hollywood narrative and American Underground film. Gordon erects the sign as a monument to his reception in this place, Glasgow, of his double inheritance of "imperial" popular cultural forms from elsewhere (while subtly referring as well to Glasgow's role itself in British empire building). This speculation linking Hitchcock's *Vertigo* to Warhol's *Empire* starts a metonymic chain of association. In fact, this chain creates its own montage of effects: starting with a still we end with a new "film" that links all Gordon's sources. From the idea of a monument joining Warhol's *Empire* to Ford's *Searchers* we conclude with the film that provided the clip for Gordon's *through a looking glass*, Martin Scorsese's *Taxi Driver*, which counted *The Searchers* as one of the main influences on its

Paul Schrader screenplay. The calculations initiated in *5 Year Drive-By* will have incalculable temporal effects on the rest of his work, *through a looking glass* in particular. As with all his film appropriations, Gordon re-creates an artifact he inherits, making it anew as a monument to time in time.

3. The Madness of the Double

Confessions of a Justified Sinner

Gordon's *Confessions of a Justified Sinner* (1995–96) introduces the henceforth persistent theme of the double in his work. Announced, however obscurely, in *24 Hour Psycho* by Norman Bates's split consciousness, the double will preoccupy Gordon — but not only thematically. He will construct his works by means of the formal operations of duplication and reversal that stand as figures of the double. The mirror is the ground of these operations, but as the double is already a type of madness, the *other* is the sign of this instability of consciousness.

The other is the doppelgänger who acts for us, usually to no benefit. If we are at all aware of its actions, we are nonetheless helpless onlookers. This Jekyll-and-Hyde scenario is so well known that when Gordon excerpts footage from one of its various film versions we know the score in this struggle of the self between good and evil. As his film source this time, Gordon has chosen Rouben Mamoulian's *Dr. Jekyll and Mr. Hyde* (1931), from which he excerpts in silent, slow motion three sequences that show the transformation of Frederic March from Jekyll to Hyde. He modifies the film, however, by replaying each segment backwards to show the immediate reversion to Jekyll. The narrative thus collapsed into its essentials, Gordon endlessly loops the three cycles. Every possibility of reflection or reversal is exploited in double projection — the images mirroring each other, one image positive, the other negative, on two free-standing screens that can be viewed from either front or back.

Those familiar with the Robert Louis Stevenson story know that the duplicity in Jekyll's own character ultimately

leads to his self-entrapment and downfall. Gordon's projec-
tions mimic the ever repeating and quickening cycles of
transformation that, once initiated, Jekyll cannot control.
The projections double, then, raising the ante, redouble the
predicament for its subject. We witness consciousness's hor-
ror in Jekyll's recognizing himself in Hyde but also Hyde's
disdainful rage at finding himself imprisoned in Jekyll. In fear
or loathing, each lies in wait in the other, for the other. The
characters' traps are not merely their physical tether to each
other but their mutual incarceration in an abstract, virtual
universe that Gordon constructs for them. At one and the
same time, *Confessions* places and displaces them within a dou-
ble structure of duplication and reversibility to which every
element of its construction contributes without deviation.

 Short-circuiting narrative and the extraneous romance
introduced by the Hollywood film, the formal operations
actualize the essence of Stevenson's story. One subject is
divided into two and sees in himself his antagonistic other.
Gordon's *Confessions* is not traditionally dichotomous, how-
ever.[1] In keeping with Stevenson's literary tale, if not any
movie version, Jekyll does not simply represent good and
Hyde evil. Hyde is the pure distillation of Jekyll's duplicity.
Jekyll admits this in himself and for a time secretly revels in
Hyde's outrages; the doctor is an accomplice to Hyde's
crimes, not his hostage. What the movie versions of *Jekyll
and Hyde* obscure is the inherently dual nature of their pro-
tagonist. Typical of the horror genre, the movies literalize the
character split, as if it would be too shocking to suggest, con-
trary to the tale, that good and evil could ambivalently in-

habit one being, an admission that the human subject is inherently unstable.

Even the title of Stevenson's 1886 tale, if read in retrospect, obliquely signals the story's ambiguities. The conjunction "and" between the names Jekyll and Hyde dissembles the true relationship between the two characters. The title does not lie, but we could say it prevaricates, like Dr. Jekyll himself, when he admitted, even before his fateful experiment, "I stood already committed to a profound duplicity of life." On the one hand, the conjunction implies two characters — a Dr. Jekyll *and* a Mr. Hyde — and the literary story maintains this fiction of two separate protagonists as long as possible (as *Psycho* only reveals the secret of Norman's psychosis and dual personality at the end). On the other hand, the "and" includes Hyde *within* Jekyll as one composite character — a Jekyll who is also Hyde, the latter a character who hides in another. (In *Psycho*, Marion Crane hides within the name of her lover, the desired not-yet husband, Sam Loomis, when she signs the motel guest register as Marie Samuels; Norman, too, hides within his "mother" when he dresses as her.)

In their bifurcated grammatical structure, many of Gordon's text pieces share the transformative rather than conjunctive function of Stevenson's titular, mirror-like "and," while never resorting to it specifically. For instance, in the text piece "From someone lost, to someone found" (*Letter Number 17*, 1994), an individual is transformed from one state to another — from being lost to being found. The comma marks both a hiatus, a temporal pause or suspension, and a turning point, a blank space of transformation that is

necessary for the transfer implied by the prepositions. The phrase can go on reversing itself, perhaps infinitely. "From someone lost, to someone found, to someone lost" would be a phrase that we could apply to the plot of Hitchcock's *Vertigo* and its reworking of the necrophilic theme of the twice-lost Eurydice.

Gordon's temporal suspension or blank space of transformation and Stevenson's duplicitous conjunction "and" participate in what I have been calling the chiasm. The chiasm is the uncertain space/time of all the reversals, inversions, mirrorings, and doublings of Gordon's works. The chiasm is the fatal crossroads, the unpresentable scene between sanity and madness, the unlocatable place and the lost time where the doppelgänger presents itself to its host and acts on his or her behalf. The doppelgänger is a being who unexpectedly comes out of nowhere to face the self. Out of what void of the self does it appear? This is a question that applies not only to Jekyll but to all the amnesiacs, hypnotics, psychotics, and sleepwalkers who people the films that Gordon is drawn to. From such duplicitous issue of the double, Gordon constructs his projections.

What constitutes the chiasm? What institutes its space/time? What fateful dilemma instigates entry into its space of madness? What role does dissimulation play in its construction and provocation? In spite of its confessional title, Gordon's work offers no answers because this space/time pre-exists our participation formed by the operations of his work. The trap it sets has already sprung.

We notice, though, that there are two pivot points in *Con-*

fessions where the image divides or returns on itself, one spatial and the other temporal, which perhaps either mimic the effects of the chiasm or offer sites for its latent inhabitation. The former is external to the image as the configuring of a spatiality through the fold made by two screens. The latter is internal to the image as the tracing of the temporal reversal of the protagonist on himself, turning from Jekyll to Hyde and back. From such spatial unfolding and temporal refolding the chiasm comes into effect. From such folding Gordon plies his ploys.

Gordon's formal intervention alone prepares the ground for the effects that transpire in this spatial/temporal nonsite. Gordon adds nothing to the image but its folding. His intervening stroke marks a double-cross: he re-marks an image by doubling it. Whether the artist's folding creates the double-cross that brings the chiasm into existence, or whether the chiasm, manifesting as the figure of the double-cross, already folds the image back on itself, we cannot ascertain. When, through the moment of a discrepant movement, the image folds back on itself, it presents an other as itself to the self, as if in a mirror. The double-cross is two-faced. And the first one deceived is the self.

We interpret these bipolar images as they confront each other on two screens — one positive, the other negative — as a face and its mirror image. Automatically, we presume the positive image to be the original and the negative to be its mirror reflection with all the connotations of good and evil therein derived. The images, however, are mirrors at their source in Mamoulian's film, where they offer Jekyll's

subjective view of his transformation. One image, therefore, has no priority over the other in Gordon's projection. The "original" is *always already* remarked by its "other." With no originating images outside Gordon's mirrors, we are present-ed with a pure structure of internal duplication, an intra-mural space that we ourselves cannot enter. As film images of mirrors, the images in *Confessions* are doubly virtual and thus twice removed from our space. Nevertheless, we must conceive the consequences of this virtual space. If we con-ceive both images as mirrors, their reflections theoretically must reflect back into each other. The negative image, for instance, must "reflect" in the other — now as the reverse positive image seen from the back side of the other screen. (That is, we must imagine both the negative image of Jekyll and its reflection back into the reverse positive image of him-self as images of Hyde even before the image of Hyde appears.) While we do not actually see these other images as multiple reflections, we must imagine them so virtually. The virtual configuration we thus visualize is X-shaped or double folded, a chiasmatic structure of reflection where we must think to the fullest the transformation of Jekyll to Hyde and back. Thinking so, we carry out the transformation. The chiasm in *Confessions* is a virtual nowhere at the cross-point of two reflecting and intersecting mirrors where a subject and image pass into another reality.[2]

The mirror doubles an image and is thus an ideal figure or metaphor for the double nature of a conflicted self, one side considered to be real or sane, the other illusory and insane. This is the traditional notion of the mirror from which the

oppositions of split identity and the accompanying dichoto-
my of good and evil stem. A double mirror, however, intro-
duces a whole new order of reflection, spatially, conceptually,
and ontologically. The double mirror engenders a virtual
world that is both closed and infinite. No outside delimits its
images. Any reflection within it is already divided, split in
itself. Every image is already a pair, not Jekyll and Hyde but
always already Jekyll-and-Hyde. Hyde does not derive from
Jekyll, split off from an originary identity. Jekyll and Hyde
are an originary double, forever doubling together without
end.[3] In this virtual world, space and time operate differently
to bind its inhabitants to a perpetual trap more complex than
the reversion of identity of Stevenson's story — as this trap is
now repeated to infinity.

Mirrors mirroring mirrors, images automatically dupli-
cate themselves as an infinite series of reflections in a closed
universe. Such a dynamic of perpetuating reflections rules
out the simple dichotomy of split personality and the oppo-
sition of good and evil that the names Jekyll and Hyde tradi-
tionally represent. Delimiting identity will have a conse-
quence for our sense of its stability; unfixing it from dualism
will free interpretations from the dichotomous world of good
and evil that commentators still ascribe to Gordon's work.
More important, virtuality imposes the conditions of serial-
ity on reflection. Seriality is implicit in the originary double:
to be an other already is to be multiple. We never stop at two.
From the start, seriality dispenses with the notion of duality
and mere doubles altogether. My earlier statement that *Con-
fessions'* double structure of reversal reveals the "essence" of

Stevenson's story must now be reconsidered in light of the more complex configuration of infinite identity that Gordon's projections set off, which assumes a *serial* form.

Unlimited becoming incited by the infinite identity of an infinite series leads to madness. This has always been the danger that philosophy traditionally has tried to allay, not to stay madness per se, but to avoid the problems of failing to assign sense in language, which nevertheless is the ballast of identity.[4] Madness, however, would be the despairing fate of Jekyll-Hyde in the virtual world Gordon binds the pair to. When as spectators we have to configure this proliferating series beyond what we actually see in his projections, we too perhaps finally enter this virtual space of madness. In Gordon's early projections we must think this virtual seriality, as we do here; in his later projections we experience it temporally.

We are far beyond a simple reflection in a mirror and with it modernism's attendant metaphor of the self-reflexivity of consciousness. *The Strange Case of Dr. Jekyll and Mr. Hyde* bears witness to a contamination of consciousness within consciousness itself. When Gordon sets his "mirrors" in front of each other in *Confessions*, it is not to create a pure structure of reflection but to capture this impurity of consciousness, to remark the stain in the tain of the mirror that perpetually reflects a disorder of origins.

Closed as this virtual world is, some event instigates its trap. Some fateful crossroads incident brings the chiasm into being — and the virtual world with it. "That night I had come to the fatal cross roads," said Jekyll when he first drank his

fateful *pharmakon*. We make a decision in life at a fork in the road, but we sell our soul to the devil at a crossroads. Perhaps the devil accompanies us all along, as resident Hyde to our natal Jekyll, as a latent virtuality that some crisis actualizes. Nothing external befalls us, no "event" but what is already inside us, whose "protagonist" is our doppelgänger, this internalized dissemblance of an other. Our doppelgängers make us guilty even before some fateful crisis. Intervening fate, then, would be the instance of the pure event of an inversion whereby the chiasm externalizes the virtual world of our internalized doppelgänger. The chiasm brings the other outward to face us as our double. Out of what void of the self does the double appear? Some fundamental deception, Jekyll's "profound duplicity" for instance, seems to bring the "first" double into being. We would not like to think so but the doppelgänger arises from or, rather, arises *in and as* deception. Neither doppelgänger nor dissemblance exist before the other; they are one. Duplicitous, Jekyll is already double. The doppelgänger is a deceptive other: a double and a dissemblance at once. We can say of the double/dissemblance what Deleuze has said of complex or disguised repetition: "Repetition is truly that which disguises itself in constituting itself, that which constitutes itself only by disguising itself."[5]

Not merely duplicative, the iteration of chiasmatic reflection is implicitly duplicitous. Serial virtuality arises equally from deception as from reflective doubling, one having no priority over the other. (Series themselves are not necessarily duplicitous, however — only where in bifurcated series, as

here, one part exceeds, dominates, or hides the other.) The very act of doubling automatically and uncontrollably proliferates endlessly. At the same time, as soon as there is dissemblance, there is a doubling that extends to infinity. Duplicity is contagious — to the "core." This is Jekyll's fate. We must conclude that there is no essence to identity other than this abyss of simulacral reflection, no essential core but one contaminated and divided by dissimulation. The double and duplicity, dissemblance and the doppelgänger: each automatically calls forth the other in infinite reflection. The mirror is the ground of this proliferation or instead the ungrounding of identity sustained in a foundationless chiasm. One and/or the other: the mirror is the visible sign of an invisible dissemblance, or the mirror is the invisible sign of a visible dissemblance. As soon as there is a mirror in Gordon's work we are warned: not only is there a double but a dissemblance as well.

A trap set for the other, deception becomes a snare for the self. Jekyll condemns himself from the start. Does Gordon escape his own ploys? Jekyll could admit his duplicity. Can Gordon? We suspect that the double-cross Gordon puts in place when he constructs his work implicates him as well. But it does not necessarily make him share in "his" characters' contradictory dilemmas. Indeed, he offers no moral lesson in their dilemma, seeming to delight instead in the fateful mechanisms of the chiasmatic trap. Is the mirror world a moral world? Yes, insofar as its protagonists seem to be guilty and are made to pay. Yet the artist has admitted the moral ambivalence of his own position when he stated that a "work

must be firmly ambiguous, moral and amoral, self-righteous in intent and self-denying in stature, communicating in tandem a desire for confession and a denial of responsibility." Whether the universe Gordon sets up is Manichean or Calvinist, he displays no interest in an ethical outcome of the struggle between good and evil. Rather, he persists in plying the divide between the two. Not surprisingly, Gordon also confessed that what he had just said above was both "true and contradictory."[6] True and contradictory — such statements we know from Norman Bates's case to be inherently duplicitous.

From the start, Gordon's projections already display a double and, therefore, duplicitous character, based as they are on the work of another — repeating that of Hitchcock, Ford, or Mamoulian. Although absent from any making of the original images, Gordon nonetheless lurks Hyde-like within them when he claims them for himself. He poises himself somewhere between outside and inside a work, on the border between author and character. His appropriative gesture seems slight: he simply finds his themes reflected in these filmmakers' works, literalizes them through his interventions, and retitles the result. In that the *title* marks the division between outside and inside a work, perhaps it is in what first announces his work that we should seek clues to Gordon's dissemblance.

Gordon's title does not acknowledge any confession Jekyll makes in Stevenson's story. Instead, it offers an obscure literary reference to an 1824 book by Scottish writer James Hogg, *The Private Memoirs and Confessions of a Justified Sinner*. Such

presumed mistitling sends us first to Hogg's text before we attempt to discover its affiliation to Stevenson's story and Mamoulian's images. Although probably an influence on the story of Jekyll and Hyde, Hogg's book is less known. His novel is an attack on Calvinism and its doctrine of the elect — the belief that one is ineluctably saved or damned since the will is inoperative in salvation. Through the action of its plot, the book asks the question, If the elect are predestined for heaven, are they free then to act as they will on earth, even to commit murder? Under the influence of the devil, one elect, a young man, Robert Wringhim, kills his half brother. Does the devil exist or is he a split-off part of Wringhim's psyche? Indeed, the devil does exist in Calvinism; Hogg's book, however, implies that the doppelgänger — the "friend" — is a delusion on the young man's part but one that has been created by religion. In what is perhaps a national predilection, Gordon follows the Scottish writers Hogg's and Stevenson's examination of the contrary sway of the doppelgänger on character. By restoring Stevenson's tale to a literary series that began with Hogg's book, Gordon reinforces the somewhat Gothic, later to become noir, theme of the doppelgänger, the other who acts within the self. If Stevenson's story is the subject and Mamoulian's film is the object of Gordon's intervention, Hogg's novel is the obscure intertext whose function we need to uncover.

Hogg's story is a richer resource than Stevenson's tale to trace the Calvinist themes in Gordon's work. But Gordon does not use the title to send us to Hogg's book in order to explicate them. His confessional title hides what it admits at

the same time. Gordon nests a number of references within the title, one hiding behind the other, so that the title immediately dissembles its role. Through Gordon's appropriation of his title, Hogg's name enters into a series of affiliations that ends with Gordon's own name, but the names are not exposed to view with the same emphasis. Initiatory it seems, Hogg's own name remains hidden.

This is because the nominal series is bifurcated between two others — that of images and that of texts. On the one hand, we have a literary series comprising Hogg's and Stevenson's texts that serves as background to Gordon's work; on the other hand, we have a filmic series comprising originally Mamoulian's and now Gordon's images that dominates our attention. What originates as a historical series passing from literature to film (Hogg > Stevenson > Mamoulian > Gordon) is reconfigured through *Confessions*' titling so that the literary and filmic series intersect and alternate (Stevenson > Mamoulian > Hogg > Gordon). In presentation, however, *Confessions* only foregrounds the visual series. This seems natural, even if sound is deleted in the process. In the case of Mamoulian's film, it is easy to orchestrate the relation of literary themes to the film since they are relatively transparent to one another, the film being based on the story but subsuming it within a visual emphasis that Gordon now repeats.

Whatever is signified by the name Hogg does not stand outside the series and therefore outside Gordon's *Confessions* as name, title, thematic reference, or historical influence. On the model of self-reflecting mirror virtuality, his name must inflect the interior as a duplicitous inscription within it.

Through titling Gordon places Hogg's name, and his own signature parasitic on it, *en abyme* between mirrors.[7] Hogg's name flashes like an intermittent signal or a light-struck mirror between Stevenson's tale and Mamoulian's images.

The expanding nominal series initiated by Hogg's title raises both the question of authorship in particular and the issue of the validating authority for identity of names in general. The series of images derived from Mamoulian's film — which Gordon proliferates as an infinite series of reflections — pertains to another loss of identity in the original film, one that is split between the names Jekyll and Hyde. In *Confessions*, the two series of images (Mamoulian, Gordon) and authors (Hogg, Stevenson) — one corresponding to an infinite series of reflections in a mirror that confuses sight, the other to a proliferating series of names that confounds identity — would then seem to intersect in the theme of the uncertainty of identity.[8] By extension, these serial effects continue to work in the reception of the viewer, in his or her identity, but not without first unsettling the notion of authorship of *this* work.

With the proliferation of authorial references that the partial title of Hogg's book sets off, should we continue to locate Gordon solely in the domain of visual art as the surrogacy of film here places him? Or can we now ally him as well to a literary tradition?[9] The two series, visual and nominal, then would culminate and combine in the bifurcated identity of Douglas Gordon as artist *and* author. The question of where we situate Gordon between image and text as artist or author is one only fiction can answer. What may be an uncertainty

for the subject may only be a fictive play that verges on dissemblance for the author. When Gordon takes up the dissembling mask of an author, as I suggest he does through (mis)titling, he no longer merely actualizes Hogg's and Stevenson's theme of double characters. He enters into another dissimulation named writing.[10]

Writing is an operation of multiple masks. We should presume no statement is truthful, even, or especially, if an author attaches his name to it. For instance, through his deceptive authorship of the text "A Short Biography," Gordon's affiliation with Hogg is asserted at the same time as his identification with the fictional doppelgänger of Hogg's book. By using the name of Robert Wringhim's split-off character, a "friend," to sign his own presumed autobiographical text, at one stroke Gordon casts himself as both an author and a fictional persona. (These would be two other series Gordon manipulates: that of characters within the work and that of authors outside it.) By uniting Hogg and Stevenson under the theme of the doppelgänger, and thus aligning himself with a particular national tradition — what Gilles Deleuze and Félix Guattari call a "minor literature"— Gordon assumes one more identity: storyteller.

None of this is obvious, nor meant to be. Gordon's confessional title only half reveals its intentions. Is this dissemblance intentional or pathological? Another Scottish author, the Glaswegian anti-psychiatrist R. D. Laing, has examined fictionalizing gestures that create pathological double selves. In *The Divided Self* — the title of the book after which Gordon probably named his video *A Divided Self I and II* (1996) —

Laing discusses the schizophrenic in terms of the "false-self system."[11] In the mechanisms that articulate the disease, the schizophrenic creates a false self as mask to protect his or her "true" inner being. Norman Bates's impersonation of his mother is an expression of such a false self. Gordon's false self would be the face he puts on through the image of another, in this case, his film appropriations. His true self presumably would be that which he hides away: that of an author. However, since, as Laing tells us, neither inner nor outer character ultimately are true for the schizophrenic, the relation of writing and film in Gordon's work would persist in being one of mutual dissemblance.

Gordon *is* divided, though. His identity is split by this dichotomy of artist-author. While the two-faced *Confessions* offers a masked, double self-portrait of Gordon as artist and dissembling author, his work as a whole would be divided at its origins by this inaugurating deception. As he is already an artist, the assumption of authorship would seem to be the aim of his deception. Yet what is he as an author? If writing is signified by the title of this work, Gordon is the author of a confession that is not an admittance of a self who is not the agent of such an intimate enunciation. At issue is not authorship per se, even the dissemblance of authorship, but the authorship of dissemblance. *Duplicity is the fundamental operation in Gordon's work.*

Gordon dissembles his divided origins in that he lets only the artist in him be visible. We would have to conclude from another double self-portrait, *Monster* (1996–97) — a Jekyll-and-Hyde photographic representation that shows his reflected

image disfigured by a Scotch-tape facelift — that authorship
is monstrous and must be hidden. Monstrosity may only be
the exposable image of dissemblance, since duplicitous
authorship is not just dissembled, it is dissembled in the
image. Gordon places the question of the author within a
space that is already dissembled because already divided: the
image. Every image is already fundamentally split through
an "inauguration" that buries its other half in a dissembling
mirror. By splitting the image in two through its mirror dup-
lication, Gordon both reveals and institutes all *Confessions'*
divisions (between artist and author, image and text, sound
and image). Nothing in itself, the mirror nonetheless articu-
lates the relation between these series at the same time that
it constitutes, unites, divides, and dissembles them.

Gordon's work derives from this sleight-of-hand insertion
of a mirror into another's scene. Appropriation is nothing
but this (dis)placement: a theft of what is only a reflection.
Silent and effective as a criminal's jimmy, mirroring pries a
film open. When the job is done, something is out of place in
the place it was. This is the subtlest of thievery. It does not
replace the original with a copy; the mirror's placement con-
founds original and copy.

Dissemblance stems from a split in origins while causing
the division at the same time. This division is also a diver-
sion. Origins are dissembled in that they are already double,
except that one part falls away in the equation to carry on a
virtual life, like Hyde within Jekyll. Such instances of dis-
semblance would be the author subsumed within the artist
or sound and literary narrative sublated in the silent image of

Gordon's projections. Despite appearances, then, we might ask what other hierarchical relations are exposed and inverted by the ruse and mismatch of title and image? The double relation Gordon's works have to their source films would be duplicated in every instance of the dissociation of text and image, for example here between that of script and film and within film itself between the components of sound and image. Gordon's critical intervention does not overturn one in favour of the other, restoring writing over images, for instance. He deceptively manipulates both orders. Dissemblance only operates as a space *between*, between artist and author, image and sound. As it creates both at the same time, dissemblance cannot be decomposed in one element over the other. Sometimes the displaced other, though, returns with a vengeance. Stevenson's story illustrates the instability of the dominance of any one narrative series or any one character or identity of the bifurcated series over an other in the ever accelerating displacement of each over the other, until Hyde seems to exceed. In the end, the author Stevenson had to call a halt to the proliferation of the series. Contrary, the artist Gordon unleashes its logic.

Doubled and dissembling as artist and author, Gordon does not share the same fate as Jekyll and Hyde. If as an artist he is marked by this encounter, he is affected by the re-mark of an other who is author, himself alone. Gordon remains a criminal author, resting secure in an undisclosed crime. His crime is not just the theft of images, nor the ruse of his titling: applying a title that is not his to images equally not his own — acts that he does not confess, in spite of the title. His

crime fundamentally is... deception itself. If we catch him in his criminal ways, if we remark his strategies, we are not so innocent onlookers but, rather, one of his implicated others. As accomplices to his crime, we countersign his act. Jekyll had to countersign Hyde's crime when he produced a cheque to buy his doppelgänger out of one of his vile acts. Countersigning, we diabolize our own signatures and throw ourselves into a bottomless abyss of duplication where we confront the demonic image of the other — ourselves.[12]

4. Before the Law

*Between Darkness and Light
(After William Blake)*

If Gordon titles his next work *Between Darkness and Light
(After William Blake)*, it is not to suggest an opposition
on display, unless once more, Jekyll and Hyde—like, these
contraries inhabit each other. Rather, *Between Darkness and
Light* is a toponymic title: it describes the work's place.
Like *5 Year Drive-By* and its ideal desert location, *Between
Darkness and Light* was conceived for a particular site. The
double-projection video installation was made for the 1997
Münster Sculpture Project, where Gordon chose to work in
a pedestrian underpass that suggested to him a physical pas-
sage that could also be taken as metaphorical. The passage-
way's nondescript, actually slightly decrepit, character, a
place where no one would want to linger, may have sug-
gested it as an appropriate site to represent the mid-place of
purgatory — that ambiguous zone between the light and
darkness of heaven and hell.

Gordon's projection joins two religious stories, one
pietistic, the other perverse, the good *Song of Bernadette* of
1943 by Henry King and the bad *Exorcist* of 1973 by William
Friedkin. Basically, the plots make these the same movie,
even though the good taste of *The Song of Bernadette* is
offended by the bad taste of *The Exorcist*. What links the
films are narratives of possession by the supernatural and
the ecclesiastic and secular doubts that respond. The differ-
ence is in the possession, one by good, the other by evil.
Bernadette (Jennifer Jones) has visitations by the Virgin
Mary; Regan MacNeil (Linda Blair) is inhabited by the
devil. The two stories intersect on the issue of faith — the
belief in things that cannot be seen — but the doubt in each

film is distributed differently. In *The Song of Bernadette*, Bernadette's faith is tested against the incredulousness of a panoply of authorities: familial, religious, and secular. Given that the event took place in the nineteenth-century age of progress, Bernadette at first is treated more as a mental patient than as an ecclesiastic dilemma. Set as *The Exorcist* is in contemporary times, it is the priest, whose primary pursuit is psychology, not theology, who must test the doubts of his modern science against the presence of evil and perform an exorcism on a girl possessed by a medieval anachronism, the devil. Gordon's title now also situates the unanswerable questions and doubts that attend both films convened in this site.

The topographic economy of the work is not just its place-ment in a particular site. The title also refers to where the work takes place operationally not just physically — to its working in a space *between*, this shifting boundary "between darkness and light." The two films are projected on reverse sides of a shared rear-projection screen where they are sus-tained in the darkness and light of their opposing images. The screen is penetrated by the light of each projection so that one film shines through or possesses the other. In allow-ing the narratives to interact (the soundtracks intermingle as well), Gordon does not stage a confrontation of good and evil so much as let one act through the other.[1] The presenta-tion immaterially realizes the two films' scenarios of spiritual possession but not without casting its own dark doubt and subversive interrogation.

The space of the two films' mutual entitling is the space

of their unworking of each other. The screen between suspends the images in the boundary of their interpenetration (neither inside nor outside each other) but disappears in their transparency to each other. This device is what Jacques Derrida calls a "hymen." On the one hand, the hymen is merely a tissue or veil, like the rear-projection screen itself. On the other hand, according to Derrida, the hymen "produces the effect of a medium (a medium as element enveloping both terms at once; a medium located between the two terms). It is an operation that *both* sows confusion *between* opposites *and* stands *between* the opposites 'at once.'"[2] Coming between, the screen doubles the discord by letting the uncertainty of one film infuse the disbelief of the other and vice versa.

Not so coincidentally, "hymen" also refers to the consummation of marriage and piercing of the veil of virginity by coitus. Indeed, regulating the bodies of girls of a certain age in order to prepare them for the passage into married possession is the unstated social subtext behind the customs and rituals depicted especially in *The Song of Bernadette*. "Girls of your age often see things which don't exist," one character says to Bernadette. Church authorities were not only concerned in such cases that the devil mingles as much as the holy spirit in young girls. Perhaps Bernadette, like Regan MacNeil, derived from a line of medieval female religious sexual ecstatics. Girls of a certain age must also be protected from a type of possession that is sexual in character and dangerously contagious. Any sign of this possession must be inspected at the site of its symptoms.

In these films religion, not the authority of law, is the meeting point where the issues of certainty and doubt stemming from a question of faith are brought into resolve. Doubt, however, is not just an internal matter of individual faith. Questioning brings forth a whole medico-juridical policing apparatus. Every system of belief has its own regimen of regulation, adjudication, and discipline. Every discourse has its judgmental authorities and its institutional enforcers. The films Gordon uses are full of inquisitorial types — doctors, psychiatrists, police, and priests — who ally themselves to one another. Their probing of guilt is essential to the bifurcated schemes of Gordon's works that turn on issues of trust. (We too infiltrate these films as shadow interrogators; standing in front of the projectors, we throw expressionist shadows into the proceedings.) Because the conflict between different systems of belief is externalized in both these films, it has its actors who stand for these opposing systems. The actors, however, do not represent opposing doctrines as equal opponents, as much as one is subject to the other as the emissary of a dangerously inverted discourse that must be exposed to the light of truth and judgment of the dominant discourse. The presumed guilt of this party is all the more problematic for authority when the deviation intransigently resides in a physical embodiment and when the body is that of a girl.

As is usual in our culture, in these films men discourse on good and evil through the intermediary of the body of a girl. In the speculum of their judgment, the body as well as the spirit of the girl are subject to interrogation. Any questioning

of spiritual disorder has its somatic counterpart in medical observation. Thus, *Between Darkness and Light* is related to a series of other projections by Gordon of seemingly medical orientation. Both *10ms^{-1}* (1994) and *Hysterical* (1994–95) derive from found medical footage that originally was made to observe pathological somatic symptoms caused by various psychic stresses. Divorced from their medical contexts and projected so that observation doubles back on itself in a theatricalization of scrutiny, the films can simply be looked at in formal terms as the relation between the horizontal and vertical enacted as a hierarchy of authority between the supine and the erect. In the case of *Hysterical*, which consists of footage of a theatricalized medical demonstration in J.-M. Charcot's Salpêtrière clinic, the opposition is posed between an anonymous female hysteric and the famous doctor and theoretician of hysteria, the woman collapsing on a bed, the man, with hands on her pelvis, administering from an erect position. In *10ms^{-1}*, medical footage showing the effects of shell-shock, the relation between the normal and the pathological is graphically illustrated in the collapse of the standing, semi-clad male figure to a helpless, writhing fallen body that cannot right itself.

Already so close to the subject of *Hysterical*, the action of *The Exorcist*, which centres on a quasi-eroticized bedridden girl to whom priests minister, strikingly repeats this structuring of horizontal and vertical made more conspicuous as an opposition between black and white. We always view this film under the sign of the cross constructed from the two figures of the bedridden girl and the standing priest, the

latter a position our shadows mimic. Perhaps every image carries within it this crossing that institutes figurability as an unconscious structuring within the framework of a veiling image. As an internal symbol of the crossing of each film into the other repeated in Gordon's intervention, this disguised cross reveals that Gordon's would be no subversive iconoclasm but would bind us further to this bed. It is not so easy to escape one's background: the cross throws a long shadow. Nonetheless, as a construction not only of the horizontal and the vertical but as a disturbance *between* them, the cross here does not function as a simple symbol. The *double*-crossing of these films is an insecure bridge: between darkness and light is the site of the chiasm.[3] Applying the cross to an image, as if to ward off or to exorcise its dangers, can only mean that the image is fundamentally demonic. Thus, convening these two films does not promote the work of the cross but, rather, the equally disguised unworking of the double-cross.

On a superficial level, Gordon slyly undermines ecclesiastic authority by means of one of the artifacts of the Church's pulpit censorship: its attacks on the book and film *The Exorcist*. By bringing these films together with no editorializing comment, Gordon lets the vulgar spectacle of *The Exorcist* contaminate the elevated spiritual tone of *The Song of Bernadette*. On the side of the girls, he advocates for the delinquency of adolescence.[4]

On a disguised level, the unworking of the double-cross is such that the intermingling projections reverse interrogation through their own juridical infrastructure that insinuates doubt, not clarity. The operation between these films makes

sure that any outcome — judgment or inspection — is inde-
terminate and undecidable. In this counter-interrogation,
Gordon rather than the girls sows confusion, Gordon who
slyly hides away and the girls who naively reveal too much.
The girls cannot escape the inquisitional gaze because not
even doubt is their own; they are objects not subjects of
interrogation. *Between Darkness and Light* reverses this
dilemma, leaving the girls an out at the cost of their being
lost between. There is never an escape from Gordon's traps;
the double projection reinscribes these religious tales within
the interrogatory domain of film noir. The invaginated struc-
ture of the hymenic "between" determines that there is nei-
ther an inside nor an outside but that the interrogative gaze is
already inherent within the subject. Only the author of this
confusion, for whom appropriation is a trope for possession,
seems at home in limbo: dissemblance is always a matter of
between.

5. Criss-cross

We are halfway through our discussion of Gordon's Hollywood projections which, conveniently for my analysis, are themselves at a crossroads. Not that at first glance we immediately see a radical change in the work; themes persist and a projection style is maintained (with continuing variation in screen placement). From now on, Gordon becomes thematically more fixed in his selection of source films, choosing examples of film noir or its derivatives to work from. Film noir was already part of his repertoire; the themes of fate, guilt, and trust readily pass from Calvinism to its dark vision. Continuity of content is a screen, though. Henceforth, Gordon will intervene in the frame structure of films to link his themes to a new order of temporality. Form and content are bound together in such a way as to bind the viewer to their temporal effects.

As if passing through the looking glass, everything doubles in the passage between these two periods of work. The second half of the book, therefore, must occasionally double back over the themes and false tracks of Gordon's earlier projections. Even I must return here to rewrite the preface of this book, initiated as it was with a falsifying gesture — a double gesture, written with two hands as Derrida would say. As countersignatory to that falsifying preface, the author (P. M.) is accomplice to the artist. The preface revealed only what we needed to know for the first half of Gordon's work. From the start readers could not know how much they were the artist's dupes and furthermore at the same time his willing accomplices.

If this text is written as if by Gordon's doppelgänger sub-
jects, without the left hand knowing what the right hand has
written,[1] we can never fully trust what is truth and what is
dissemblance, what is literal and what is fictive within its
authorship. Nevertheless, we must continue even though
this chapter must be written with two hands as well, since it
functions at the same time as a conclusion to the first half of
the book and as a preface to the second. As in the false start
of the double film *Psycho*, we must begin again in the mid-
dle, this time with the "true" story.[2]

Through the diversity of their source films, each of *24 Hour
Psycho*, *5 Year Drive-By*, *Confessions of a Justified Sinner*, and
Between Darkness and Light (After William Blake) develop a
repertoire of closely linked themes that persist throughout
Gordon's works. Themes being continuous, we might think
that the second half of this book can concentrate on Gor-
don's new temporal techniques. In fact, we might think,
through the crossover function of this chapter, that the pre-
dominance of either theme or technique invert themselves in
each part: that Gordon's themes of fate, guilt, trust, and the
madness of the double dominate the first half of his work and
technique the second. Gordon's interventions, however, are
always only technical; they are formal, not thematic. His
work reveals its themes only through the formal manipula-
tion of an original. Parasitic though Gordon's themes are on
those of others, they figure within a temporal dynamic that is
his alone. Gordon's language works have already demon-
strated a performative temporality operative in his projec-
tions. Gordon's noir themes are enveloped within a temporal

operation whose figure we can take to be the fateful turn of the double-cross. They only instantiate themselves within this chiasmatic double-folding of time. This structure is such that the time of turning can be understood as successive or simultaneous, repetitive or reversible. Thus, trust and guilt are linked to each other by a turn that leads to an irreversible trap; fate reciprocates with guilt; guilt issues in madness; and duplicity automatically produces the double.

Gordon's early projections collectively employ the devices productive of all the formal and thematic variations of his future works. On the one hand, they insinuate a new temporal world in that of the original. On the other hand, they institute a chiasmatic architecture of simulacral reflections. Gordon's first acclaimed projection, *24 Hour Psycho*, established the model of appropriation of another's work, which is modified by a simple, but effective, technical displacement — here, slow motion. Extracting the image from its spatio-temporal coordinates, slow motion in *24 Hour Psycho* uncovers a new temporal reality within the original film without physically modifying it. These new temporal conditions open the space of the unconscious for us while at the same time creating a trap for the film's protagonist. Beginning with *Confessions*, the uninvasive device of the mirror effect (itself emblematic of the act of appropriation) contributes the other essential feature of Gordon's projections. From the discrepant return of the image on itself we derive the complex effects of serial virtuality. The mirror automatically produces the double through a dissemblance that is one with it. While these operations of insinuation and institution are

separate in the first half of his work, henceforth Gordon will construct his works from the combination of temporal *and* virtual factors.

Perhaps we can generalize that if the figure of intervention in the early work was extension produced by slow motion, in the later work it is the cut.[3] Although seemingly an extreme version of *24 Hour Psycho*'s slow motion, *5 Year Drive-By* anticipates, through the calculations necessary for the stasis of its stills, Gordon's later physical intervention into film matter and plot line. Early projections, such as *24 Hour Psycho* and *5 Year Drive-By*, dilate narrative by extending it, while respecting the plot and the physical form of the film at the same time. Starting with *through a looking glass* and *left is right and right is wrong and left is wrong and right is right*, both from 1999, Gordon's projections re-narrativize plot by strategically cutting into it and playing it against itself in a repeated yet self-differing structure. Gordon's cut into a film creates a situation where not only the protagonist but *we* become other in the double-folding, double-crossing chiasm of time. Whereas what we earlier merely witnessed in the plight of the film protagonists, we now experience ourselves. As the spiral announced itself right from the opening credits of Hitchcock's *Vertigo* as the figure signifying the madness of its protagonist, so for each of Gordon's new projections we soon discover the structural figure that enfolds us in the work's delirium.

What we do not see, because its workings are obscure and do not announce themselves, is the continuance of Gordon's dissemblance. Gordon succeeds in disguising himself in

work that is all dissemblance. *All* dissemblance. Forget good and evil; any of the work's oppositions or contradictions — we must constantly remind ourselves — are a result of this dissimulation. If the first half of the book thinks duplicity through the falsifying signatures of the artist as author, the second half is devoted to dissemblance through the simulacral images the artist proffers. The image, however, is no more than the re-marked signature of the double-cross. Dissemblance prefers to operate in a space between — between signatures and simulacra, texts and images. Such is the formalism of Gordon's projections that the implied crossover space and time of the *between* implicates all the elements of the work — us too — as if mirrored in each other. This is the case no less for the two parts of Gordon's work represented, likewise, by the two halves of this book. Always presenting itself as a mirror image, the symmetrical effect of this operation only hides a dissymmetry of causes that is dissemblance itself.

6. Talking *en abyme*

through a looking glass

If we consider the second part of Gordon's work as returning and folding over that of the first, then, in a sense, *through a looking glass* (1999), based on Robert De Niro's famous "You talking to me?" scene from Martin Scorsese's 1975 *Taxi Driver*, is a remake of *Confessions of a Justified Sinner*. For both projections, Gordon has chosen films in which dissociation of character drives the plots. Reworking each film, he literally makes one character become two before our eyes. Such a repeat strategy would seem to lend credence to complaints of Gordon as a one-note artist. Repetition in his work would seem to partake of a cliché.

In *through a looking glass*, Gordon excerpts the seventy-one-second sequence in *Taxi Driver* where De Niro's character, Travis Bickle, addresses an imaginary other, drawing the gun that is rigged in his sleeve against his other self. In Scorsese's film we see what Bickle imagines while looking at himself in the mirror: he is watching himself as well as addressing the other. Across the space of the gallery, Gordon installs the same sequence, but to the side so that the now reversed and thus reflected image is not directly opposite but askew. As usual, the image Gordon has chosen from Scorcese's film is already a mirror image, a reflection of the posturing Bickle who is absent from view. The second projection would then not just materialize his self-produced adversary; supposedly it would restore Bickle to his subjecthood outside the mirror space.

We deny this status for the subject if we refuse to put our own identity at risk. Some viewers immediately dismiss Gordon's set-up, saying "I get it," without spending more than a

few seconds of recognition with it. They presume a banal mimicry on the part of the artist: double image equals split personality. Such rejection is proof that a cliché is still talking to them through an image — but not the images actually before them. Bickle's all-too-iconic scene is a cliché of culture, not just of this movie. Gordon himself *heard* Bickle's taunt frequently mimicked in school grounds and bars years before he saw the movie sequence. His doubling of the image is no simple repetition, though. In the age of mechanical reproduction, to juxtapose two identical images, as, say, Andy Warhol did in his silkscreen portraits, implies nothing at all about a split subject.

Meanwhile, Gordon has introduced an element to the scene that completely changes the dynamic of the interaction, though it takes time to see it. He adds nothing physically to the original scene. He only repeats it — but with the difference that time makes. While excerpting about 1700 successive frames from Scorsese's film, Gordon maintains the image-sound relation of the original, only to play the relation as a whole against itself. On opposite screens, two identical scenes start in sync but over a period of time in their looping slowly go out. The second projection begins to deviate from the first based on a geometric progression, first by one video frame, then 2, then 4, 8, 16, 32, 64, and so on. When it reaches 512, it reverses and slowly returns to sync. Starting from seventy-one seconds of film time, the cycle takes about an hour to complete. As in *5 Year Drive-By*, an abstract calculation will have immeasurable effects on our perception of the work.

Across the space of Gordon's installation, Bickle's psychotic monologue becomes a dialogue with his other self. Given the work's basis in the one-sided questioning of De Niro's original monologue, the two images now answer as well as reflect each other. As the two images almost immediately begin to go out of sync, Bickle's words start to echo. "Are you talking to me?" is answered — as if the other subject suffers from echolalia — by "Are you talking to me?" Then the mimicry stops and a "dialogue" separates out more clearly. Because of the delay that Bickle builds into his monologue with pauses for imaginary answers, the two protagonists now begin to converse. With the progressive deviation of the two images, over time each spoken line permutationally answers every other and a dialogue absent — or only imagined — from the original film fully asserts itself.

Gordon previously employed the device of intersecting soundtracks in *Between Darkness and Light*, but, derived as they were from two different films, the arbitrary overlap did not have *through a looking glass*'s uncanny effect of an actual verbal confrontation. Chance rather than structural necessity dictated the interaction. If one film image possessed the other in *Between Darkness and Light*, now, on the contrary, an image becomes dispossessed from its likeness over time.

If Gordon merely repeats the scene as a whole, sound and image nonetheless pursue contrary movements. As the delay between the two images increases, the images seem to spin out in a wide entropic arc that traces the slippage in the subject, the disintegration of Bickle's personality that

Scorsese plays out over two hours. At the same time, the two soundtracks force a dialogue between the two protagonists so that the conversation spirals inward, tightly coiling the interlocking exchange into the figure of one of those infinitely divisible nautilus shells — or, indeed, of the pathways of the ear. Halfway through the cycle, the inwardly and outwardly coiling effects of sound and image reverse themselves. Curiously, at this point, Bickle's other takes the lead in the confrontation, reversing the interrogation.

The centre of the two spirals traced by sound and image is also the viewpoint the spectator inhabits between the mirrored images. We are divided not only between two images but between sound and image as well. Caught in the middle of the two projections, we both witness and participate in the splitting of Bickle's psychosis. Gordon complicates our perception of the original scene through the subtle shift brought about by his intervention, by his calculation of a temporal difference between the images. While the mirror effect instantly splits the facing images apart, the unravelling of the subject therein takes place in time. The temporal element makes a world of difference in creating another world for these split images. The return *through a looking glass* makes is — *en abyme* — through the looking glass.

This complex altercation of a divided self differs from the earlier *Confessions of a Justified Sinner* with which *through a looking glass* seems to share so many thematic features. *Confessions'* dissolution of character is internal to the film's images. Even if the transformation from Jekyll to Hyde and back takes time in Gordon's projection, the cycle is internal

to the video loop. Our experience is external to the time of transformation. The installation is in our space but we are not yet in the space of the work. Or rather, we are not yet in the *time* of the work; we have yet to pass through the looking glass. The temporal dilation the work unfolds, however, does not let the viewer merely inhabit the interiority of Bickle. There is nothing of the character Bickle (even as a crisis of the image of masculinity) that we witness in and as this effect of time. In the end, it is not the character but the fictitious identity of the spectator that comes undone. It is not just Bickle but we who become other than ourselves in this division of time. We can inhabit the psychology of the psychopath because time is not interior to us but we who are interior to time.

Gordon's temporal operation spools us in and out. That is, the work plays the spectator, not just displays the character's dissociation. Gordon's intervention in *Taxi Driver* has two effects on spectatorship. On the one hand, since we have no place to see this work except between its images, we are conceptually displaced from our own physical space in the gallery to a virtual noplace between reflections, somewhat like Lewis Carroll's *Through the Looking Glass* pointedly referred to in Gordon's title. On the other hand, since we experience the work between its images as a differentiating temporality, we are continuously displaced by the counter-time of the images. If the first effect on spectatorship pertains to space and the second to time, creating a counter-space and a counter-time respectively, the latter returns upon the former to dissociate its spatiality entirely.

The images' spatial decentring is enveloped by a temporal displacement.

Henceforth in Gordon's projections, we must divert our attention solely from the space of the image, where we observe the installation, to the time of the image, where we experience the works' effects. Already latent from the start with *24 Hour Psycho*'s slow motion, the time-image now becomes the calculated effect of Gordon's interventions. The same yet different, the time-image is not that of the duration of the host film's images. Gordon's calculation of an interval applied to Bickle's scene dilates structure and opens it to a new temporality. Without intervening at all into the frame structure of a pre-existent film but only ever so slightly diverging the repetition of its images in projection, Gordon has introduced his own temporal slippage into a closed system. Yet the difference that time makes pertains only to a repetition of *like* images. Gordon repeats images that do not, as a set, change in themselves; they are indifferent. By the divergence Gordon builds into the installation, each screen has its own time of self-repeating (simple and progressive) *and* a syncopated time of repetition of the other (complex and implicated). Each screen's images recur in a part-to-part relation but play against each other in a counter-time that brings forth a new temporal whole. One relation is internal as an identity of the Same, the other external as a repetition of complex difference. The first functions like a cliché to repeat itself (us too) while, in the second, we are a function of a repetition that incorporates us in its difference.

Time between these images is twofold: that ever increas-

ing deviation that the geometric progression unfurls, which has a logical, linear, and spatial basis; and that which unfolds and refolds in the virtual space between these "mirrors."[1] The first, numeric, series, we know to be mechanical or quantitative in its abstract calculations; the second, temporal, series, we can only experience qualitatively — without measure.[2] The first series constructs the work; the second envelops our experience of it. The first is dependent on the source film; the second is independent.

The difference between the series that constructs the work and the series that envelops our experience articulates the difference between *Confessions* and *through a looking glass*. Of the two works, only *through a looking glass* incorporates the first series within the second. *From now on, the difference between the numeric and the temporal, as an implicated relation between inside and outside the work, conditions the reception of Gordon's projections.* This relation both structures the work and is the source from which its dissemblance springs.

This differential relation only begins with *through a looking glass*, which makes its repetition different from the duplication of images we find in *Confessions*. While infinite, the reflective self-implication of *Confessions'* virtual series is limiting nonetheless. Its structure necessarily pre-existing, *Confessions'* formal operations preclude our participation in the work's closed universe. By means of the spatial divergence and temporal dilation brought about by a complex repetition, this closed structure opens to a differentiated temporality in *through a looking glass*. (This divergence and dilation mutually derive from the repetition of a calculated difference

that engenders time.)[3] Seriality of time now encompasses the serial virtuality of the image. In *through a looking glass*, operations are displaced to shape the temporality governing the work as a whole, a situation that now includes our participation. Our experience is not just added to the repetition of images; it is necessary for the work's functioning. In the earlier work, we think virtual duplication abstractly; in the later work, we experience its temporal unfolding. In the first, the virtuality of the image is implied; in the second, the seriality of time is actual. The consequence: *Confessions* does not need a spectator; *through a looking glass* does. Not only the film's protagonist but we too are now subject to the operations of the work. We no longer just imagine the virtuality in which Bickle would be trapped, as we did for the characters of *Confessions*. We too unravel within the same contrary distensions of sound and image, space and time, structure and temporality that Bickle is subject to.

In that the work's temporal effects now implicate the spectator as well as trap the protagonist, has the new work not changed both thematically and formally? We might look closer at the effects of serial virtuality in the two works for an answer. Acknowledging that themes repeat in terms of literal content, let's compare the formal differences between *Confessions* and *through a looking glass*. In *Confessions*, everything follows from the mirror apparatus Gordon sets up, excised from the mirror images within Mamoulian's film. The "mirror" alone is the formal ground of operations. The mirror itself does not make the work, however; Gordon's duplicitous operations of doubling do. Just as the mirrors instantly

constitute a virtual space, so they immediately institute the thematic and formal conditions that devolve from the operations of doubling, reversibility, and reflection. In that the double automatically ensues from formal conditions, the work theoretically is without need of Stevenson's literary theme. (Already then, in *Confessions*, themes disappear into the formal operations of the work; or they appear only as a result of the operations, produced by them.) From these three figures of doubling, reversibility, and reflection, which appear similar but function differently, we derive the concepts respectively of the virtual, the chiasm, and the infinite series. Joining concepts to figures, each operation is implicated in the others: mirror virtuality sets the ground for the dissembling double in a structure that automatically leads to infinite series; at the same time, the double — dissemblance itself — enables both virtuality and instantaneous proliferation. All this happens at once; duration is not an issue.

Through a looking glass shares all the same formal conditions brought about by the mirror — of doubling, reversibility, and reflection. The concepts we derive from these operations, however, are all modified because of another formal element, if we might call it so, that of time. Because of the temporal envelopment of the work, the duplication we derive from all three operations transforms its concept to one of repetition. What is repeated in each work necessarily differs as an image in *space* or an image in *time*. Duplication is a spatial concept, repetition a temporal one; both differently determine virtuality: one is static, the other dynamic. In *through a looking glass*, Gordon has introduced a dynamic

concept into the static structure of the virtual image. As for virtuality, so for the chiasm and the infinite series: each is dynamic in turn. Temporality complicates each function in implicating the spectator in a dynamic that is not just a formal element but the factor that binds form and content in our experience of the work.

Does the spectator inhabit the same temporal dimension in this work as Bickle, or is Bickle subject to one and the spectator to another? Gordon's temporal calculations seem to shift the focus of the work towards the spectator. Lest we think that the trap is now transposed to the viewer alone, Bickle is still its primary victim. As in the case of Jekyll and Hyde, Bickle's trap is the dissociative doubling of character. His problem in Gordon's projection is that his doubling makes him a prisoner of the ebbs and flows of time, not only of spatial virtuality. Not just a mirror but a temporal difference, time, makes the same image — himself — other than it is. But even the mirrors in *Confessions* do not repeat identically; they throw impure reflections. The mirror image of Jekyll, for instance, neither portrays him exactly nor yet reflects his diametrical opposite, Hyde. The mirror reflects his self appearing other in negative form. Jekyll's internal duplicity manifests itself as a dissymmetry of reflected images: one light, the other dark. Nothing other than dissemblance makes the pairing appear symmetrical within this dissymmetry. Skewing the mirror catches another look within the image that is slightly off from appearances. This dissembling discrepancy creates an instability that adds a dynamic to the image-pair, belying the static instantaneity of the virtuality that structures it.[4] We have already

noted such an overturning dynamic in the nominal and visual series of *Confessions* whose terms are in disequilibrium to one another, sometimes disguised one in the other or opposed to each other, Hyde and Jekyll–like, in a struggle for dominance. If we find a dynamic repetition operative in *Confessions*, in return where do we locate the dissemblance of that work within the divergent repetitions of *through a looking glass*?

One rightfully asks, Where is the dissemblance in Bickle that would bring his doubling into line with that of Jekyll's duplicity? Is he not just an illiterate psychotic with no dissembling attributes? Hardly Jekyll-like at all, he is too much on the eruptive surface for his Hyde to need disguising. Rather than a perpetrator, he must instead be a victim of dissemblance. Doubleness is not necessarily a sign or symptom only of the internal disturbance that may issue from duplicity, as in the case of Jekyll and Hyde. It may be instilled in one through the manipulations of another who, however, only feeds on a self-disturbance already manifest in the victim, as in the case of *Psycho* or the film *Whirlpool*, on which Gordon bases his succeeding work *left is right and right is wrong and left is wrong and right is right*. Such is the case, as well, with *through a looking glass*, although no other than the artist manipulates a deception that does not exist in its source film. However dissemblance appears, any description of its function in *through a looking glass* must take into account the temporal dynamic that makes its virtuality different from that of *Confessions*.

Neither simply internal nor external, dissemblance brings about a new structure that includes the original film and is

made from it but exceeds it. Dissemblance is more than a theme derived from the psychology of the protagonist or content of the source film. The relation between inside and outside conditions this structure insofar as it contrapuntally creates the work's temporality through repetition. But duration is not deception. Dissemblance insinuates another element virtual to the film: virtuality itself. Dissemblance enters the work through a virtual structure implicit to it. But again, virtuality is not itself solely dissemblance. Dissemblance first *half* exposes itself as the virtual image of the mirror opposite. A doubling external to the film that uses film's own images produces a structure with corresponding actual and virtual elements. This is the basic set-up of Gordon's facing mirror images. (It is a fiction we at first assume with Gordon's work that the image and its mirror opposite, the two images before us, are actual and virtual when both are virtual.) If the virtual image is not the same as its opposing image, yet it initiates the new structure in that its splitting-off actualizes a structure that was only implicit before. Dissemblance is a difference that derives from a divergence within the image and a displacement that repetition sets up and sets off. The two ensuing images are not the same, though they share a genetic basis in the resulting dynamism. This relation of the virtual image to its seemingly similar other is, to use Deleuze's concept, a "disguised repetition."

Disguised repetition is a result of the double nature of every image or object: "Every object is double without it being the case that the two halves resemble one another, one being virtual and the other an actual image. They are un-

equal odd halves." In fact, Deleuze contends that "the virtual must be defined as strictly a part of the real object — as though the object had one part of itself in the virtual into which it is plunged as if into an objective dimension."[5] Does this not describe the mirror domains of Gordon's works, as well as the dissociated consciousnesses of his characters? The only difference is that in *Confessions* and *through a looking glass* the virtual image itself is split in two with no corresponding object or image outside itself. Though seeming the same, even opposing virtual images in Gordon's work must also carry this difference within themselves. All images, even before they are mirrored, are dissymmetrical; mirroring merely exposes their unequal, odd halves. The mirror effect is a disguised dissymmetry: "the repetition of dissymmetry is hidden within symmetrical ensembles or effects."[6] If symmetry is in the effect and not in the cause, the cause of this effect is dissemblance. Both cause and effect are dissemblances. The actual image only seems the same as its mirror opposite because "another repetition is disguised within it, constituting it and constituting itself in disguising itself."[7] What seems unreal, the virtual, is constitutive of what is actual. *All* is dissemblance.

If repetition *is* dissemblance and dissemblance repetition, we must conclude that every operation of *through a looking glass* is a dissimulation, now even its temporal effects:

The displacement of the virtual object is not, therefore, one disguise among others, but the principle from which, in reality, repetition follows in the form of disguised repetition. Repetition is constituted

only with and through the disguises which affect the terms and rela-
tions of the real series, but it is so because it depends upon the
virtual object as an immanent instance which operates above all by
displacement.[8]

When both mirror images are virtual, their displacement is
ever ongoing. The instability of this constant displacement
in the repetition of dissymmetry — a perpetual plunging into
another dimension — causes the dynamic of the work and has
a number of interrelated consequences. The displacement of
the disguised repetition creates the work's temporal diver-
gence, which is reflective of *and* (re)produces *both* the distur-
bance internal to the character *and* the dissemblance that
seems to act on him externally. Within this temporal spiral-
ling, the appearance of Bickle and his other is always ahead
or behind itself by the fractioning and fractured delay of a
dialogue. The crisis of Bickle's temporal displacement,
locked together in the disguised repetition of his other, each
one taking its turn in time repeating and dissembling the
other, is the perpetual machine that entraps Bickle and
drives the work.

Gordon has chosen the precipitating event of *Taxi Driver*
that expresses Bickle's downward spiral to destruction, out
of which Bickle himself ironically is spared by some saving
grace. Deleuze has proposed that this contradiction of
enchaining and saving, "the gift of living and dying," is the
constitution of life itself. It has its genesis in the figure of the
spiral that describes the temporal operation of *through a
looking glass*:

Even in nature, isochronic rotations are only the outward appearance of a more profound movement, the revolving cycles are only abstractions: placed together, they reveal evolutionary cycles or spirals whose principle is a variable curve, and the trajectory of which has two dissymmetrical aspects, as though it had a right and a left. It is always in this gap, which should not be confused with the negative, that creatures weave their repetition and receive at the same time the gift of living and dying.[9]

This dangerous gap reinstates my earlier question, Out of what void of the self does the doppelgänger appear? In the false mirror of ourselves — where left and right are confused in a dynamic dissymmetry unknown even to the self — the doppelgänger is constituted as a disguised repetition. Our double might be friend or foe. Gordon forces this question of alliance or deceit by playing out Bickle's precipitating crisis through repetition. Repetition may enslave or it may free. In his research into repetition and difference, Deleuze found that "the perpetual divergence and decentring of difference corresponded closely to a displacement and a disguising within repetition," difference itself being derived from repetition.[10] This implication of difference within repetition explains the operations and effects of *through a looking glass*, with this qualification: that under the same conditions, if repetition imprisons Bickle, difference potentially liberates the spectator. Perhaps life-gifting temporality offers the spectator an escape from the trap Gordon installs for Bickle. Paradoxically, repetition is also a concept of freedom.

7. Dark Mirror

left is right and right is wrong
and left is wrong and right is right

Even before we enter the work, the title of Gordon's *left is right and right is wrong and left is wrong and right is right* (1999) warns us we are on unsteady, if familiar Gordon, ground. Suggesting that we will be unable to situate ourselves either spatially (where left is right) or morally (where right is wrong), it offers us no secure place to stand. The ever-shifting dilemmas expressed by the title, where clear-cut oppositions dissipate in dyslexic confusion, will keep us and the subject of the work in perpetual disequilibrium.[1]

Gordon further disturbs us once we enter his double projection. But first a description of the film source since Gordon's projection is based on a little-known 1949 film noir by Otto Preminger entitled *Whirlpool*. Here is a partial plot outline from the moment of a theft at the beginning of the film to an implication of the heroine in a murder partway through. Ann Sutton (Gene Tierney), the young wife of a prominent psychoanalyst, Dr. William Sutton (Richard Conte), is caught shoplifting a piece of jewellery from an upscale Los Angeles department store. A stranger, David Korvo (José Ferrer), intervenes to extricate her from charges. He is a hypnotist, and later he suggests hypnosis to cure the kleptomania that she cannot admit to her husband. She agrees to his treatment while staving off his predatory sexual advances. The hypnotist is a charlatan who preys on wealthy women, one of whom is a patient of the psychoanalyst and who is about to expose Korvo for extortion. She has admitted such on the recording that Dr. Sutton makes of all his sessions. Informed of her intent by this woman as well, Korvo decides to murder her. He has the perfect alibi: by chance, we learn later, he is

taken to hospital with appendicitis. There, he hypnotizes himself not to feel the debilitating pain from his operation, sneaks from the hospital, and murders the woman. Meanwhile, he has hypnotized Ann Sutton so that she will report to the murder scene, where she is arrested, confused as to why she is there when the police arrive.

In Gordon's projection, Preminger's film is screened in its real time of ninety-seven minutes. Like *Confessions of a Justified Sinner*, the projection is doubled with one image reversed, but now the two mirrored images are abutted, joined as if at a seam. The left screen is the correct version, so literally the first half of the title of Gordon's work is truthful in its description. An optical flicker in the images and a stuttering soundtrack — which initially makes seeing and hearing difficult enough to have called for a warning for epileptics — cue us to some further manipulation. Although it gives the appearance, the film's images do not exactly mirror themselves. The film has been internally divided by Gordon at the junctures of its most fundamental units — film frames — in order to produce two streams of discordant images. What we do not see, but what causes our disturbance, is that each side of the projection is slightly out of sync by one frame, since each is a projection of either the odd- or even-numbered frames of the film, and is thus mirrored by its immediately preceding and ever so slightly discrepant frame. (All the odd frames have been compiled on one DVD, with the even frames on another.) Actually, each image is faced, left then right, by an invisible black frame, which the persistence of vision, necessary to filmic illusion, compensates for and obscures in order

to deliver the mirror effect. A dark mirror grounds every suc-
ceeding image and induces the symmetrical effect.

Joining the projections at the seam creates a new gestalt
from a combination of the two images and establishes a sec-
ond composite space that now dissolves the mirror effect.
The architecture, so to speak, constructed from this symme-
try produces a space that is both formal and dynamic. When
the camera shot is static, the composite space has an archi-
tectural grandeur absent from the original Hollywood sets.
When the camera shifts, as it does when it is centred on the
moving actors in the interiors, any oblique line in the con-
struction of the set suddenly becomes alive.

Symmetrical and formal as this composite space is, it is
unstable at the centre whenever there is movement. One of
the peculiarities of this new structure is that when one of the
actors passes into the original off-screen space of *Whirlpool*,
at the seam he or she begins to merge with him- or herself, as
if he or she were melding with a Siamese twin. Sometimes
the actors disappear, sometimes they fuse and separate
again. The ensuing Rorschach effect marks a void where the
action empties with a rush and bodies dissolve, as it seems,
into a whirlpool.

When they do not disappear into this chasm, but look
towards it, the characters witness themselves acting in the
mirror of the other projected image. Or perhaps, since we
now also apprehend the space of the two images as one total-
ity, what they see acting in a real, and not virtual, space is
their other — their doppelgänger, the split-off part of them-
selves that they cannot control, or perhaps are not even aware

of, except as another being. This is the dilemma of the kleptomaniac who is under the sway of her compulsion, or the hypnotized subject who has lost her will and is under the control of another who operates her as if she were an automaton.

Hollywood has played with the theme of the duplicitous double, using the device of one actor — usually a woman — playing identical twins, where either one is the victim of the other or one deceptively implicates the other in a crime.[2] In *Dead Ringer* (Paul Henreid, 1964), Betty Davis murders her rich widowed sister and impersonates her. In *Dark Mirror* (Robert Siodmak, 1946), Olivia de Havilland is suspected of murdering her boyfriend, who really has been killed by her psychotic twin. Dividing the identity of one actor into two characters for the purpose of deception implies no doubt of self-certainty for the subject in control, for the dissembler. Identity is split otherwise for the self-deceived subject like Ann Sutton.

Deceit is always two-faced, but the division of character is performed and measured differently according to the degree of self-consciousness of the subject. For the deceiving subject, like the characters Davis and de Havilland play, deceit is always turned towards the other. For the impaired, self-deceived subject, like Ann Sutton, it is only turned towards the other inadvertently and towards the self unconsciously. In the first case, the double is a relation of exteriority. Only a deviation in the pattern of imitation, a mistake in the performance of false identity, becomes evidence of deception to the observer. Discovery furthers the plot with cover-ups or ends it. In the second case, the double is a relation of interi-

ority. Discrepancy cannot be controlled as it proliferates the identity of the self-observant yet self-deceived subject in an immeasurable fashion. This confusion and split of character, where the subject does not know or cannot control the actions of his or her counterpart, initiates the plot.

Gordon literalizes duality of character in another way than the Hollywood model. Simply by changing the space of the image, his formal construction reveals what the original scenario of *Whirlpool* cannot show — a character who is internally dual. Gordon makes madness visible. But he also shows madness's dynamic instability and the subject's alternating passage between states of sanity and insanity, certainty and uncertainty. The seam between the two projections, the whirlpool chasm at the juncture of the mirror images, the vortex where the actors merge and separate from themselves, is the scene of this uncertainty. The subject vacillates in her doubt here.

Since the subject cannot know herself, she cannot trust herself. What makes her compulsively steal? Since she is a thief, could she not commit other crimes? If she cannot trust her own actions, why should others trust her? After all, she is duplicitous: she keeps her kleptomania from her husband who could cure her compulsion. Instead, her husband is compelled to believe that she is having an affair. In his eyes, she has already broken the marriage trust. Why should he believe that she did not commit murder as well, when all evidence points towards it? Placing herself in the care of a hypnotist only furthers Ann Sutton's dilemma. She must submit to the hypnotist, trust him to cure her kleptomania, while he abuses her trust to turn her into a somnambulist. In Korvo's

first, surreptitious hypnotizing of Ann Sutton, he whispers the words of film noir deceit: "Trust me." Unable to seduce her (ultimately, even under hypnosis, her moral fibre is strong), Korvo turns her into an unconscious accomplice to his crime. Once again, as in so many of the films Gordon is attracted to, trust is the issue in *Whirlpool*.

Others' doubts only follow from the subject's own uncertainty before herself. Can she even trust her own senses? Trust turns to madness when the senses cannot be believed — or sometimes when they mistakenly are. Doubt starts with a disturbance of the senses. Gordon exacerbates our own through the flickering images and stuttering soundtrack. These disruptions physically manifest two aspects of *Whirlpool*'s plot — the psychological disturbances effected by the hypnotic cure or abuse. Perhaps the dual disturbances of eyesight and hearing relate back to both disciplines of hypnotism and psychoanalysis, which exert their effects, their cure, or their control more particularly through the sense of hearing. The plot of *Whirlpool* turns on mechanical devices of hearing: the telephone by which various summons are coerced and the recordings of the psychoanalytic sessions that implicate Korvo, that he has Ann Sutton steal from her husband's office, and that he must recover later from the murder scene at the climax of the film.

In *Whirlpool*, hypnosis and psychoanalysis are opposed as fraudulent and authoritative disciplines. Woman is the helpless object of exchange between the two discourses, just as she is between the two men. (As such, *Whirlpool* is a film that would satisfy film theorists who have suggested it is no coin-

cidence that hypnotism, psychoanalysis, and film had their birth in the same milieu.) Like the female characters brought together in *Between Darkness and Light*, Ann Sutton, too, is subject to interrogatory doubt. She is subject, as well, to the regulations of marriage: her kleptomania repeats her relationship to her father in her marriage to her husband. In the conflict of authority, Gordon is unwilling to choose one discipline over the other; he confounds them by further entrapping their mutual subject, Ann Sutton, through the channels of their cures. After all, Gordon is not committed to a cure. Instead of seeking a reconciliation of a whole subject, he persists in dissociating our senses. Doubt is only support to what is already displaced to effects of seeing and hearing produced by the medium of film.

If the dissociation of sound and image are instituting factors in Gordon's projections, in *left is right* they are not split from one another any more than they usually are in the assembly of film. We only think so because of their initial disturbance of our seeing and hearing. Rather, each individual component of film and sense of hearing and seeing are split in themselves. But it is sight that is most dissociated from itself because it actually creates a pathological space.

Through some disturbance internal to the subject, perception is split into two. We witness this dissociation as one image split into two and reflected back on itself to create the mirrored space of *left is right*. The subject within the image, however, cannot perceive this disturbance of sight in the same way. Although the "same" image, one is projected in front of the subject as the other of the self: the self-same

image is an image of an other at the same time. The doppel-gänger effect derives from a split image because the self can-not perceive the image as its own or recollect it as belonging to itself through memory. The body can neither actualize the memory nor act on the perception. Body and image cannot link together, which leaves the body of the other to act on its own beyond the will of the subject — exactly Ann Sutton's problem, which David Korvo exploits through hypnotism.

Hypnotism was also to help Ann Sutton to sleep, to still her body from the unconscious effects of the mind that lead her compulsively to steal. Instead, it has the opposite effect of making her sleepwalk. In the reverse of David Korvo rising from his hospital bed, his mind overpowering his debilitated body, Ann Sutton acts against her conscious will in uncon-sciously reporting to the murder scene. The doppelgänger acts for the unconscious self; one is helpless against its duplicitous ministrations even though it uses one's body.

The doppelgänger is the dark mirror of our unconscious. Deriving from the same self, two protagonists act within the space of a doubled image. Yet one of the two bodies is immo-bilized watching the other act. We are familiar from dreams with this helpless state of severance of motility, which we re-experience sitting in darkened movie theatres as a relation of the body to an image. (Slow motion also induces this state for the characters of *24 Hour Psycho* who are unable to intervene in their fate.) Ann Sutton shares this inability to command the body with a class of pathological subjects having appeared in a series of Gordon's earlier projections. Made immediately following the close observation of behaviour

permitted by the slow motion of *24 Hour Psycho, 10ms*$^{-1}$ (1994), *Trigger Finger* (1994) and *Hysterical* (1994–95) are based on found documentary medical footage from early in the past century, projected, in part, in slow motion. In every case, we observe a compulsive behaviour the subject cannot control. The subjects cannot trust their bodies to perform. The body of the shell-shock victim in *10ms*$^{-1}$ cannot right itself.[3] The hand of *Trigger Finger* is locked in a compulsive, though complexly articulated, tic. The swooning woman in *Hysterical* is in the sway of her sexualized hysteria.[4]

Ann Sutton's case condenses a number of symptoms shared with these clinical subjects as well as with those of the other suspect figures that populate film noir. David Korvo's surreptitious hypnotizing of Ann Sutton induces two such related film noir conditions where body and mind misalign: sleepwalking and amnesia. "You'll remember nothing that happened here, nothing," Korvo whispers to Ann Sutton when he hypnotizes her for the first time. Arrested at the murder scene and interrogated at the police station, she cannot recall her actions (thus questioning her own sanity), as if in fulfillment of Gordon's three disembodied text wall works of 1994 — *I cannot remember anything*; *I have forgotten everything*; *I remember nothing* — that reiterate this helplessness. The inability to remember is no simple forgetfulness but is linked to a disturbance of motor activity. Sever a memory image's link with the real — that is, with action —"and you do not necessarily destroy the past image, but you deprive it of all means of acting upon the real."[5] Only the virtual doppelgänger maintains the ability to act — for us, against us.

The virtual other appears with the disturbance of sensory-motor mechanisms in the subject. This break with the action-image, where the subject cannot link her images to the real, ensues within an altogether new spatiality whose occluded temporality plays out the subject's dilemma. The doppelgänger derives from and operates within this virtual space that inheres within our own. While we share its sightlines, within this space we observe while it acts on our part. Gordon's manipulation of *Whirlpool* thus opens another space for its characters' actions that registers a disturbance in its principal subject that we now can witness. He does not just represent this disturbance but pathologizes the virtual space of its action. The mirror effect of Gordon's transformation of the Hollywood studio set also transforms the nature of the action within it. As a consequence, the action-images of *Whirlpool* give over to the time-images of *left is right*.[6] The temporal dimension does not get rid of movement altogether; the chiasm exaggerates it, while inverting its effects. Exacerbating our perception at the same time, it forces us to visualize a new virtual space that the double protagonist — Ann Sutton and her doppelgänger — act(s) in; or, at least, one acts while the other barely looks on. This space corresponds not just to the vision of a disembodied subject split in two; it is still a space of action — or rather, curiously, of both action and inaction at the same time. We see this space according to its Cartesian coordinates, but this rational grid is contaminated by the incorporation of the virtual within the actual. The vortex floating in the centre of the image is the sign of this disruption. This chiasm is not produced by the mirror image, as if it automatically appears

with any doubling of images, referencing an actual space. It is a spatial anomaly that surfaces between the actual and virtual as an eruption of the virtual in the actual. Thus, the actual and virtual do not mirror each other; the whole space has been virtualized. On the one hand, as spectators, we see this as a disruption within the image or actual space of action where the liminal vortex sucks in and spews out images and bodies. On the other hand, as surrogate protagonists identifying with the plight of Ann Sutton, we witness this eruption as the insinuation of the doppelgänger's space of action within our own. The other does not just appear as an image of activity countering the subject's passivity but as an image of activity *within* the subject's passivity, as a "passive activity."

In Gordon's projection, Ann Sutton can neither link her conduct to the images she "sees" in front of her on the opposite screen, which are the actions of her doppelgänger, nor remember them. Already an object of exchange between the psychiatrist and the hypnotist, she substitutes her doppelgänger's for her actions, her other for herself. This exchange is never one of equals, and the resemblance between the two — as a reflection in a specious mirroring — rather belies a fundamental inequality where the self is at a disadvantage in relation to the other. Against appearances, self and other are doubles without resemblance, no more similar to each other than we found in *Confessions* and *through a looking glass.*[7] The troubling image of the doppelgänger issues from the invaginated chiasm that splits the screen. Our double steals out of this space to enact a theft of character.[8] Stealing from the self only makes the self guilty in turn.

8. Master and Rival
Feature Film

With *Feature Film* (1999), Gordon has made an original film. He has returned to Hitchcock, the source of his first appropriation, however, in order to make it his own — or, at least, half his own. Even though Gordon's own, *Feature Film* is still strictly based on Hitchcock's *Vertigo* in that while Gordon has deleted the images to Hitchcock's masterpiece and filmed his own, he has retained Bernard Herrmann's soundtrack.[1] Yet the soundtrack now is not quite the original either. Gordon has further appropriated Hitchcock's film to himself by re-recording the score. He purchased the rights to Herrmann's haunting music to *Vertigo*, hired James Conlon of the Paris National Opera to record it (the soundtrack is available as a CD), and then filmed Conlon conducting it.

There are two versions of *Feature Film*. A feature version has the running time of the music score (about 75 minutes) and screens in a theatre; an installation version, accompanied by a video version of *Vertigo*, runs the Hollywood film's 128 minutes. Both depict James Conlon conducting Herrmann's score but without the orchestra present. The feature version never departs from various close-ups of the conductor. In the installation version, the longueur between musical parts corresponding to the place of dialogue is filled by pan shots of the empty, darkened concert hall. In its installation at The Power Plant, *Feature Film* was projected on an obliquely placed free-hanging screen with an aspect ratio typical of a movie screen, while a commercial VHS version of *Vertigo*, formatted for television, was projected in smaller scale — the size of a television image — in an alcove against a wall. Hitchcock's *Vertigo* is silent, although when the

orchestra falls quiet in *Feature Film* — matching the absence
of music in the original score — *Vertigo*'s dialogue wells up
tinny and half-audible in Gordon's soundtrack. (This is a
trace of the recording; a monitor version of *Vertigo* was on
stage pacing Conlon during conducting.) As sound is split
from the image of the original, so our looking is divided
between the two films as we try to follow the story and piece
image and new soundtrack back together. Gordon deliber-
ately obscures the sightlines between the two films as if
to make our recall more difficult; to make the music more
effectively haunting in that effort, as if we cannot quite
place a memory; and to demand that we look at *his* film, not
Hitchcock's.

Gordon's placement, and abasement, of *Vertigo* in the
installation reminds us that television or video is probably the
means by which Hitchcock's work is mainly seen today. Gor-
don's full-scale theatrical treatment of his own *Feature Film*
would thus seem to set up a hierarchy between Hitchcock, now
relegated to television, and Gordon in his self-elevated presen-
tation. The relation between the two, however, only inverts the
usual one between sound and image where the image domi-
nates. Whereas *24 Hour Psycho* overemphasized the visual at
the expense of sound, in *Feature Film* sound now commands
attention. Gordon not only inverts the relation between image
and sound, but he reverses their production order as well.
Where the score traditionally follows the film production and
is made to fit the edit of images, in Gordon's case the film is
made after the soundtrack, and from it. So scrupulously does
Feature Film follow the music that it gives the appearance of

being a documentary of the recording of Herrmann's score.

Herrmann's masterful score fulfills the traditional, secondary role of musical accompaniment: establishing mood, guiding the subjective response of the viewer to the action on the screen, and providing musical motifs for the main characters. These background functions in *Vertigo* have been brought to the fore in *Feature Film*. Attention to the soundtrack alone, confirmed by listening to the CD, reveals structural recurrences that our seduction by the visible obscures. As the score nearly repeats itself from one half to the other, we begin to understand that the music has two particular functions in *Vertigo* itself: guiding, rather than reflecting, the interior emotions of its protagonist, Scottie Ferguson, and underscoring the cyclical nature of his dilemma.[2]

Gordon's substitute image track would seem to distance itself from Scottie's dilemma, concentrating as it does on the conducting of Herrmann's music. Gordon's film focuses solely on James Conlon and the drama of conducting, with continuous tight close-ups on either Conlon's face or hands and arms.[3] *Feature Film* is neither documentary nor portrait, though; Conlon is acting more than he is conducting. There is no orchestra present, so he is performing to the already recorded music. By turning the conductor into an actor, and thus into the hero of *Feature Film*, Gordon makes Conlon a rival to James Stewart/Scottie Ferguson, the actor/hero of *Vertigo*. In this rivalry, Conlon succeeds exactly where Scottie fails: in the mastery of emotions. In Gordon's film, the conductor controls the music that he draws, as the interpretative representative of the composer, from its subjective source in

himself — a struggle and resolution we read through his body language. Conlon more than subjectively masters his own emotions; he is the romantic demiurge who manipulates the emotions of *Vertigo*'s characters. His Hegelian sublation of material — its lifting up in emotional resolution in musical form — is the opposite of Scottie's vertigo, where loss of control is felt in his recurring sense of falling.[4]

Concentrating on the score in *Feature Film*, hence on the music of *Vertigo*, dramatically shifts the register of effect from eye to ear. The eye stands for Scottie's mastery. He was a policeman; he is engaging in private detective work in *Vertigo*, spying on Madeleine Elster. The ear represents his inner emotions, which, as insult to his professional decorum, he no longer controls. (This condition was precipitated by his vertigo incident.) Gordon's transposition of meaning to the register of sound bares the essentials of the story. But first we must get beyond the fetishizing of sight that both the protagonist and theory remain enthralled to.

In feminist theory, *Vertigo* is taken as one of the key exemplars of the subjection of the female image in the male gaze. In *Vertigo*, the voyeuristic policeman Scottie is the traditional representative of the gaze, substituting for the camera, the director, and the male spectator. Madeleine Elster is subject to the look (however knowing her masquerade is, though) as Judy Barton is subject to being made over within it — to look like another (whose appearance, moreover, she has already mastered once).[5] It seems that mastery is vexed and not so simple where woman may participate and *command*. Perhaps *Vertigo* is not only about the scopophilic control of the male

gaze — a domain in which we learn halfway through the film that Scottie has been duped anyway. Hitchcock's film seems more about the male loss of mastery.

Does this sorry series of events sound like mastery? At the beginning of *Vertigo*, the police detective Scottie Ferguson immediately succumbs to a fear of falling, the vertigo that changes his life, and that makes him feel guilty for the death of the policeman who tried to save him from a fall. Thinking that he can recover, he relapses, collapsing pietà-like into the arms of his friend Midge. He then falls into a trap; unknown to him, he is being duped and manipulated by an old college acquaintance, Gavin Elster. Elster convinces him that his wife, Madeleine, has become delusionally enthralled to a nineteenth-century tragic figure who haunted San Francisco, Carlotta Valdes, unconsciously acting out her character and dangerous history: Carlotta committed suicide, and, unknown to Madeleine, supposedy was Madeleine's great-grandmother. Scottie falls in love with Madeleine as he tails her, not knowing that he himself has become enthralled to a simulacrum, to an impostor who plays the role of Madeleine. He loses Madeleine through a faked suicidal jump from the mission church tower, which is really a cover-up for the murder of the real wife. He feels guilt (as a repetition of his self-blame in the policeman's death), and is blamed, though not implicated, for her death by the coroner at the beginning of part two. After a deranged dream, now mad, he enters a sanitarium and is diagnosed with acute melancholia accompanied by a guilt complex. He is released but obsessively repeats all his actions of part one, stalking the past, mistaking

identities until he happens to see Madeleine look-alike Judy
Barton who had been in league with Elster from the start to
deceive him. Then the enthrallment to an image takes over
again and turns his mind as he makes Judy over into the
image of Madeleine, until his madness culminates in a sec-
ond loss in the real death of Judy in an accidental fall from
the mission tower. In spite of this excess evidence of the loss
of mastery, in the second part of the film, Scottie's sadistic
refashioning of the body of Judy Barton seems to retain
the mastery of male scopophilia, after all, as overcompensa-
tion for the failure of the look of part one. Seems, we note.
Still, this masquerade — conceived by a male but conducted
through a female substitute — is only the delusional fulfill-
ment of Scottie's madness, and in the end he is a loser again.

Gordon divorces mastery from the look by diminishing
the role of sight. By inverting the hierarchy of the senses
(sight being privileged in Western culture and philosophy),
he does not necessarily re-invest it in hearing. Just as Scottie
spied on Madeleine from afar during the first half of *Vertigo*,
so we continue to seek a reconciliation of the two films in the
visual field. We desire to know Scottie's story and are drawn
to the silent version of *Vertigo* to follow it, but the force of the
music persistently pulls us back to *Feature Film*. Continu-
ously conflicted, we shuttle between seeing and hearing in
the installation. We seek a resolution of meaning and a solv-
ing of mystery by reuniting what the artist has sundered. As
the relations of the look cannot answer the dilemma of the
mystery, we must give up one of the two tracks we are trac-
ing, let ourselves go and follow the music — whatever the

consequences. Like Scottie tailing Madeleine's unpredictable movements, we let ourselves be conducted by the music. Although the musical soundtrack in both films is virtually the same, in *Feature Film* it is an externalized representation of what acts internally in *Vertigo* where it was a measure of Scottie as much as a conveyance of the mystery. As auditors, we seem to wordlessly understand without the need of *Vertigo*'s dialogue what was a mystery for Scottie — we are ear witnesses to Scottie's eyewitness. We find in sound what Scottie searched for in vain in the image.

For instance, Madeleine's meandering drive through San Francisco to deliver a message to Scottie's residence (not knowing the address, she says, she was looking for landmarks) puzzles him. Landing at his own door, then satisfied with Madeleine's explanation, Scottie is only further drawn into her maze of deception. Cued by the music accompanying this drive, *our* ears are attuned to her siren call.[6] Gordon's inversion of sight and sound brings the background to the foreground so that the ground of deception, which Scottie cannot recognize because he is captive to the visual, partially becomes evident to us.

Overwhelmed by the music of *Feature Film*, we are hostage to the score as Scottie is to his emotions. At the same time, Gordon's structural foregrounding of the music allows us to join in the artist's mastery. In the CD and the soundtrack to *Feature Film*, Gordon abstracts from *Vertigo* what was already abstract in the score's function. (Hegel calls the ear the most abstract organ.) By abstracting the structural characteristics of this most fateful of films, Gordon makes us return

to what that structure imprisons: the repetitive actions of *Vertigo*'s protagonist who is a victim of a criminal deception. By this emphasis of sound, we are privileged over Scottie who is still led by a series of simulacral *images* that extends back through the mannequin Madeleine to a painting of Carlotta Valdes. Nonetheless, like Scottie, we have to discover what it is in the image that still seduces us.

Why is Scottie so easy a victim? Why is he so susceptible to deception? Gavin Elster chose him knowing his weakness, speculating that his vertigo would not allow him to climb the mission church tower and uncover the deception of the murder of Elster's wife. Maybe Elster chose him also knowing his susceptibility to the image. (Scottie's designer friend Midge is something of a repressed artist.) When Elster asks, "Scottie, do you believe that someone out of the past, someone dead, can enter and take possession of a living being?" and Scottie sensibly answers no, he is already on the path to being possessed by an image. (Scottie, not Madeleine, becomes the "sad, mad Carlotta" he encounters in his dream from which he wakes deranged.) Scottie is seducible because he is already susceptible. Something within Scottie has made him ready for possession. Because he is susceptible, he is already guilty. He is guilty because he cannot act on his *own* desire.

Is Scottie so susceptible to the wiles of a feminine masquerade not because he is a man but because he is not quite a man? Is he not *yet* a man, that is, is he still something of a boy? Or is there too much of a *woman* about him? Is this the knowledge that the man of the world Elster possesses over him?

Is Scottie not yet a man? He is called by a boyish diminu-

tive.[7] An aging bachelor, he has been unable to marry; there is a stunted quality to his relationship with the motherly Midge. Something Oedipal blocks his relationship to the other woman, Madeleine, whom he desires.

Is he too much a woman? He displays an unusual interest in women's clothes. At the beginning of the film, Scottie wears a feminizing corset because of his vertigo incident; although he wishes to rid himself of this corset, at the same time he is fascinated by the women's undergarments that Midge designs. In the second half of the film, he displays a precise fetish for women's clothes and obsessively dresses Judy Barton, whom he has made into a substitute mannequin. Is this the image perhaps he wants for himself? Judy Barton is Scottie's displacement of *his* transvestism onto an image of another. This displacement aligns Scottie's to Norman Bates's transvestism: as Norman is to his mother, so Scottie is to Madeleine. Behind both transvestite images is the body of a dead woman, the death of whom the man is responsible for and whom he thus tries to resurrect. (But what of the women behind the image who continue to determine the psychotic divisions and who command by sound not duplicitous image? Their seductions are not so easily subdued.)

Scottie regains masculine self-mastery only through the death of a woman. The price of winning is that he loses again — Scottie, always the loser. In the second tower scene, Scottie regains his manhood when he overcomes the vertigo that has feminized him, but he loses the object of his desire — which would have made him a man and not as he is a male

hysteric — when Judy falls from the tower. Could that object
of desire ever be his in the first place and not always be an
illusion — a simulacrum?

Scottie's desire is the classical desire for another's desire —
that of Gavin Elster's presumed desire for his wife, Mad-
eleine. Here we have a perfect mimetic triangle consisting of
the two rivals and the object of their rivalry: Scottie enters
into competition with Elster for Madeleine. Madeleine is
only a simulacrum, however, a lure that Elster has fabricated
for Scottie. She does not really exist. Moreover, not wanting
the wife he seeks to kill, Elster does not even desire Judy Bar-
ton, who plays the wife's role; eventually he abandons his
accomplice. In turn, Scottie cannot desire Judy when he
meets her in the second part of the film because she is not
desired by another. He must change her back into Madeleine
as the previous object of another's desire. In so doing, he cre-
ates a simulacrum of a simulacrum that Elster never desired
in the first place. A simulacrum of a simulacrum — here mad-
ness lies. With the second kiss of the film after he has trans-
formed Judy back into Madeleine, Scottie enters again, now
willingly, his complicity complete, into the space of madness.

As the subject of a deception or the object of a desire, the
simulacrum Madeleine only differs from itself by the dis-
crepancy of a repetition. In the end, though, it is not enough
for Scottie to possess this simulacrum of Madeleine. To
reassert final mastery in his rivalry with Elster, Scottie must
unravel, through his recognition of Judy's betrayal, the
enigma of Madeleine — the task he was deceitfully asked by
Elster to undertake in the first place. Woman is disposable

within this rivalry, which is why Madeleine/Judy must die. *Vertigo* is not only a twisted, necrophilic love story; even though Elster disappears near the beginning of part two, *Vertigo* is a story of rivalry between two men played out through the expendable image of a woman.

Here then is an interpretation that *Feature Film* offers as a rival film to *Vertigo*. By introducing a rival in the domain of sound (between Conlon and Scottie in *Feature Film*), Gordon makes us pay attention to the rivalry that exists in the domain of sight (between Scottie and Gavin Elster in *Vertigo*). *Feature Film* is a work about mastery and rivalry because its rival film *Vertigo* is as well. In Gordon's installation, rivalry passes back and forth between its two films, setting up different opponents. To the chain of rivalries — Scottie and Elster (*Vertigo*), Scottie and Conlon (*Feature Film*) — we logically add Douglas Gordon and Alfred Hitchcock. (If in the domain of sight Gordon is a rival to Hitchcock, in the domain of sound Conlon would then also be a rival to Herrmann.) In a work about rivalry, we ask the obvious question, Is *Feature Film* Gordon's competition with Hitchcock, moreover, an Oedipal rivalry with the father? Furthermore, could this rivalry reproduce the deceitful relation between Elster and Scottie? Who would master whom in this relationship?

Certainly, *Feature Film* seems no homage when, in a work of appropriation, the integrity of the original disappears and the master's film is relegated to minor status in the corner. This slight, however, is only a consequence of restrategizing the relation between sound and image and the division between hearing and sight. Hitchcock has only disappeared

in a chain of substitutions, but he stands behind them all. Hitchcock acts through the proxy of Gavin Elster, who in turn uses the surrogacy of a simulacrum, Madeleine, to dupe his victim, Scottie. Similarly, Gordon acts through his look-alike proxy Conlon, who employs the simulacrum of music to seduce the viewer. On the basis of this parallel, are we dupes like Scottie? Why should we think that we are privileged by Gordon when Hitchcock himself deceives his hero Scottie?[8] As Conlon is successfully acting at conducting, is he not also a master of deception, like Elster — and Hitchcock? Is his medium, the simulacrum of music so associated with Madeleine, not a veil of deception? As Gordon's proxy, is he not an image of this operation in process — Madeleine herself? Like Madeleine, does Conlon not combine image and music, the effect of the two as one?

We should not now think, through the inversions Gordon performs, that sound alone is the ground of deception because both Gordon and Conlon manipulate our experience through images as well as sound. There is no rivalry between Gordon and Conlon as there is no rivalry between sound and image — there only appears to be one between these components of film. Gordon's deception is initially derived from his separation of the original sound and image tracks across the space of the installation. Was this division not already signalled from the start of *Vertigo* itself in Saul Bass's credits? The extreme close-up of Kim Novak's ear, eye, and mouth combines powerfully with the music during the credits to make her ear-and-eyewitness to what she remains silent.[9] Gordon periodically repeats this framing device in

Feature Film in close-ups of Conlon's face, focusing on his eye and ear, such that it can be taken as emblematic, as in so many of his works, of the separation of seeing and hearing. Curiously, the crossover of *Vertigo*'s credits into the structuring of *Feature Film* is an inversion of Gordon's seeming downgrading of *Vertigo* in his own aggrandizing installation.

Simulacra do not operate in separate domains after all, as if they were medium based, so to speak — on the one hand, visual, on the other, auditory. Duplicitous in their structure, simulacra are split in themselves as they are "built upon a disparity or upon a difference" and part of their manipulative confusion is that the spectator is included within them.[10] Scottie becomes one with his. Something rose out of Scottie, signified by the music, that settled in the image of Madeleine. Scottie was more than a victim of visual masquerade; nonetheless, deception must first be understood within Scottie's search for the truth in the visual field.

The visual field remains the domain of Scottie's deductive mastery. As a detective, he plys his discipline there. Within this field he knows that while suspects lie, their actions conveyed through images do not. So he presumes that the views he spys from afar tailing Madeleine will eventually reveal their true meaning independent of their subject (who, he thinks, is not dissimulating since she is the victim of a delusion). The visual is also the domain of Hitchcock's aesthetic mastery; criminal-like, he is so certain of his deceptions that he can leave them in the open. Operating like the detective Scottie is, Eric Rohmer and Claude Chabrol think otherwise when they write:

> In Hitchcock's films, the images never lie, though the characters do.
> The same sequence shown without the soundtrack can illustrate
> the true version of the event. It is the commentary that makes it
> false, that lies, that assigns the actions another cause, another goal.
> Sleight of hand, it will be objected. Not at all.[11]

Feature Film dramatically proves this comment wrong: both
the images and dialogue in *Vertigo* lie while the music tells
the truth, although the music is the truth of a lie. Music is
the truth of an untruth connected to the perpetrator of the
illusion, the double dissembler Madeleine/Judy. In the end,
the simulacrum of woman reveals only that what is true is
the untruth of truth.

Duped by Judy Barton's masquerade as Madeleine in the
first half of the film, Scottie seeks instead the truth of
Madeleine's presumed delusion, that of her unconscious
identification with Carlotta Valdes. In the process he ulti-
mately becomes possessed of the simulacral lie and loses his
senses.[12] Near the end of the second half of the film, Scottie
once again seeks the truth, but now the truth of a deception,
the truth of Madeleine's lie, with just as dire consequences.
In the aftermath of this cyclical film, where the second part
repeats the first but with higher stakes, we wonder whether
another form of madness might correspond to this truth for
Scottie as was visited upon him after the "death" of the first
Madeleine. Perhaps instead of seeking first the truth and
then the truth of a lie, Scottie should have accepted the
untruth of the truth that was being offered him.

Seeking the truth of Madeleine in the visual field, is the

detective Scottie not like "the credulous and dogmatic philosopher who *believes* in the truth that is woman"?[13] Spying on Madeleine from afar, at a distance from where woman seduces with her siren song, he could not have realized that "perhaps woman is not some thing which announces itself from a distance, at a distance from some other thing.... Perhaps woman — a non-identity, a non-figure, a simulacrum — is distance's very chasm"; that "there is no such thing as the truth of woman, but it is because of that abyssal divergence of truth, because that untruth is 'truth.' Woman is but one name for that untruth of truth."[14] If there is no truth for Scottie to uncover, no essence for him to discover in Madeleine; if the untruth of the simulacrum is the truth and woman the truth of simulacrum; if the simulacrum is no lie but the mastery of the female for herself, perhaps Scottie should have heeded his inner voice sounding in the music. Perhaps he should have listened to his feminine side. Then he might have avoided the counterpart male hysteria that led to his first bout of clinical madness and then to his perverse obsession with making Judy Barton over into a simulation of Madeleine.

Scottie cannot fathom the simulacral dissemblance that is woman. In spite of her plunges into another world and into the frigid waters of San Francisco Bay that so cleverly deceived Scottie, there is no depth to Madeleine. In that the surface deflects the look and confounds the gaze, simulacra reverse the mastery that always commands a view through, behind, or in depth. Depending on one's point of view as a man or woman, this is a crisis of understanding or not. But is

not the idea of point of view put out of play in the play of sim-
ulacra that enfolds us in their dissemblance? Isn't the simu-
lacrum's very chasm the distance that Gordon maintains in
Feature Film, a distance that frustrates our reconciliation of
sound and image? *Feature Film* does not so much offer a
reversal of the hierarchy of image and sound, surface and
depth, as much as it uses music to deny a truth that lies
behind an image. Simulacral strategies supplant the repre-
sentational model where truth is what is revealed in the
image while dissemblance hides the lie behind it. At one in
sound and image, simulacra mock Scottie's modus operandi
seeking truth in the visual realm alone, while lulling him in
this belief at the same time. The detective Scottie is deceived
within the realm he claims to master. (This trope of film noir
makes *Feature Film* an adherent of the genre.) He himself
does not deny dissemblance; he is a detective, after all: his job
is to uncover what dissemblance obscures. But when all is
simulacral surface and there is no thing behind, when dis-
semblance acts in the open, there is no truth to discover
behind the lie. Bypassing this model of meaning does not dis-
sipate the problem. Simulacra do not simply disappear where
they rule. With the reversal of the mastery of the look, the
passive woman becomes an active agent of herself through
the simulacra she deploys.

Escaping the grip of men, simulacra return on rivalry in
order to subvert its pursuit of mastery. The revenge of the
image of woman now makes *Feature Film* into a fable of the
simulacrum that embodies rivalry only as a delusion within it.
In this interpretation, Judy Barton is no victim but the femme

fatale heroine — in spite of the fact that she does not appear in *Feature Film* and dies in *Vertigo*. Who and what dies in *Vertigo* and *Feature Film*, however, differ. In *Vertigo*, Elster operates and Scottie eventually exposes the simulacrum. Both Elster, who initiates the deception, and Scottie, who solves it, turn Madeleine into a simulacrum that only differs from itself by men's different investments. The fatal consequence of these masculine machinations is that the real woman behind the simulacrum dies (actually two women die — the real Madeleine we never see and the false one we witness exposed). Judy's and Scottie's punishment is that Judy really becomes Madeleine through death. This is the moral that the movie must impose even though its structure might perversely indicate otherwise.[15] This moral is predicated on an ethical model of possession that complements the representational model of truth: woman/simulacrum is to be possessed in its truth as an appropriation that is the concern of men alone, whereas punishment is allotted to deceptive women; exposure of the simulacrum means death to the simulator. The cipher of Judy Barton's identity means she has no role of her own, nor subjectivity to match, outside men's manipulations, first in the hands of Elster, then Scottie. Could we even suspect that she possesses mastery over her own masquerade? Contrary to *Vertigo*, in *Feature Film* there is no simulacrum to expose, hence no identity or essence behind the simulacrum to die; there is no truth to maintain and no moral to impose. Using the lever of sound, Gordon unleashes the simulacra that inhere within the images of *Vertigo* and frees Judy Barton from men's hold. He unmans the possessive mastery that even Hitchcock

himself retains over his images. Accomplice to the woman, Gordon shows the image for what it is: a combination of effects that the femme fatale temptress Judy Barton (Gordon himself) allocates — part seductive image of herself, part siren sound. While simulacra possess others in *Vertigo*, "woman" now first takes possession of herself in *Feature Film* through a simulacrum of herself that she alone masters.

Hitchcock, like his minor character Elster, set up the simulacrum of Madeleine in order to ensnare Scottie in a vertiginous trap. Once the trap is sprung, the simulacrum is as disposable as his true and false wives are for Elster. Plotwise, the simulacrum also is expendable because once it has served its purpose and the truth behind the illusion is revealed, it loses its deceptive effect on us, though not on Scottie. This is the source of the film's suspense, where we possess a knowledge the protagonist doesn't. Gordon, on the contrary, disposes the simulacrum in all its effects, manipulating the dissembling power of the simulacral whole outside of which no truth exists. Both spectator and protagonist are kept in its thrall. Gordon's ruse is to preserve the rivalry between Scottie and Elster (meanwhile extending it to Herrmann and Conlon, Hitchcock and himself) while undercutting or, rather, ungrounding all claims fundamentally. Given that the object aspired to (Madeleine) is a simulacrum, the rivalry between Scottie and Elster — which is a false rivalry because the ground of its claim is also a simulacrum — must dissipate as soon as Judy Barton is exposed in *Vertigo*.[16] But dissipation in groundlessness is the medium of simulacra. Once we presume in *Feature Film* that "simulacra are the

superior forms,"[17] their effects continue through all the operations of Gordon's/Barton's dissemblance; moreover, they continue to undermine *Vertigo* itself.

By allowing simulacra to rule, Gordon subverts all claims of rivalry and mastery between *Feature Film*'s coupled series of male heroes: Elster-Scottie; Herrmann-Conlon; Hitchcock-Gordon himself. Contrary to the conclusion of *Vertigo*, where Judy's death is the dire consequence of his drive for knowledge, in *Feature Film*, Scottie does not emerge the despairing sole survivor. Rather, *Feature Film* affirms the simulacral power of the heroine, Judy Barton. Although she does not appear in *Feature Film*, yet she is the agent for the artist's substitution of new simulacral series that supplant that of rivalry. As image-artificer, Gordon delegates to his look-alike music maestro Conlon the role of sound, but both image and sound in *Feature Film* substitute for the disappearance of Madeleine therein. Gordon himself disappears in this chain of deceptive substitutes — music, Madeleine, Conlon — but he is *in* them all, rather than, like Hitchcock, behind them. Image and sound are no longer gendered attributes corresponding to male and female characters respectively. By being the one to manipulate simulacra from the distance between two screenings, Gordon takes on the role Scottie could not assume for himself — that of the appearing/disappearing femme fatale.

Mastery and rivalry that are the privilege of a free and self-centred subject lose their power in the abyss from which simulacra rise, conducted through the possessive self-mastery of the femme fatale. As a *man*, Conlon dissembles this operation

while conducting it all the same. In this transgendered oper-
ation "all the signs of a sexual opposition are changed. Man
and woman change places. They exchange masks *ad
infinitum....* As a result, the question, 'what *is* proper-ty,
what *is* appropriation, expropriation, mastery, servitude,
etc.,' is no longer possible."[18] Unwilling as he is to give up the
"freedom and power" of his manly position, although by the
end of the film he is less assured of his mastery, Scottie
refuses this exchange of gender.[19] He cannot relinquish his
inquisitory questioning of "what is?" At the beginning of the
film, Scottie jokes with Midge that with the removal of his
corset, the last feminizing trace of his vertigo, he will be "a
free ... a free man," the corset interrupting him as it pinches
him mid-phrase. Said with the same falter as Norman
Bates's "fal ... falsity," the statement suggests doubt as to
whether it ever will be true. In the simulacral universes
Hitchcock and Gordon condemn him to, of course it will not.

★ ★ ★

Both Norman Bates in *Psycho* and Scottie Ferguson in *Ver-
tigo* are undone by the *image* of a woman. This image sets off
divisions within the self that the men cannot control. Their
active male selves that command vision are belittled and
belied by an unacknowledged and supposedly *passive* female
agency that, unbeknownst to them, has become interiorized;
a virtual image guides their actions. Both Norman and Scot-
tie hear voices or sounds that contaminate their vision, but
this reception is registered instead as a separation of seeing
and hearing. Consequently, their actions are split between

these senses. We are led to believe, though, that vision, reproduced as the mode of film, still dominates. Seeing is Scottie's established professional mode; Norman's vision has been psychotically induced. In actuality, the senses have not just been driven apart but maintain a relation to each other in their dissociation, although in the connection of inner (hearing) and outer (seeing), the former actually is prior and determines the latter.

Take Norman. As witness to the primal scene, he must repress what he sees. The mechanisms of repression are such, however, that "the rejected thing is present in the scenario, as a visible thing, but it is absent as an audible word."[20] As we have seen, the word is displaced by the image of the silent scream in Norman's victims and substitutes, Marion Crane and Milton Arbogast. Norman's psychosis seems scopic. Nonetheless, as with schizophrenia, in the withdrawal of cathexis from reality, a hallucinatory inner world takes over Norman where word presentation (the auditory) supplants thing presentation (the visual).[21] The visual is a screen for an auditory mental life that the "mother" rules.

The separation of seeing and hearing in the dissociated psychotic consciousnesses of Norman and Scottie is reflected in Gordon's projections by their inaugural division of image and sound. In spite of the fact that his sources are films, a combination of image and sound in which image presumes to dominate, the deletion of sound in *24 Hour Psycho* belies another effect. Against the appearance of the original film, the displacement of sound, now internalized in the viewer, reproduces Norman's true psychosis.

What of Scottie? Are the mechanisms of his dissociation articulated by Gordon's division of *Vertigo* into two films? His psychosis cannot be the same as Norman's because Gordon divides *Psycho* and *Vertigo* differently. Perhaps before answering, we first should compare Scottie's and Norman's fundamental truth dilemmas. Norman's problem of veracity and falsity cannot be settled by the referential domain of the visible since he relinquishes his cathexis to objects in favour of that to words. His psychotic sense of truth is confirmed by the logic of the paranoiac structure of his auditory inner world. Scottie, on the contrary, believes and acts in the visible, the place where he is nonetheless deceived. He must settle this difference within the lie of the visible. Norman's judgments of truth or veracity are solely internal; they are as regulated as the routine he keeps at the motel until the anomaly of desire disrupts his system. Since the vertigo that unsettled him, Scottie is not so secure in his judgment. He no longer masters the field of visual deduction but is divided between the internal and the external, between what he sees and what he hears within. The chasm of *Feature Film*'s two projections confirms Scottie's subjection to the simulacra that rule him and that "do not pertain to either the true or the false, the veracious or the mendacious."[22] The unity and division of simulacra are deceptive. Operating through the senses, they disguise one effect in the other. Obeying the rules of one (sight), Scottie is seduced by the other (sound). In the case of *Feature Film*, Gordon must not just separate image and sound, as he did in *24 Hour Psycho*, but combine them in their differences.

Just as we had to articulate a logic of the invisible extrapolated from the visible yet virtual structures of Gordon's mirror universes, as in *Confessions of a Justified Sinner*, for example, so too must we attune our ears to another type of hearing whenever it is the case of the separation of image and sound in his work. Even in cases where sound is absent, the purity of sight is immediately spoiled by this inaugural trauma of separation. This originating split repeats itself throughout Gordon's work: in their divisions and deceptions, all Gordon's works derive from it. What is absent commands. In fact, I suggest that the performative injunctions of his language works are primary to the temporal structure of obligation of all his work. We are obligated, even if unconsciously, to act within the realm of the visible through the silent structure of the aural command.

<p align="center">* * *</p>

Can we think of the operations of Gordon's works as those of the seductions of the film noir femme fatale and by extension Gordon himself as such a manipulative perpetrator? For a criminal author this would be the most elaborate double-crossing inversion and ambiguous disguise of his masculine production. I have already suggested that there is a surreptitious becoming-female in his work. Right from the start appropriation itself is a type of transvestism that was immediately signalled in *24 Hour Psycho*'s dependency on *Psycho*. Transvestism is a disguise, not always necessarily evidence of psychosis: Gordon is not Norman. Something other than a femme fatale in *24 Hour Psycho*, Gordon assumed there

instead the role of Norman Bates's wizened mother. Like her, he controls us through a strategic absence by means of his suppression of language, here the soundtrack. In *Feature Film* on the contrary, by manipulating sound and image in their separation, Gordon allies himself with the absence now of the femme fatale Judy Barton. He directs us, not Judy Barton, from the distance between his two films. This distance between is also the site that Judy Barton issues from and disappears into in the original film as an unremarked absence. Male identified as it is, *Vertigo*, we think, is Scottie Ferguson's story. But in the hiatus between its two parts, untold though it is, Judy Barton reverts to herself. In *Feature Film*, this site is not her origin and true identity but an operation of duplicity where, through an invagination of the original, she commands in her absence from the simulacral distance between the installation's two films. This act transforms *Vertigo* into a woman's story but of another, more perverse, variety than the Hollywood melodramas of the 1950s contemporary to *Vertigo*.

Such a reversal and transgendered operation might make us rethink some of the other dichotomies of Gordon's work, even those that seem natural. Or unnatural — the monstrous other of his double self-portrait *Monster* might also be considered as Gordon becoming female. If Gordon keeps male and female within himself to allocate as needed to seduce the viewer, what do we now make of the persistence of the kiss as a theme, whether at the remove of the embraces within *Psycho* or *Vertigo* or directly in Gordon's photographic works such as *Kissing with Sodium Pentothal* or *Kissing with*

Amobarbital? The kiss between a man and a woman is an ideal image of the symbol where two halves come together in unity. With Gordon's becoming-female, the kiss, on the contrary, would be another image of the chiasm that, for the male-identified viewer (always the case for rivalries, as in *Vertigo*), would be one more troubling seduction by an uncertain, inverted sexuality.

9. Dead Awake
Déjà vu

Beginning during World War II and passing through three distinct phases, film noir ended in the early 1950s, but it had its straggler in Orson Welles's *Touch of Evil*, which, dating from 1958, is considered to press the genre's chronological outer limits. These limits should also embrace the sun-drenched Technicolor noir of *Vertigo* of the same year. Perhaps *Vertigo* is the real summation of film noir as it interlaces two stories typical of the genre: on the one hand, the duped private detective (this story being further distinguished by a descent into madness common to another strain of the genre); on the other hand, the ordinary private citizen to whom some event has befallen, leading him or her to fatal consequences (this story being further characterized by a visit from the past that reawakens feelings of guilt and that leads to further fateful entwinement). The former is Scottie Ferguson's story; the latter is Judy Barton's, the simple shop-girl chosen by Gavin Elster because of some resemblance to his wife, and then rechosen by Ferguson for much the same reason.

D. O. A., the Rudolf Maté film on which Gordon bases *Déjà vu* (2000), belongs to the latter, Judy Barton–type scenario in which a fatal event befalls an unsuspecting victim. In *D. O. A.* (the abbreviation stands for "dead on arrival"), a small-town chartered accountant, Frank Bigelow (Edmond O'Brien), has notarized a bill of sale, an everyday occurrence that becomes potential criminal evidence because of which Bigelow, while on vacation, is murdered. The novelty of the plot rests on Bigelow's discovery of his murder by iridium poisoning (used to spike his drink) that gives him a day or so

to live and to find his murderer. This situation leads to such paradoxical lines as open the movie — of Bigelow to a detective: "I want to report a murder." "Who was murdered?" "I was." Or a doctor to Bigelow: "I don't think you fully understand, Bigelow. You've been murdered." Or Bigelow to another character: "But I'm not alive, Mrs. Philips. Sure I can stand here and talk to you. I can breathe and I can move. But I'm not alive." Both Maté and Gordon exploit the paradox of Bigelow's death in life.

Perhaps Gordon chose this film because, released in 1950, a year after *Whirlpool*, it represents the culminating phase of film noir in which forces of personal disintegration and "psychotic action" come to the fore.[1] Gordon makes the action of *D. O. A.* all the more psychotic by repeating it. He simultaneously projects the film three times but at different speeds. The middle image is projected at the normal twenty-four frames per second, the left screen at a faster twenty-five fps, and the right screen slower at twenty-three fps. This slight modification neither distorts the images nor alters the soundtrack, but the three films rapidly begin to diverge. The films do not separate altogether but communicate with one another at varying distances through the repetition of images and scenes. Three streams of time divide from one another as divergent series — past, present, and future — corresponding to the slower to faster projections. These differing speeds mean that time varies and that the future is diminishing faster than the past is accumulating.

Time — losing one's time, not having enough of it — time obsessively is of the essence in Gordon's reworking of *D. O. A.*[2]

Frank Bigelow has been given a death sentence that he cannot comprehend; his time is running out. This time is measured by the action of the fatal poison, although Bigelow is uncertain of its potency — a day or two, a week at the most, he is given to live. For us, his remaining time is determined by the faster projection, always ahead of the present, that we see mechanically expiring. We also see what Bigelow, pushing himself to the limit, has no time to dwell on, except to solve his own murder: his past. Some unknown action in the past is mirrored in the future by the unseen agency of the poison administered in an obscure present. If time is of the essence, nonetheless its character is not simple but divided in its effects. Time is not simply the present, that is, as what is present to consciousness. As Bigelow frantically strives, at any one moment on the three screens, we witness the fleeting present bifurcated into past and future, each with its own demands on our consciousness.

Let us delay what Bigelow cannot — the future — and examine the past through the recursive structure of the flashback. *D. O. A.* shares this defining device with many other films of the genre, for example, *Double Indemnity*, *The Postman Always Rings Twice*, *Out of the Past*, *Mildred Pierce*, and *Sunset Boulevard*. From the instant of the consequence of a crime or apprehension for it, the protagonist, with no self-delusion or self-justification, unmercifully recounts the twists and turns of his or her moral tale, which is also that of a personal crack-up. The flashback (which begins and ends in *D.O.A.* with the image of a whirlpool) starts from the present, immediately returns to a past origin, traces a tale, and returns

once again in the film's denouement to the same appre-
hended moment where we started. While the flashback is cir-
cular in structure, the story within it relentlessly unfolds on a
linear basis. (Whereas guilt is eternally circular for the sub-
ject, with the past ever returning to haunt the present, for the
audience the subject's act leads in a straight line from crime
to consequence.) Thus, during the opening credits of *D.O.A.*,
the camera substitutes for Bigelow determinedly striding
down hallways and through doors to deposit him in the
homicide division of the Los Angeles Police Department
where he begins his story. The credits economically set the
tone of urgency for the ensuing drama Bigelow is about to
recount but also visualize the relentless linearity propelling it.

There is no necessary contradiction between the linearity
of time and the recursivity of the film noir plot. The past is
recalled or recounted in the *present*, where it is simultane-
ously conflated: we are always in the present in film time
even though the story is totally in the past. The present is a
medium through which the past continuously recycles while
at the same time being projected into the future with the
force of destiny that the flashback reckons — although we
cannot witness its effects there yet. The present in film noir
is haunted by the past. As for the unforeseen future, it seem-
ingly is as indeterminate as the complicated twists and ob-
lique turns film noir is noted for — that is, until we reach the
plot's conclusion and all is made evident in the administra-
tion of guilt. In bringing past *and* future into view at the
same time as the passing present, Gordon's tripartite projec-
tion not only dramatizes the relation between these three

zones of time — where the growing accumulation of the past and the deadly diminishment of the future bracket the disturbed standpoint of the present — he shows the future to be just as consequential and determinant on the present as the past. In *Déjà vu*, the past and future reflect each other but in inverse proportion.

When Bigelow returns to the present after his flashback narration, he immediately dies. Yet he was already dead: he was dead on arrival. It is not because of the logic of the plot that he dies at the end; by another logic he is already dead at the beginning. What conclusion do we draw? That if he was dead on arrival — that is, if he is dead in the present — the vital present therefore does not exist? *Déjà vu* unfolds this contradiction of time in that the character lives only divided between the past and future but not, it seems, in spite of his precipitate action, in the present. Bigelow's problem is that his past condemns him to death in the immediate future. With no time to dwell on the past, Bigelow must not live in but orient the present toward the future, where he dies. The future, however, is only differentiated from the present by the merest discrepancy as the death in life that vitality disguises.

Gordon's intervention typically reacts on the original film plot-wise as well as time-wise, drawing out its characteristics or contradictions. Depending on the point of projection in *Déjà vu*, at any one moment we are shown one, two, or three different scenes. But even within one scene, we are given three successive moments. Not only the divisions of time, but the divisions of character are revealed in this method.

So within one scene, we might witness Bigelow's different moods: when talking on the telephone to his secretary and girlfriend, Paula, he displays aggravation, distraction, and reconciliation on the three screens. Likewise, with three separate scenes displayed, we might simultaneously see his contradictory treatment of three different women.

Gordon's tripartite division visualizes a device that already exists in the film but played out through the sense of hearing. In *D.O.A.*, the telephone is used variously to split the protagonist's attention. Ostensibly, the telephone simply helps further the plot by relaying information from Paula to Bigelow about the mysterious transaction in the past, which he then impulsively acts upon. It also connects Bigelow to his nagging past, which he is temporarily trying to escape: his girlfriend wants to marry and, once-divorced and perhaps not wanting to be tied down, he is resisting. Thus, more significantly, the telephone articulates the complex divisions within the hearing subject himself. For instance, when Bigelow first checks into his hotel in San Francisco and returns a call from Paula in his desert hometown of Bannock, he glances through the open doorway of his room to a woman partying in the hallway to capture her interest (the scene is shot in deep focus, linking Bigelow in the foreground on the telephone to the woman in the background in the hall), until Paula yanks him back to his contradictory present by saying, "There's nothing you can do that you ever have to feel guilty about," and of course he immediately feels guilty. The telephone is a hinge between past and future as the medium through which Bigelow's psychological vacilla-

tions between guilt (the past) and desire (the future) are con-
ducted in the present.

As in his other projections, Gordon distills Bigelow's psy-
chological dilemma to temporal series. Desire and guilt are
given temporal equivalents; their contrary consequences are
fulfilled but not in ways Bigelow anticipated before his crisis.
These series do not just realize Bigelow's psychological
dilemma, the vacillations between desire and guilt that his
poisoning instantly obviates, as much as they play out his
physiological dilemma as the measure of his short-circuited
biological clock. Gordon transfers to film the exchange func-
tion of the telephone but now takes advantage of film's dura-
tional form. If the telephone represents the psychological
divisions within the present conveyed through hearing, film
must proceed otherwise according to the demands of a
changed medium addressed to the sense of seeing but not
without, as well, dividing the present. Film being the pure
medium of the present, to actualize the past, present, and
future at once, Gordon must separate the screening into
three strands of time. Perhaps this division of the present is
addressed to us more than to Bigelow, who has no time for it.
We have time; or, rather, we have time *before* us to see the
consequences of this division. The effects of this temporal
division depend on one's position inside or outside the film.
Inhabiting the film, Bigelow can only experience immediate
succession, time's radical foreshortening. From our vantage
point outside the film projection, we see that succession is
not merely temporal but consequential in reverse as well.
Though Bigelow's desires are split in the present that he is

constrained within in *D. O. A.*, their consequences can only
be judged in relation to the past *and* future, a vantage point
only we possess in *Déjà vu*. Contrary to Bigelow who is
trapped in the contractions of the present, as spectators we
have an ever widening perspective on the events through the
very division of the present into past and future that conflicts
Bigelow. For any one moment, we can look back to what
produced the event and look forward to its effect. Holding
these three screens in view, we have the moral luxury to
observe the consequences of a character's acts. From his nar-
rowed perspective, Bigelow does not have this advantage.
His unravelling present is compromised by his standpoint.
He is running on the spot, out of sync with time past and
future. For him, the future now represents only the race
ahead to find a solution while the past now stands for the
desire to slow time down, to live still. The action of the poi-
son has reversed Bigelow's desires, reoriented them from the
future to the past.

Is it Gordon's intention to give us this god's-eye view, or,
instead, to encompass us in Bigelow's temporal confusion?
Gordon names his work after a psychological condition: that
uncanny sensation of perceiving an image or event as one we
think we have lived before. Bigelow has no occasion for this
experience; he is consumed by his actions in the present.
Only we do: as privileged spectators of the triple projection,
we do not systematically track the repetition of a scene on
two or three screens but sometimes are suddenly struck by
its reappearance. Our surprise precisely reproduces this
automatic feeling of déjà vu. Still, there is an analogy be-

tween Bigelow's experience of a split present and our experience of déjà vu. The relation between actual and virtual images that characterizes déjà vu is also that of the temporal structure of the contradictory present theorized by Henri Bergson. Taking up Bergson's analysis of the inherently dual nature of the temporal present, Deleuze explains:

What is actual is always a present. But then, precisely, the present changes or passes. We can always say that it becomes past when it no longer is, when a new present replaces it. But this is meaningless. It is clearly necessary for it to pass on for the new present to arrive, and it is clearly necessary for it to pass at the same time as it is present, at the moment that it is the present. Thus the image has to be present and past, still present and already past, at once and the same time. If it was not already past at the same time as present, the present would never pass on. The past does not follow the present that is no longer, it coexists with the present it was. The present is the actual image, and its contemporaneous past is the virtual image, the image in the mirror. According to Bergson, "paramnesia" (the illusion of déjà-vu or already having been there) simply makes this obvious point perceptible: there is a recollection of the present, contemporaneous with the present itself, as closely coupled as a role to an actor.[3]

Bigelow's crisis, as revealed in *Déjà vu*, would be emblematic of this division of the present but witnessable to us alone through a double déjà vu of past *and* future.

Paramnesia, or déjà vu, is only one of a number of complexes, such as amnesia, hypnosis, hallucination, and madness,

recurring in Gordon's work that share this bifurcated consciousness, a doubling of the present where in the instant the subject is divided as if in a mirror between actual and virtual images. For the subject, these complexes derive from a sensory-motor disturbance where the body is unable to link an image to an action or recollection. "When we cannot remember, sensory-motor extension remains suspended, and the actual image, the present optical perception, does not link up with either a motor image or a recollection-image which would re-establish contact. It rather enters into relation with genuinely virtual elements, feelings of *déjà-vu* or past 'in general.'"[4] This inability to link body to image through action or recollection is lived by its subjects differently. Ann Sutton's hypnotic sleepwalking is the opposite of Bigelow's frantic search. Although both act in it, the present, curiously, does not exist for either. For Ann Sutton, it disappears into unconsciousness, her actions forgotten. For Frank Bigelow, the present contradictorily evanesces into pure action itself, with no time for it to be lived. (Scottie Ferguson combines these two characters' dilemmas in his somnambulant search in the second part of *Vertigo*, repeating past actions divorced from present images. Before he discovers Judy Barton after leaving the hospital, Scottie retraces his past surveillance of Madeleine as if sleepwalking but also links his memories to false images, for instance, when he misrecognizes a woman for Madeleine. Meeting Judy Barton is the first of a series of unintentional and then conscious déjà vu experiences.)

Bergson claims that "my present is, in its essence, sensori-

motor ... my present consists in the consciousness I have of my body."[5] Yet for Sutton and Bigelow the body disappears in the unconscious, each in different ways, occluded in the present, supplanted by virtual images. Any sensory-motor disruption affecting our bodily functioning in the present must, analogously pursuing Bergson's argument, also affect our sense of time. Ann Sutton cannot remember time past; Frank Bigelow is too conscious of the moment. A present in dissociation from itself reveals this moment for the illusion it is, split between past and future; the disjunction opens our experience to the virtualities of past and future. Thus Bigelow's predicament (of the present having disappeared between the virtualities of the past and future that *Déjà vu* reveals) is linked to our temporal disruption of déjà vu in *Déjà vu*. The seeming contradiction between a futile action in the present (Bigelow) and a powerless witness to images (Ann Sutton's problem in *left is right* and our experience of déjà vu) is conceptually resolved by the split of the present into actual and virtual images.

An illusion of consciousness, the present is also the illusion of a still point, however much it is belied by Bigelow's frenetic activity. The body is "an ever advancing boundary between the future and the past, ... a pointed end, which our past is continually driving forward into our future," says Bergson.[6] Yet the precise position the body marks — the present — is an abstract point in space and a moment outside of time. At this point, the present divides space from time or feeds one into the other. When this standpoint is disturbed, the effects of space and time can reverse themselves and

confuse the subject's actions. Normally, space presents the possibility of action on objects, which is our future; time represents the closure of memory, which is our past. The future is unlimited; the past is a closed chapter.[7] Gordon's intervention in *D.O.A.* supplants the open and indeterminate spatiality of the future by a temporal determinedness. Both Bigelow's past and future are closed to him, while the present is a cul-de-sac.

Bigelow is both alive and dead in the present. Dead is when he is most alive. Eventually, he can speak of this contradictory condition, certify its aporia. The testimony of Bigelow's flashback opens the space of impossible witness to his own death. At first, he cannot accept this news; others, such as the doctors, testify to his murder but he flees their insane testimony. Until this unfair visitation on him ("All I did was notarize one little paper out of hundreds," he says), he might have felt unperturbed though he was in the crisis of his contrary desires. "I know what's going on inside you, Frank," Paula says to him. "You have a feeling of being trapped, hemmed in." Like a contrary *pharmakon*, the poisoning brings him to life as if precipitating the critical condition he persisted in while, at the same time, sentencing him to death. If the poisoning is like a religious call to the dead-in-life, its consequence is more like a Poe-like entombment while still alive.

Gordon is alive to the paradoxes of death in life, to a death that stalks life doppelgänger-like, to the always latent internal threat unleashed by some untimely intervention. (As we are already dead, it takes an untimely intervention to reveal

how we are still alive; but this reborn vitality is then ever threatened by death at every instance.) Gordon's language works have shown us that his fateful intervention enfolds within it a temporal dimension that exceeds the present. His *Instructions* are momentary acts that succeed in the immediacy of our hearing or reading. Analogously for Bigelow, it is not the body, as Bergson maintains, but rather hearing in *D.O.A.* that maintains him in the present, enlivens him while setting off the divisions in him at the same time. Hearing commands the body against its will. When two different doctors try to convince him of his iridium poisoning, Bigelow reacts frantically, manically fleeing into the streets. Henceforth, this dynamic propels him straight to his destiny, to his fatal end, but not without continual recursion to the still present. Progressively through the film, Bigelow passes from physical complacency to physical intensity; ever returning to the telephone, he is launched into new frenetic series of which his body is the periodic measure. At the end of his narrative, his time up, his body suddenly seizes and collapses in death.

Bigelow can act on sound in *D.O.A.* but not on the images in *Déjà vu*. We alone can witness images in their entirety. Yet contrary to the clairvoyance the three screens offer the viewer, sound in *Déjà vu* confuses our experience. What is separate in our sense of sight is combined in our hearing: each screen is faced by three speakers, each emitting the soundtrack for one of the projections. Nonetheless, what Bigelow experiences through hearing (the conflict he feels in the moment between his guilt and his desire, between the

past and the future), we experience through the déjà vu of sight. This crossover experiencing what the other cannot (which once again splits film into its image-sound components) is produced by different mechanical devices: the telephone and the projector.

The telephone is a recurrent device in film noir, where it plays a function momentarily to suspend the plot, relay an action, or switch plot direction. I wager Gordon has chosen films from this genre, for instance, *Whirlpool* and *D. O. A.*, partly because of the importance in them of the telephone.[8] Like the letter, the telephone is the signal of an event, in that it is the medium through which we receive the premonitory effects of a future event that has been sent from the past. But like the present, it is a null sign, the chiasmatic suspension of the medium, when we unsuspectingly pick up the receiver as in any of Gordon's *Instructions* and hear the voice that changes our lives.

Through receipt of Gordon's letters and telephone instructions, we analogously experience the fatal blow struck film's protagonists. We could call this their film noir effect. The contracted temporality of this moment unfolds, sometimes dramatically unleashes, the effects that bind us henceforth, dynamics we no longer control but are captive to. In this moment, the call disposes a divided time: the present is a hiatus; only in the past did we live; in the future we are dead. What the telephone literalizes as a medium of exchange in *D. O. A.*, Gordon transposes to film projection in *Déjà vu*. (The telephone is a sign internal to *D. O. A.* of the external mediumistic divisions of the senses of sight and sound that

Gordon's reworking in *Déjà vu* imposes.) The telephone in film noir can visibly symbolize this function (witness *D.O.A.*) but not film projection itself. What Hollywood film accomplishes through its plot it cannot achieve in its form. Film cannot divide from itself and display this internal division as a sign of its split characters' disturbed yet suspended actions. The flashback is the only possibility of this internal reflection of the medium, which, however, always must assume the temporal form of the present. In *Déjà vu*, Gordon transfers this divisive power to the medium itself, though when film sees itself divided in projection, this doubled image is no more than déjà vu.

Gordon imposes the conditions of film noir paramnesia on film itself. Doing so, he makes us more than witnesses by inflicting through it the same disturbance on us. He forces upon both protagonist and spectator, however differently, the fundamental characteristics of film noir morality: a fateful temporal intervention that awakens the dead in life, only to impose another death in life. Paul Schrader has written that film noir's "third phase is rife with end-of-the-line noir heroes," citing *D.O.A.* "for the John Doe American."9 Gordon's end-of-the-line logic differs from Maté's. For Maté, "dead on arrival" means eventual physical expiration at the exhaustion of the paradox of Bigelow's death-in-life. The poison supplies the realistic raison d'être for Bigelow's dilemma; when the poison has run its course, the dilemma is resolved: Bigelow dies embracing the past as he calls out Paula's name. Embracing neither the past nor the future, Gordon, a true noir hero, rather confronts the contradictory

null present with the cynicism of the LAPD chief detective. At Bigelow's belated death, the detective has his report stamped D.O.A. — dead on arrival — as if, in the end, the contradictory testimony of Bigelow's own death, like his life, was nil. In a final irony, Bigelow's life is no more than this notarized document that anticipated and certifies his demise but does not express the experience of his contradiction — if it can be said to be "experienced" at all.

Conclusion
Fate and Freedom

A new and unexpected light finally arose in a quarter where I least hoped for it — namely, out of mathematical considerations of the nature of the infinite. There are two labyrinths of the human mind: one concerns the composition of the continuum, and the other the nature of freedom, and both spring from the same source — the infinite.
> **— Leibniz, "On Freedom"**

Will we one day be able, and in a single gesture, to join the thinking of the event to the thinking of the machine? Will we be able to think, what is called thinking, at one and the same time, *both* what is happening (we call that an event) *and* the calculable programming of an automatic repetition (we call that a machine)?
> **— Jacques Derrida, "Typewriter Ribbon: Limited Ink (2)"**

"That night I had come to the fatal cross roads." So wrote Dr. Jekyll after he first drank the potion that fatefully turned him into Mr. Hyde. The fateful moment is an irreversible act that divides before and after. It might be a kiss. Or it might simply be the wrong turn on the highway so close to her destination that Marion Crane makes during the short-lived rainstorm in *Psycho*. Marion Crane's theft and her wrong turn to the Bates Motel are two separate instances of fate — one does not follow necessarily from the other. One is willed, the other is accidental, but both are consequential.[1] Was hers a case of being in the wrong place at the wrong time? Or was Marion Crane destined to cross over into Norman Bates's world, to join her ample actuality to the virtual world of his madness?

Whatever the case, the series that constituted Marion Crane's world intersected with the series that constituted Norman Bates's to link her small madness to his. Once the crossover of this chance encounter locks the two series in place, the logic of the meeting's irrational outcome cannot be reversed. Marion Crane cannot reverse her action as easily as she changes her mind. Her decision to go back and return the stolen money only makes her guilty in Norman Bates's eyes. Slipping out of her false identity only proves her duplicity and betrayal of his trust, which enrages Norman, so he kills her. Once spoken to Norman, her proper decision is only the sound of a trap within a trap springing shut.

Fate and guilt are inextricably entwined in acts of madness and the madness of acts. Accidents of fate link Marion Crane's theft to her murder by Norman Bates. Her impulsive crime may lead to her death, but in what way was she guilty even before her theft? In an inversion of an effect preceding its cause, might guilt initiate the fatal moment rather than be a consequence of it? Such is the unusual twist of fate to which all Gordon's characters are doomed. For Gordon, the fateful turn is a trap that repeats forever in the vertiginous instant of the chiasm around which his film constructions are made. Here is the paradox at the centre of his work: its structure is formally reversible, but our engagement with it is consequential and seems to lead only to one fateful conclusion.

Gordon's interventions open another world within his host films. Although this world was already latent within the films or their characters' split consciousness, it opens only to further enclose and entrap its victims. (Similarly, the tempo-

ral operations of the work open a space for us, but its virtual reflections close it again, absorbing us in the protagonists' predicaments.) The act that befalls each film is so decisive that the traps Gordon thereby constructs for their characters seem to have existed forever.

Film noir is a moral universe. Yet, by cutting into the plot of a film, Gordon infinitely delays any moral outcome that the plot's climax and denouement would impose. What then is Gordon's motivation? Does his criminal satisfaction rest in purloining another's image and disguising his theft? Or does he take some sadistic pleasure in the plight of his victims? For victims they are. Every one of Gordon's projections is nothing if not a more elaborate and damning trap than the original directors, even the "evil demiurge" Hitchcock, inflict on their protagonists. Gordon suspends his protagonists in an unending repetition of their horror with no hope of resolution or release offered by death, capture, confession, or judicial punishment.

Gordon has selected a gallery of deluded and psychotic individuals to torment further: Norman Bates, Ethan Edwards, Dr. Jekyll, Regan MacNeil, Travis Bickle, Ann Sutton, Scottie Ferguson, and Frank Bigelow. These characters are as self-deluded as they are otherwise deceived, as much victims of their own crimes as those of others. Whether the subjects are "normal" or psychotic, they are the victims of some deception. Duplicity might be internal to a character, as it was consciously in Dr. Jekyll or unconsciously in Ann Sutton. Or deception might befall the already troubled character from outside, as in the cases of Scottie Ferguson, Frank Bigelow,

or Ann Sutton again. The double character Norman Bates
bridges the two as victim and perpetrator and catches Mar-
ion Crane — herself divided — in the wake of his confusion.
But then all Gordon's characters are compromised by some
internal dissemblance even if they are innocent.

Innocence means nothing in the noir worlds Gordon con-
structs: we are all presumed guilty before the interrogation of
his work, as if we had something to hide. After all, there is
only interrogation with the presumption of guilt. Film noir
plots are primarily constructed around the interplay of insti-
tutional questioning and private doubts. Dependent on their
necessary appearance in the films he chooses, Gordon's pro-
jections repeat both institutional inquisition (*24 Hour Psy-
cho*, *Between Darkness and Light*, *Feature Film*) and self-ques-
tioning (*Confessions of a Justified Sinner*, *through a looking
glass*) although the two usually appear together as in *left is
right*. In film noir, interrogation and dissemblance feed and
face off against each other, both sides using the feints of
deception towards their own ends of revelation or cover-up.
In Gordon's projections, they derive from one and the same
overarching simulacral operation that the artist controls. No
longer just victims of self or others, Gordon's protagonists
are also prisoners of his falsifying machinations. (Fate is dou-
bly inscribed in Gordon's projections, both internal to the
plot of the original and external to the film through the
artist's intervention.) Their original crime or deception is
only pretext and justification for the trap in which Gordon
imprisons his protagonists. Vigilante-like, he has judged that
any doubt is proof they are already guilty. All Gordon's pro-

jections are figured around the differing relations of deception and interrogation — but there never is only one suspect. Protagonist *and* spectator are subject to the same insinuating snares. If we are interrogated in turn, what proof does Gordon concoct of our complicity? Our dilemma is that we have no excuse when the "elsewhere" of our alibi places us at the scene of a crime where, like Ann Sutton, unknowingly we have been commanded to appear.

We too are subject to the same duplicitous operations of Gordon's work. Gordon not only fabricates a deception, he hides the facts of its dissemblance. The trap that imprisons the protagonist in his or her predicament implicates us as well. Already tainted by our own small crimes of folly, once we step into the space of Gordon's projections we all are like Marion Crane crossing over into the virtual world of another's madness. Marion Crane and Frank Bigelow are just two proper names for countless stories of middle-class desperation where the promise and openness of life narrows to the condemned finitude of a closed series. Each character tries to escape one unfulfilling, dead-end series only to foreclose their actions in another worse. Through some unforeseen consequence of their dissatisfaction, their lives pass from conditions of relative freedom to fate. Yet are we ever free, film noir persistently asks? Are we not prisoners from the start, incarcerated in the prison cell of Marion Crane's illicit rendezvous, or, dead already, entombed in our lives like Frank Bigelow? Doesn't Gordon, like Hitchcock, condemn us to an unfree fictional world with no hope for escape?

So the thief Gordon is a moralist, after all, a noir Calvinist.

The double image of one of his projections is no more than a vanitas mirror he holds to his appropriated film in order to reveal the deathly image within the psycho smile, the skull beneath the skin.[2] As in *left is right*, this dark mirror is the grave for every (other) image. Gordon excavates what is already entombed therein, but in that this mere mirroring only reveals not what was hidden but what always floats unobserved on the surface, is not this overt act of moralism dissemblance itself? If death and dissemblance are mutually inscribing figures, Gordon's work is a deceitful allegory of deception as well as, traditionally, that of death.[3]

Blinded by the virtuality of a double mirror, film does not see itself in Gordon's double construction as its doppel-gänger other. This memento mori is offered to *us* with the same force of recognition as the self-interrogation of the guilty. Is not every image of Gordon's projections, like many allegorical paintings, both *our* seduction *and* grave? If *24 Hour Psycho*, to take one example, is a memento mori, it is not because of the skull that emerges beneath Norman's smile during his incarceration as a reminder to us: "remember you will die." What seduces us is more than a symbol. Something else operates in the image to fulfill the function vanitas painting could only represent: time in the image. In *24 Hour Psycho*, slow motion *is* memento mori.

It is not that we will die but that we are dead already that calls for a life-affirming decision. Is this sentiment not the common link between religion, film noir, and Gordon? But does Gordon offer us any saving grace as religion does? Doesn't he, like film noir, preempt any corrective life-

yielding decision from the start? His dead-end traps are meant for spectator and protagonist alike, with no way out, it seems.

Gordon's deception is double, folding the acts of both protagonist and spectator in the same unsuspected snare. He condemns both by awakening the deceit of the character in the guilt of the spectator. Guilt thus transferred, both character and spectator hence are now protagonists within Gordon's overall scheme. No longer having lives of their own, but subject to the deception of this other author, Norman Bates and Marion Crane, Scottie Ferguson and Ann Sutton are Gordon's, just as much their original authors', characters. They become Gordon's own through the new dilemmas he binds them to, traps that he then proceeds to lure us into. Gordon manipulates a cast of characters more than displays a collection of themes in his works. The characters, however, are only subject to these themes fulfilled in *our* falling prey to the works' temporal effects. Although he hides his agency, this deception irrevocably links the characters internal to the film's plot to the external spectators of Gordon's projections through no more than a cut into the film. This relation between protagonist and spectator analogously repeats that of Norman Bates's and Marion Crane's intersecting series where we cross over into the virtual world of another's, this film's, madness. If the film intervenes in our lives as Norman does in Marion's, it is merely as screen for the artist's artifice.

Gordon distances himself from his source film and the themes he derives from it by so intervening in *our* affairs. His cut into a film duplicates in our experience the untimely

event that unsuspectedly befalls the film's protagonist. This cut formally repeats itself in every instant thereon as it plays itself out, frame by frame, in a temporal series that constitutes an allegory of film construction. Thus it would seem that Gordon's intervention, though temporal, is an abstract act, after all. Yet every frame of the film incessantly repeats the instant of threat, guilt, or betrayal of trust and extends this psychological burden through time. Still, Gordon's act binds us to different effects than the film's protagonist. Gordon constructs his effects solely from formal interventions into films that set up the virtuality and temporality within which both characters and spectators are henceforth trapped. Effects are differentiated in that two operations take place through Gordon's interventions — one technical, the other temporal; one virtual, the other actual; one affecting the protagonist, the other the viewer. The first operation maintains the film protagonist in a closed film noir universe that Gordon inherits from his film sources but that he further abstracts. The victim cannot escape from the virtual trap he or she is condemned to repeat. The "trap" Gordon sets for us, though, derives only secondarily from the guilt we complicitly share with the film's fictional characters. Although leading to the same formal conditions of virtuality the protagonist shares, the operation that affects us, and not the protagonist, liberates a temporality that exceeds this structure through a differing repetition. While the virtual imposes real conditions of entrapment on the protagonist (even though we imagine these fictively), the temporal is a potential that only actualizes itself through our engagement.

Thematic relations are secondary to relations of form in our experience, which are of a temporal elaboration. Only we maintain an articulated, contrapuntal relation between outside and inside the film, not the protagonist who is maintained within the film's virtuality. Once again, Gordon's projections divide their effects in two (though they are derived from the same act): the series that constructs the work maintains the protagonist helplessly within it while the series that envelops our experience of it frees us, but only if we commit ourselves to its temporal dynamic. The differential relation that makes Gordon's projections independent while at the same time dependent on their film sources, reproducing images that are the same yet other, is the differential temporal relation that condemns or frees us. That is, the same yet differing relations lead to fate for the film protagonist or to potential freedom for the spectator, the former imprisoned by an abstract repetition, the latter freed by a differential temporality deriving from a disguised repetition.

So it is a matter of a decision for us, after all. Not all entrapment and deception, film noir always has a freeing element, even if only a cynical alienation. On the occasions when he saves himself, the film noir hero sometimes distributes justice, usually betraying the femme fatale for whom he has fallen in the process. Witness Sam Spade's treatment of Brigid O'Shaughnessy in *The Maltese Falcon* — or, indeed, Scottie Ferguson's unintentional condemnation of Judy Barton in *Vertigo*. Freedom for one means fate for the other. Only the film noir hero survives.

Yet, if we escape an imprisoning abstract repetition in

Gordon's projections, do we not betray the doppelgänger we leave behind? Is this our aim, to free ourselves from our duplicitous doppelgängers in order to ensure ourselves fully responsible for our own acts? In spite of the virtual traps Gordon sets for his protagonists, hasn't he himself embraced his own doppelgänger in his double self-portrait *Monster*? In this work, he revealed his hidden side as a monstrous other but only, I argued, as a disguise for that part of him named author. The other is not only a screen for a deceptive strategy but a necessary part of the artist; it represents a commitment, Jekyll-like, to a "profound duplicity of life." What would a "profound duplicity of life" consist of that was life-affirming rather than deadly denying? On our part, what would our complicity in the duplicity of the artist/other be? We have already seen that everything in *Confessions* conspires against the unity of the subject constituted under a proper name. Do we now want to restore this subject to wholeness deprived of its other? Perhaps once again we are deceived by the unexpected reprieve Gordon's work seems to offer us. Might the differential relation we maintain with Gordon's projections that seems to privilege our escape be our embrace of our other at the same time?

Embracing the other, we must accept the conditions that imprison our doppelgänger in a machine-like repetition. With its abstract repetition of like units, film is nothing but a simple machine. (Manipulating film frames, for instance by the slow motion of *24 Hour Psycho* or the oblique editing of *left is right*, reveals this truth of the image, automatically turning protagonists into automatons.) Writing also is the dis-

guised repetition of a machine. With its articulation of both abstract and disguised repetitions, Gordon's projections too must be thought of as complex machines. Still, with all the repetition that a machine implies — its merely reproductive, calculable, inanimate, anaesthetic effects — Gordon's projections produce a contrary condition: the event. On the one hand, the double cut of Gordon's formal intervention into a film creates a virtual machine that imprisons the protagonist; on the other hand, it produces the performative event of our engagement. Contradictorily, the cut is both machine *and* event.[4] This peculiar status is an anomaly, since how can a happening be calculable? Moreover, how do we experience such an anomaly?[5] Yet, we have already experienced the anomaly of the machine-event through the act that befalls Gordon's machine-like automatons, repeated in our exposure to our doppelgänger's, that is, the protagonist's, inanimation. The event *is* the machine; the doppelgänger's automations stem from it: "If, then, some machinality (repetition, calculability, *inorganic* matter of the body) intervenes in a performative event, it is always an accidental, extrinsic, and parasitical element, in truth a pathological, mutilating, or even mortal element."[6] I feel uncomfortable making the claim, but isn't Gordon's the future thinking Derrida heralds in the epigraph to this chapter: the event-machine? Perhaps not Gordon's at all, but that of the machine his virtual structures function as. The machinality of Gordon's projections, however, does not intervene in a performative event as an invading parasitic element; it produces it. Producing the event, machinality produces a monster. Does not the anomaly

of the event engender a degenerate: our doppelgänger? Indeed, Derrida predicts that this new logic of the event-machine will have the appearance of an unrecognizable monster. The monstrous, though, is not an image; that is, it is not an appearance: we must think the unfigurability of the monstrous, since it abides by no resemblance, rather as the event itself.[7] (We already know, through the Jekyll and Hyde–like structure of Gordon's work, whose dichotomies cannot be separated in their dynamic interaction and reciprocal implication, that the monstrous other appears only as an event.) The image of monstrosity would only be the simulacral appearance for another operation that stems from the chiasm. The doppelgänger does not derive from the chiasm; the other *is* the chiasm.

Perhaps we are more concerned with saving ourselves than identifying with the film noir victim. We thought to escape the themes that entrap the film's subjects by thinking that elevating form belonged to us alone, not to the film's victim. Or we believed that the work's formal institution was not brought about by the interruption of the event of the other but by the technical intervention of the artist. The latter, we think, is a rational act leading to an aesthetic effect we control, coming and going as we please. Embracing the other, rather than betraying our doppelgänger selves, might mean that we have to assume for ourselves some of the lifeless, autonomic character of film noir's machine-like protagonists. We must be sympathetic, for instance, to Ann Sutton's plight, complicated all the more by Gordon's doubling and theft of character. Repetition in *left is right* is the theft of

the identity of the self from the self; but perhaps the traps Gordon sets instead "free" the unpredictable event of monstrosity that lurks within us. Our doppelgänger frees itself in us to double effect: to condemn or free us in turn. Sleepwalking and amnesia — the disturbed psychic states that Gordon induces for the spectator of *left is right* by his mimicry of hypnotic effects — would be means to escape the propriety and self-presence of identity that correspond to daily life and its societal norms. The dead-in-life would counter the dead-in-life as an antidotal *pharmakon*, as in Frank Bigelow's iridium poisoning, as the poison that is also a remedy or gift. The states film noir heroes and heroines flee or fall into would be sustained for us, not just temporarily but as events that proceed counter to the laws of institutional interrogation and identity restitution to which characters are subject in film.[8] Instead, our doppelgänger would be the *friend* who binds us willingly as accomplices to a crime spree, thereby enabling us to escape from our normatively constituted selves.

The friend has been constant throughout Gordon's work — perhaps not just as a strategic shield to his fictional self but loyal to him, as well. Opening us to the doppelgänger, to the experience of our other, to our other's "experience" through the deception of his act of engendering degeneracy, does not make the artist our friend, however. Deleuze has remarked this in identifying the role of the "invisible imperceptible *dark precursor*"[9] as the figure that relates difference to difference in the simulacral system through acts of disguised repetition in which it perpetually

displaces and disguises itself.[10] The deceptive artist Gordon would be the dark precursor of his simulacral system. But even though *our* doppelgänger "friend" arises in these conditions, Deleuze states that "the dark precursor is not a friend."[11]

Nonetheless, we are contractually related to the artist through signatures and countersignatures that triangulate a relationship between artist, viewer, and our doppelgänger friend that is not necessarily just one of dissembler, dissembled, and dupe. Gordon acts through the signature of his other when he signs his texts by the name "friend." Participating in his work, we countersign the artist's deceptive act. The performative act of the signature is such that it engenders its subjects at once — both sender and receiver, artist and viewer. Gordon's dissimulation not only joins artist and viewer in a deception and enjoins the viewer to act on it, it constitutes artist and viewer together in the performative act. Surprisingly, the artist's identity therefore is no less prior to the call of his language works than ours is.

We are beginning to realize that the call is not so much a threat to us as it is the gift of the other as event. Nonetheless, this event is ambiguous and potentially dangerous. The doppelgänger's doubling repetition is both theft and gift: theft makes us victim of our other; reciprocally, the gift of disguised repetition makes us host to the doppelgänger as guest. I have already asked, Out of what void of the self does the doppelgänger appear? Perhaps this question should be rephrased as, Out of what void does the other *arrive*? The guest is not constituted as a passage past a threshold that

exists in advance. The line of demarcation, trespass, and in-
terrogation is created only by the arrival itself. The whirlpool
chiasm of *left is right* but also the impossible temporal divi-
sions of *Déjà vu*, the borders that Bigelow cannot step past,
are the eventual figures of such an arrival. In the end, the
chiasm is not set up by the artist in order to entrap the film
protagonist in the evil ministrations of his or her doppel-
gänger. Nor is it made to seduce us in order to make us fall
victim to our other acting in our place as our mirror image.
The mirror effect of our doppelgänger is only an illusion of
symmetry, of a distorted image of ourselves thrown beyond
the falsifying demarcation of a mirror's edge. Rather, the
other is an image of the demarcation of arrival of the event
itself.[12] Any intercourse that transpires there is an interroga-
tion of the self before the other.

The deceptive "friend" is a theme of film noir but not the
friend who initiates the reciprocal structure of guest and
host. The film noir hero is too wary, even though he is sus-
ceptible to seduction. But then there is little of the tradi-
tional film noir, Sam Spade—or Philip Marlowe—like, hero
in the films Gordon is drawn to. Scottie Ferguson is the only
one — yet he too is a victim. Like these other private eyes,
Scottie survives. The rest of Gordon's victims, with their
double characters and half lives, do not. But given that
survival is the thematic conclusion of his source films and
not the logic of Gordon's work itself, what lives on in his pro-
jections? Sur-vival, as Derrida writes, is the condition of an
"excess over present life." This "beyond-the-living-present"[13]
makes us recall Frank Bigelow's facing an impossible present

that he could not live divided between the contradictory demands of the past and future — although it is precisely his misfortune that he did not survive. We, on the other hand, do. Living on, we experience through the event of our other the impossible "experience" of film noir protagonists, but only if we ourselves are displaced from both the present of our viewing and the original experience of the source film.

Neither Frank Bigelow nor Ann Sutton could experience their actions or, indeed, the present they acted in. We experience the void space and time film noir protagonists could not as they were oblivious to their acts — but these acts are reproduced as an oblivion that they now act out in us. The internal dissemblance of these protagonists is realized in Gordon's projections as another space they perform in, a space that is not that of the original film but one that has been further distorted and virtualized. Norman Bates, Scottie Ferguson, and Ann Sutton act out the internalized world of their deception in these spaces. The virtual image they *project* is both the image that we view and the transformed space and time that is the ground of *our* dubious "action."

This space and time opens only through a disturbance of the visual field that Gordon's formal yet temporal interventions provoke. The disturbance of perception yields another view not just on the interiority of the subject but on the unseen structuring of the visual field, the invisible framework of the visible.[14] As is left unexposed to view but determinant of our perception in Gordon's reworking of *Whirlpool*, a dark mirror is the ground for every image. Philosophy teaches us that "that which enables us to see should remain invisible: black, blind-

ing."[15] Even the oblique editing of *left is right*, where, in the "chiasm of the eyes,"[16] one eye should see what the other cannot because of the alternate blinking of images, does not reveal this condition. The blink is not what makes one blind to what the eye alternately does and does not see. Ann Sutton's walking hypnotic state is a type of blindness with open eyes. If a dark mirror is the ground for every image, nonetheless this ground is unsettling because it "shows" the ungrounding of the actual in the abyss of the virtual. Thus, the disturbance of our visual field is only one state of a group of related — grounding and ungrounding — conditions affecting sight and activity: of the invisible within the visible, the virtual within the actual, and passivity within activity.

Events without experience, actions without decisions, the world of film noir protagonists is reproduced in Gordon's works or, rather, we are absorbed into that world through the works' chiasmatic inversions. In this invaginated world, passivity and activity do not so much reverse their effects as act in each other. All these words—"experience," "act," "decision," "event"— are problematic in Gordon's machinic noir universe. Without any knowledge of them, Ann Sutton passively acts out the decisions of her other. The "passive decision" of the other in her is reproduced for us in our encounter with Gordon's projections. Our relation to Gordon's works would duplicate that of his film noir split subjects by inducing in us the event of the other before ourselves, which is really, as in the case of Ann Sutton, the decision of the other in us. The decision of the other in us neither strips nor exonerates us of responsibility; it makes us responsible to the other before ourselves.[17]

I have been writing as if, in confronting Gordon's projections, eventually it was only a matter of a decision for us, a decisive act for which we alone are responsible. Merely a decision there would allow us to counter the ill effects of our deceitful doppelgängers. Triumphally adapting to the work's temporality, I suggested, frees us from the virtuality that still entraps our others, those whom we willingly abandon because we think they are a threat to our integrity of identity, action, and responsibility, to the intimacy of our intentions. Perhaps it would be more faithful to the operations of Gordon's work — and perhaps to the faith that the artist keeps with his characters — to think that we share the same temporality, although not the same space, that the works' protagonists "experience." The double nature of Gordon's work, where we experience, outside ourselves, both the protagonist's predicaments and our own implication, frees us from even our own expectations in an "unwilling" identification with what splits our identity. The impossible event produced by a calculable act of a machine is not a trap but a freeing moment, even if a passive act on the subject's part that produces him or her.

In this process, Gordon must deceive and double-cross even film noir itself. Although reliant on these films as his source material, he takes film noir dissociation and doubles it back on itself. This act maintains the plot and characters in a state of irresolution that the original film always seeks to resolve. Historically, the radical cynicism of film noir itself was caught up in the post-war collective campaign to promote and enforce middle-class familial normalcy that mars

one of its last products of the 1950s, *D. O. A.*[18] Gordon's work is true to the original subversive impulses and dark vision of film noir, but he continues to diabolize what it normalizes. Perhaps this diabolism is only an inversion of Calvinist morality that enables an ethic within Gordon's duplicities and that infects the odd decisions that the chiasm forces in our actions. Paul Schrader has written that film noir was "a moral vision based on style." Its perverse originality stemmed from the genre being caught up in the contradiction of "promoting style in a culture which values themes."[19] For Gordon, working a half-century later, film noir is a morally divided vision of the world of the work of art based on the complexities of temporal form.

Notes

Preface
Duplicitous Signatures

1. "Chiasm" derives from the Greek "chiasma," meaning an X-shaped configuration, an intersection or crossing. Its contemporary usage is of Derridean derivation.

Introduction
Author!

1. The 1998 Kunstverein Hannover catalogue, *Douglas Gordon*, published this text, entitled "A Short Biography," indicating that it was written "By a Friend." Republication in *Douglas Gordon • Black Spot* (Liverpool: Tate Liverpool, 2000) identifies the text as "A Short Biography — by a friend." Since "friend" was the name of the satanic doppelgänger to the protagonist in James Hogg's 1824 novel *The Private Memoirs and Confessions of a Justified Sinner*, we wonder whether the "friend" here is a split-off part of Gordon himself writing.

The Tate Liverpool catalogue contains what we might call Gordon's other autobiography, the visual equivalent to the textual "A Short Biography." The first 250 pages function as an artist's book composed of religious chapbooks and tracts, girly photos, Hollywood movie stills and fan ephemera, and their equivalents from American Underground film, all presumably influences on his youth and artistic development. A catalogue devoted to his language works, typically it is split between image and text.

Since I wrote this, another "autobiography" has appeared as a ghostly revenant, "Ghost: The Private Confessions of Douglas Gordon," *Douglas Gordon: what have I done* (London: Hayward Gallery Publish-ing, 2002), 13–44. Of ambiguous status, fictionally contrived from a series of edited fragmentary manuscripts like Hogg's novel, the text seems novelistically extrapolated by another writer from an "autograph" text (chapter 9) by Gordon himself.

2. *Douglas Gordon • Black Spot*, 278–79.

3. See the 1997 interview "Oscar van den Boogaard talks with Douglas Gordon," republished in *Déjà-Vu: Douglas Gordon, Questions & Answers, Volume 2 1997–1998* (Paris: Musée d'Art Moderne de la Ville de Paris, 2000), 37–46, for Gordon's comments on his background. "I can't tell you what the worst thing I have ever done is; what's bad… is to break trust with someone. That's the worst thing you can do if you do it intentionally" (39).

4. Raymond Durgnat, *The Strange Case of Alfred Hitchcock* (London: Faber and Faber, 1974), 47.

5. For every Gordon work there seems to be an opposite. For instance, *List of Names* (1990 ongoing), in which Gordon inscribes on the walls of a gallery the names of all the people that he can remember having met, can be taken as the inversion of the 1994 *Wall Drawing (I remember nothing)*. The reflection created by this opposition duplicates the cross-figure of an hour-glass, where at any moment forgetting passes into remembering and remembering into forgetting.

6. Note the sequence that the sentence sets in motion between ear, eye, and mouth. The relations between eye and ear and between eye and mouth recur in Gordon's work, perhaps standing for the relations of image and sound. Sometimes these relations seem benign, as in *Something between my mouth and your*

ear (1994) or *A few words on the nature of relationships* (1996) whose text reads "Close your eyes, open your mouth." The relation of title to text in the latter implies an open trust if the relationship is one of intimates. But earlier in Gordon's *24 Hour Psycho*, the relation of eye to mouth appears in its more sinister context.

7. Gordon's language works are parasitic on the performative model. They are "unhappy" performative utterances, however, because certain rules are infringed. The artist's right to issue a command would be an "infelicity" because a deception is involved. Gordon's command is corrupted because we are deceived by an unauthorized sender (the one who conscripts the postal system or telephone network or who appropriates the film images of another to his service). Nonetheless, Gordon's commands are effective, though not legally binding, since, deceived, we act on them. Perhaps Gordon is confident that our guilt will make us act and fulfill the conditions of the performative. On the performative, see J. L. Austin, "Performative Utterances," *Philosophical Papers* (London: Oxford University Press, 1970), 233–52; *How to Do Things with Words* (1962; second edition Cambridge, Mass.: Harvard University Press, 1975).

On the question of guilt, cf. Heidegger: "This essential Being-guilty is, equiprimordially, the existential condition for the possibility of the 'morally' good and for that of the 'morally' evil — that is, for morality in general and for the possible forms which this may take factically. The primordial 'Being-guilty' cannot be defined by morality, since morality already presupposes it for itself." Martin Heidegger, *Being and Time*, trans. John Macquarrie and Edward Robinson (New York: Harper & Row, 1962), 332.

8. "Nothing will ever be the same" is the text to *Instruction (Number 6)*, 1993.

9. Gilles Deleuze, *Difference and Repetition*, trans. Paul Patton (New York: Columbia University Press, 1984), 89.

10. Already the four cases I cited above led us on a complicated path of implication linking words to images, works of one artist to those of another, and sender to receiver. Indeed, each of the sample language works is also implied in the others. The temporal structure of performative enactment of *Instruction, Number 3b* carries within it the remembering and forgetting of *Wall Drawing (I remember nothing)*; the latter work implies, in turn, the self-doubt and questioning observation of *Tattoo (for Reflection)*; it, in turn, institutes a guilty division that might only be derived from the question of betrayal of trust suggested by *Tattoo*.

11. Jacques Derrida, "Before the Law," *Acts of Literature*, ed. Derek Attridge (New York and London: Routledge, 1992), 185.

12. Gordon's 1993 work *Trust Me* employed a circus tightrope walker.

1.
The Split of the Unconscious
24 Hour Psycho

1. Richard Flood makes this point in "24 Hour Psycho," *Parkett*, no. 49, 37.

2. Marion Crane's theft is only the lure to draw the spectator into the murder. What seems to be two films (by killing the star Janet Leigh about halfway in) is really Norman's alone. See Raymond Bellour, "Psychosis, Neurosis, Perversion," *The Analysis of Film* (Bloomington: Indiana University Press, 2000), 238 ff.

3. Let me merely signal the theme of becoming-female that is disguised in Norman's desire/blame of women and his transvestism.

4. The relevant texts, written from the mid to late 1950s, are collected in Gregory Bateson, *Steps to an Ecology of Mind* (New York: Ballantine Books, 1972).

5. In questioning how the speech of the psychiatrist provides a solution to the false tracks of the opening of *Psycho*, an opening that confounds the principles of classic film where the conclusion answers to the beginning, Bellour writes that "it is necessary, here, to conceive of Hitchcock as pursuing, through fiction, an indirect reflection on the inevitable relationship, in his art and in his society, between psychosis and neurosis, inscribed respectively in narrative terms as murder and theft.... What appears from the fact that the subject of neurosis is offered up in the logic of the narrative to the violence of the subject of psychosis, man or woman, mutually interchangeable throughout the course of the narrative, is the obscure numinous point of a fiction that carries to a vertiginous degree of duplication the fascinated reflection on the logic of desire." Bellour, "Psychosis, Neurosis, Perversion," 243.

6. Harald Fricke, "Confusion in Noir," in *Déjà-Vu: Douglas Gordon, Questions & Answers, Volume 1 1992–1996* (Paris: Musée d'Art Moderne de la Ville de Paris, 2000), 24. The full quotation reads: "he even recapitulated a situation, where he saw the film [*Dial M for Murder*] as a very small child while in bed with his parents late at night. Slowly the interpretative mind rises to the bait: Gordon's attraction to Hitchcock — isn't it like some sort of fixation on childhood?"

7. Lacan has written on the place and temporality of the unconscious, which differ from those of logical space and time. On its place: "The primary process... must, once again, be apprehended in its experience of rupture, between perception and consciousness, in that non-tem-poral locus, I said, which forces us to posit what Freud calls... *die Idee einer andere Lokalität*, the idea of another locality, another space, another scene, *the between perception and consciousness.*" On its temporality: "The unconscious is always manifested as that which vacillates in a split in the subject.... The appearance/disappearance takes place between two points, the initial and the terminal of this logical time — between the instant of seeing, when something of the intuition itself is always elided, not to say lost, and that elusive moment when the apprehension of the unconscious is not, in fact, concluded, when it is always the question of an 'absorption' fraught with false trails." Jacques Lacan, *The Four Fundamental Concepts of Psycho-Analysis*, trans. Alan Sheridan (Harmondsworth: Penguin Books, 1979), 56, 28, 32.

8. In a subsequent projection, *Hysterical* (1994–95), Gordon divides this device in two, showing the same footage on separate screens, one at regular speed and the other in slow motion.

9. The dissolve to the skull is the completion of a series of key camera shots that punctuate and condense Norman's passage to madness that include the slow zoom that breached the open hotel window at the beginning of the movie and the rapid montage of the shower scene halfway through. These shots economically trace the inward progress to a sightless madness that the skull represents.

10. Gilles Deleuze, *Cinema 1: The Movement-Image*, trans. Hugh Tomlinson and Barbara Habberjam (Minneapolis: University of Minneapolis Press, 1986), 3–8.

11. Yet double bind theory claims that no originary traumatic act sets the victim on his course of psychosis. How can we as

spectators, entering after the fact, know that this act has not repeated without an origin?

12. In an analysis of the division of the senses of seeing and hearing in the origins of Western culture, Jean-François Lyotard aligns sight to Greek philosophy (Plato and his rationalist derivatives in Descartes and Husserl) and hearing to Judiasm. "By moving from eye to ear, Judaism allows humanity to move from the worship of a divinity who shimmers and dances in deep space to a god who is, in theory, presumed to be the subject of a completely audible (intelligible) utterance, but who is not in fact that subject because he is at the moment silent." "Figure Foreclosed," *The Lyotard Reader*, ed. Andrew Benjamin (Oxford: Basil Blackwood Ltd., 1989), 82. This division is pertinent to the hallucinated inner voice of schizophrenia (cf. Norman). Lyotard states that "the Judaic word relates to schizoprehenia…. No longer seeing at all, only listening." Ibid.

2.
The Calculations of Time
5 Year Drive-By

1. Actually, we experience sound and image; Gordon would only possibly have heard sound in both cases.

2. In *The Searchers*, a Civil War veteran, Ethan Edwards (John Wayne), returns to the family of his brother after a number of years of wandering. (We sense that perhaps he has stayed away in part because he himself allowed his brother to marry the woman he loves and who obviously loves him in return.) Immediately, he is drawn away by a ruse and returns to find the homestead attacked by Comanches and the family slaughtered, except for his two nieces who have

been kidnapped. Edwards sets out on a grim, determined five-year search to recover the one remaining niece (the other was soon raped — we presume — and murdered). We are led to believe after a time that his obsession is not to find but to kill her since her white kinship has been contaminated by her sexual possession by the native other.

3. In a written response to an interview question whether *5 Year Drive-By* need be actualized, Gordon stated, "Sure, this piece need not be made. But in some ways, the struggle necessary to realize it and situate it where I want it runs parallel to the narrative of the original film. Although I know what you're saying here, I would like to make it as a drive-by cinema, ideally situated in, or nearby Monument Valley in Southern Utah. I like the idea of a physical monument to the idea of the search — and if this is the case, then the potential viewer has to be involved in some kind of physical journey in order to see the work. This is a real parallel with the story." Nancy Spector, "This is all true, and contradictory, if not hysterical. Interview with Douglas Gordon," *Art from the UK* (Munich: Sammlung Goetz, 1997), 84.

4. Letter to Thierry Pratt, dated November 4, 1995, "… an apology as a short story/a short story as an apology," *Douglas Gordon: Kidnapping* (Eindhoven: Stedelijk Van Abbemuseum, 1998), 138.

5. For illustrations of the overnight projections of *Bootleg (Empire)* and *5 Year Drive-By* at the National Gallery of Berlin in 1995, see Russell Ferguson, ed., *Douglas Gordon* (Los Angeles: The Museum of Contemporary Art, and Cambridge, Mass.: MIT Press, 2001), 36–37.

6. P. Adams Sitney lists the four characteristics of structural film — all of which the slow-motion appropriation of Gordon's projection somehow interpret — as

"fixed camera position (fixed frame from the viewer's perspective), the flicker effect, loop printing, and rephotography off the screen" and suggests that "to the catalogue of the spatial strategies of the structural film must be added the temporal gift from Warhol — duration." *Visionary Film: The American Avant-Garde* (New York: Oxford University Press, 1974), 408, 412. In his summary of the characteristics of structural film, Malcolm Le Grice adds the concerns, also pertinent to Gordon, of "celluloid as material, the projection as event, duration as a concrete experience," as well as "camera-functioning and the consequences of camera-motion." *Abstract Film and Beyond* (Cambridge, Mass.: The MIT Press, 1977), 88.

7. Sitney, 411.

8. Sitney, 412. Warhol projected his films at 16 frames per second, silent film speed, not the standard 24 fps, which gave them an almost imperceptible sense of slowed motion.

9. "… an apology as a short story/a short story as an apology," 139.

10. Deleuze, *Cinema 1*, 46. References that follow here to the Kantian sublime are found in Immanuel Kant, *Critique of Judgement*, trans. J. H. Bernard (New York: Hafner Press, 1951), § 25–26.

11. From Kant's observation, Deleuze concludes: "This is the second aspect of time: it is no longer the interval as variable present, but the fundamentally open whole as the immensity of future and past. It is no longer time as succession of movements, and of their units, but time as simultaneism and simultaneity (for simultaneity, no less than succession, belongs to time; it is time as whole)." Deleuze, *Cinema 1*, 46.

12. "An object is *monstrous* if, by its size, it destroys the purpose which constitutes the concept of it. But the mere presentation of a concept is called *colossal*, which is almost too great for any presentation (bordering on the relatively monstrous), because the purpose of the presentation of a concept is made hard [to carry out] by the intuition of the object being almost too great for our faculty of apprehension." Kant, § 26.

13. Ford achieves his presence by cutting his narrative from a past and a future that are just as unavailable as those of Gordon's projection. (There is almost as long a period of wandering before the movie commences as in it, and, presumably, after it: Ethan Edwards roamed for three year after the Civil War he fought before he returned home.) Ford makes this clear for us in the opening and closing scenes of *The Searchers*, which are both shot from inside the door of the black interior of the Edwards's cabin through to the blazing landscape in which the film unfolds. The doorway opens the narrative to its duration and closes it. It is a threshold sheltering the dark past and dark future, revealing only the luminous present of the search. The opening and closing shots also mimic the start and finish of a movie that the light of projection creates in the dark space of the theatre, where we are taken out of ourselves, joined to the movie, and then returned to our bodies when the lights are turned on. We are liberated by eyesight in the quest, but just as surely Ford returns us to society. Inhabiting the dark interior of the theatre, the audience substitutes for the society of the family Ethan Edwards briefly joins and leaves in the opening and closing shots. The contradictions of American society reflected in its movie genres, Westerns in particular, are such that we can participate temporarily in the spectacle of a violent present, but we cannot live there as an outsider or outlaw might. (The darkness of the doorways at the beginning and

end of the film are crossroads in Edwards's journey and are mimicked by the sunset and sunrise of an outdoor projection of 5 Year Drive-By.)

14. Making sense in this hostile landscape is the function of society and the family. This is why there is such a structural emphasis in *The Searchers* on kinship and marriage, as well as on laws expressed in the plot interweaving of true and false vows and oaths in orders, letters, wills, and marriages. The discord of Edwards's obsession is in conflict with community accord; it is a disorder that must be excluded from the order community imposes on rude nature.

15. Deleuze classifies pre-war and post-war cinema by their treatment of their images' relation to time. The *movement-image* of pre-war classical cinema produces an indirect representation of time, whereas post-war cinema's *time-image* (initiated by Orson Welles, Italian neorealism, and the French New Wave) offers a direct presentation of time derived from the image itself and not from montage. See Deleuze, *Cinema 1: The Movement-Image* and *Cinema 2: The Time-Image*, trans. Hugh Tomlinson and Robert Galeta (Minneapolis: University of Minneapolis Press, 1989).

In adapting a Western, Gordon has transformed an indirect image of time into a direct time-image contradictory to the original genre. In Deleuze's terminology, he has turned an action-image into an affection-image.

16. In conjunction with Gordon's exhibition at the Museum of Contemporary Art in Los Angeles, a screening was held at Twenty-nine Palms, September 22, 2001, between sunset and sunrise.

17. Our experience is only part of a work that continues to exist long after we have departed. Once the work is experienced, though, we continue to intersect with it. Gordon opens up for our experience what

Ford denies but on condition that we remain "outsiders" to the projection. In the case of 5 Year Drive-By, isn't the search itself reversed? Perhaps we are not searchers but prey. If this project was to realize itself, in the back of our minds we would be aware that there is a film out there continuously playing for five years, relentlessly searching for an audience.

18. Gordon would soon memorialize *Vertigo* in *Feature Film*.

3.
The Madness of the Double
Confessions of a
Justified Sinner

1. *Confessions of a Justified Sinner* was shown in the 1996 Tate Gallery Turner Prize exhibition together with the video *A Divided Self I and II* (1996). In *A Divided Self*, the two arms of the artist — one shaved, the other hairy (sending us back to the biblical rivalry of the brothers Cain and Abel) — wrestle each other. The struggle mimics the scene of self-strangulation in Mamoulian's film, which Gordon excerpts for *Confessions*, and seems to reinforce the dichotomous conflict within the self between good and evil.

2. The "mirrors" actually reflect one another but virtually intersect each other.

3. The initial reflection of Jekyll-Hyde is thus repeated to infinity as a series of reflected pairs that continuously duplicate. The pair originates divided in reflection ($1|1$); then the *pair* is reflected ($[1|1]|[1|1]$); then reflected again with its new pair ($\{[1|1]+[1|1]\}|\{[1|1]+[1|1]\}$), *ad infinitum*.

4. Stemming from the paradox of infinite identity, the infinite series in philosophy is a figure of madness. "Plato invites us to distinguish between two dimensions: (1) that of limited and measured things, of fixed qualities, permanent or temporary

which always presuppose pauses and rests, the fixing of presents, and the assignation of subjects (for example, a particular subject having a particular largeness or a particular smallness at a particular moment); and (2) a pure becoming without measure, a veritable becoming-mad, which never rests. It moves in both directions at once. It always eludes the present, causing future and past, more and less, too much and not enough to coincide in the simultaneity of a rebellious matter.... The paradox of this pure becoming, with its capacity to elude the present, is the paradox of infinite identity (the infinite identity of both directions or senses at the same time — of future and past, of the day before and the day after, of more and less, of too much and not enough, of active and passive, and of cause and effect). It is language which fixes the limits (the moment, for example, at which the excess begins), but it is language as well which transcends the limits and restores them to the infinite equivalence of an unlimited becoming." Gilles Deleuze, *The Logic of Sense*, trans. Mark Lester (New York: Columbia University Press, 1990), 1–3. The paradoxes of infinite identity help explain some of the curious traits of Gordon's virtual world: of the reversals of time, cause and effect, guilt and fate. On series, infinite series, and the paradoxes of infinite identity, see especially, 36–41, as well as Deleuze, *Difference and Repetition*, passim.

5. Deleuze, *Difference and Repetition*, 17.

6. Nancy Spector, "This is all true, and contradictory, if not hysterical. Interview with Douglas Gordon," 87.

7. I quote Alan Bass, Jacques Derrida's translator, on the *mise en abyme*: "*Mettre en abyme* (to put into *abyme*) is a heraldic term for the placement of a small escutcheon in the middle of a larger one.

Derrida is playing on this old sense of *abyme*, with its connotation of infinite reflection, and the modern senses of *abîmer*, to ruin, and of *abîme* — abyss, chasm, depths, chaos, interval, difference, division, etc." Translator's note 73, Derrida, "White Mythology: Metaphor in the Text of Philosophy," *Margins of Philosophy* (Chicago: The University of Chicago Press, 1982), 262.

On the signature *en abyme*, see Jacques Derrida, *Signéponge/Signsponge*, trans. Richard Rand (New York: Columbia University Press, 1984), passim, for example: "If I say that the whole process of the placement in abyss consists in a triumph of the countersignature, it is not for the purpose of explaining the one in terms of the other, supposing we really know what goes on in a placement in abyss. On the contrary, it is to pose the possibility that every placement in abyss carries in it some economy of the countersignature. The signature is the placement in abyss (of the proper) itself: exappropriation" (132).

8. Deleuze writes of *Alice's Adventures in Wonderland*, that "all these reversals as they appear in infinite identity have one consequence: the contesting of Alice's personal identity and the loss of her proper name." Deleuze, *The Logic of Sense*, 3. These strategies are pursued by Gordon in a complementary photographic work, *Selfportrait as Kurt Cobain, as Andy Warhol, as Myra Hindley, as Marilyn Monroe* (1996). The metonymic chain of association of the title is set off by Gordon's posing, transvestite-like, in a blond wig.

9. What do we make of the part of the title Gordon deletes (*The Private Memoirs*): that he reserves for himself the disguised pleasure of authorship?

10. Writing may be conceptualized other than traditionally thought: "Now, this refer-

ence [in the sense of the mimetic representation of truth] is discreetly but absolutely displaced in the workings of a certain syntax, whenever any writing both marks and goes back over its mark with an undecidable stroke. This double mark escapes the pertinence or authority of truth: it does not overturn it but rather inscribes it within its play as one of its functions or parts. This displacement does not take place, has not taken place once, as an *event*. It does not occupy a simple place. It does not take place *in* writing. This dis-location (is what) writes/is written." Jacques Derrida, "The Double Session," *Dissemination*, trans., Barbara Johnson (Chicago: The University of Chicago Press, 1981), 193.

On the one hand, to re-mark an image by a double cross is to write over it, however disguised this writing might be. On the other hand, text cannot be deleted without leaving a trace in the image; but the effacement of writing (screenplay) by the deletion of sound in *Confessions* only marks the image as the trace of a space between text and image (a trace which Gordon surreptitiously restores through titling). Deletion is not in itself a dissemblance.

11. R. D. Laing, *The Divided Self: An Existential Study in Sanity and Madness* (London: Tavistock Publications, 1960).

12. I derive the diabolized signature from Derrida's use of Bertrand Russell's term in *Signéponge/Signsponge*, 118.

4.
Before the Law
Between Darkness and Light
(After William Blake)

1. Since these films are of unequal length, they repeat with ever new intersections.

2. Derrida, "The Double Session," 212.

3. As a religious symbol, the cross represents the coincidence of the two realms of the visible and the invisible; it is a sign that leads one from the sensible to the divine. It does not represent the supersensible divine; the sensible and the non-sensible are united in the tangibility of the symbol. The symbol binds the faithful but is no vehicle for judgment of their faith. See Hans-Georg Gadamer, *Truth and Method* (New York: The Seabury Press, 1975), 66 ff., for a discussion of the symbol.

Ushering in the Romantic era with its crowning concept of the symbol, Kant saw the faculty of judgment derived from aesthetic experience as a middle articulation between the faculty of understanding that legislates nature and the faculty of reason that legislates freedom. Judgment would be the means to bridge the great gulf (*grosse Kluft*, also abyss) of the sensible and the supersensible and mend the divisions between philosophy. "The analogy of the abyss and of the bridge over the abyss is an analogy which says that there must surely be an analogy between two absolutely heterogeneous worlds, a third term to cross the abyss, to heal over the gaping wound and think the gap. In a word, a *symbol*. The bridge is a symbol, it passes from one bank to the other, and the symbol is a bridge. The abyss calls for analogy — the active recourse of the whole *Critique* [*of Judgement*] — but analogy plunges endlessly into the abyss as soon as a certain art is needed to describe analogically the play of analogy." Jacques Derrida, "Parergon," *The Truth in Painting*, trans. Geoff Bennington and Ian MacLeod (Chicago: The University of Chicago Press, 1987), 36. Neither analogy nor symbol, *Between Darkness and Light* is a work of art that offers neither faith nor judgment but sustains the gap

of the abyss in a failure of the double-cross to bridge the abyss that it is.
4. As Gordon pursued his literary heritage in *Confessions of a Justified Sinner*, so too, perhaps, *Between Darkness and Light* has its autobiographical associations of adolescent sexuality expressed through a fascination with popular culture encountering the religious strictures of his Glaswegian youth. See the artifacts of this encounter in the first hundred pages of *Douglas Gordon • Black Spot*. The catalogue scrapbook combines "good" and "bad" images, those religiously approved and disapproved, for it is not imagery per se that is censured as much as simulacral—that is, demonic — images. So does Catholicism follow Platonism where "the function of the notion of the model is not to oppose the world of images in its entirety but to select the good images, the icons which resemble from within, and eliminate the bad images or simulacra." Deleuze, *Difference and Repetition*, 127.

5.
Criss-cross

1. I refer to Gordon's text work *the left hand doesn't know what the right hand doesn't know what*, which is from 1998.
2. Since we are telling the truth here, I might as well admit my frequent application of Jacques Derrida's chiasmatic *mise en abyme* and Gilles Deleuze's "disguised repetition" in my analyses of Gordon's projections. It is not as if Gordon makes his works according to these theories; everything I describe in this book follows from his projections' formal structures. Philosophers as they are, Derrida and Deleuze can better describe the effects of the simulacral worlds Gordon puts in place. Lest we think that Gordon

is only illustration to these philosophers, it was only after I had before me the analytical example of Gordon's works that I was able to fully understand such a work as Deleuze's *Difference and Repetition*. Deleuze does not explain Gordon; Gordon explains Deleuze.
3. Other than *Confessions*, none of the early projections edited film by cutting into it, which is why commercially available VHS tapes could be used in the projections. But *5 Year Drive-By* is projected from a disk; a computer program releases each frame.

6.
Talking *en abyme*
through a looking glass

1. The temporal calculations of *through a looking glass* would seem to open *Taxi Driver* to the same effects of infinity as those we found in *5 Year Drive-By*. Yet, since the time we are now caught up in here has no correlation in space, space "through the looking glass" being only virtual, time here operates differently. Ungrounded from spatial correlation, time does not proceed along a line to infinity but, like the dialogue, reverses and turns back on itself. In spatial terms, time is a straight line dividing itself equally to infinity; in virtual terms, as with the effect of gravity on light, madness makes time recursively coil.
2. On numeric (quantitative) and durational (qualitative) multiplicities, see Gilles Deleuze, *Bergsonism*, trans. Hugh Tomlinson and Barbara Habberjam (New York: Zone Books, 1991), 38, 80.
3. In a statement that could equally be applied to the chiasm, Deleuze describes this engendering of time thus: "We may define the order of time as this purely formal distribution of the unequal in the

function of a cæsura." *Difference and Repetition*, 89.

4. Perhaps the inflection within the chiasm, described by Derrida as an inequality of the points of the chiasmatic *X*, also explains the unbalanced dynamic of this dissymmetry: "The form of the chiasm, of the *X*, interests me a great deal, not as the symbol of the unknown, but because there is in it … a kind of fork (the series *crossroads, quadrifurcum, grid, trellis, key*, etc.) that is, moreover, unequal, one of the points extending its range further than the other: this is the figure of the double gesture, the intersection…." Jacques Derrida, *Positions*, trans. Alan Bass (Chicago: The University of Chicago Press, 1981), 70.

5. Deleuze, *Difference and Repetition*, 209–10.

6. Ibid., 24.

7. Ibid., 21.

8. Ibid., 105.

9. Ibid., 21. Deleuze's description of arithmetic versus geometric symmetries and cadence-repetition versus rhythm-repetition is directly applicable to an analysis of the numeric and temporal series of *through a looking glass*. Arithmetic (static) symmetry (i.e., the numeric construction of *through a looking glass*) "refers back to a scale of whole or fractional coefficients"; geometric (dynamic) symmetry (i.e., the temporal constitution of *through a looking glass*) is "based upon proportions or irrational ratios…. Now, the second of these is at the heart of the first; it is its vital, positive, active procedure" (20). "Cadence-repetition is a regular division of time, an isochronic recurrence of identical elements [the mere repeating of images in *through a looking glass*]. However, a period exists only in so far as it is determined by a tonic accent, commanded by intensities. Yet we would be mistaken about the

function of accents if we said that they were reproduced at equal intervals. On the contrary, tonic and intensive values act by creating inequalities or incommensurabilities between metrically equivalent periods or spaces. They create distinctive points, privileged instants which always indicate a poly-rhythm [the syncopated counter-time of repetition of *through a looking glass*'s images]. Here again, the unequal is the most positive element" (21).

10. Ibid., xx.

7.
Dark Mirror
left is right and right is wrong and left is wrong and right is right

1. To fall between two positions is as dangerous, it would seem, as assuming one pole: the "and" turns us to ever new dilemmas. We have seen the grammatical function of the "and" in Stevenson's *The Strange Case of Dr. Jekyll and Mr. Hyde* subtly announce the character's duplicity. Now again, every "and" and "is" of Gordon's title invite us to seek clues to the structure of the work. Is not the grammatical construction of the phrase "left is right," for example, with its equivalence of subject and object articulated through the verb, a description of the conditions of mirror virtuality, a specious mirror that turns the meaning of its word to its opposite? Yet, at the same time, it accurately describes the spatiality of mirror phenomena. As well, do not the spatial ("left is right") and moral ("right is wrong") correspond to the disjunction between the mind and body that we find in this work, where a careening moral gyroscope is divorced from an out-of-kilter body?

2. Compare Hitchcock's transfer of guilt, which indissolubly links two characters

even while one is unaware of the other's actions. The other's uncalled-for intervention implicates the hero or heroine in a series of actions he or she cannot control. "The idea of the 'exchange,' which we find everywhere in his work, may be given either a moral expression (the transfer of guilt), a psychological expression (suspicion), a dramatic expression (blackmail — or even pure 'suspense'), or a concrete expression (a to-and-fro movement)." Eric Rohmer and Claude Chabrol, *Hitchcock: The First Forty-Four Films*, trans. Stanley Hochman (New York: Frederick Ungar Publishing, 1979), ix.

3. By coincidence, Dr. Sutton is treating a war patient when Ann Sutton returns from her shoplifting incident.

4. Charcot used hypnotism to instigate hysterical attacks in his female subjects. Curiously, the gestures of the arms of doctor and patient of this film footage are repeated in the combative arms of Gordon's *A Divided Self I and II*, which also seem locked in an erotic struggle. We might now interpret the division of the self there not just to be between good and evil as automatically suggested by the earlier context of presentation of the work with *Confessions of a Justified Sinner* but between the conscious and unconscious self, between mind and body.

5. Henri Bergson, *Matter and Memory*, trans. N. M. Paul and W. S. Palmer (New York: Zone Books, 1991), 79. "That which is commonly held to be a disturbance of the psychic life itself, an inward disorder, a disease of the personality, appears to us, from our point of view, to be an unloosening or a breaking of the tie which binds this psychic life to its motor accompaniment, a weakening or an impairing of our attention to outward life" (14–15).

6. Doubling the set gives *left is right* the appearance in long shots of another era of film, for instance, of *Last Year at Marienbad* (1961), whose characters somnambulantly track through its settings' formal symmetries, lost in long takes in its architecture, ambiguously placed between the duration of the present that the camera movement registers and the memory of the past that the same images evoke or are. This film by Alain Resnais has been called the last of neorealist film but it could also be considered a film noir.

7. Deleuze claims a category of exception for reflections and doublings, as well as echos, souls, and twins: "They do not belong to the domains of resemblance or equivalence" but rather to repetition. Deleuze, *Difference and Repetition*, 1.

8. Deleuze states that "if exchange is the criterion of generality, theft and gift are those of repetition." Ibid. During the shoplifting episode, Korvo says of Ann Sutton's kleptomania, "It wasn't a thief that put it there," that is, that put the stolen jewellery in her purse. In Gordon's work, theft is mirrored by the anonymous gift. Hence Gordon's opposing work *Pocket Telepathy* (1995) in which, instead of stealing something from the pockets of coats in the Stedelijk Van Abbemuseum cloakroom, where he was then having an exhibition, he left a slide portrait of a telepathist, a medium who is akin to a hypnotist. For an illustration, see *Douglas Gordon: Kidnapping*, 22.

8.
Master and Rival
Feature Film

1. Gordon's treatment is unlike Gus van Sant's slavish shot-for-shot 1998 remake of *Psycho*, which also keeps Herrmann's music intact: Gordon substitutes a com-

plete dependency on Herrmann's score rather than on Hitchcock's shots. But then is not Gordon's own film just as much a slave to Hitchcock's film, devoting itself to its soundtrack?

2. For an analysis of the structural characteristics of Herrmann's music to *Vertigo*, see Royal S. Brown, "The Music of Vertigo," in *Feature Film: A Book by Douglas Gordon* (London: Artangel Afterlives; London: Book Works; and Paris: Galerie du jour - agnès b, 1999), 5–8.

3. Conlon wears a black turtleneck that frames his face and arms against the surrounding darkness. We recognize the motif of the arm from Gordon's other works as we recognize something of Gordon himself in the appearance of James Conlon.

4. In this spiritualization of the senses, Conlon's mastery passes from the virtual to the actual, while Scottie's madness passes from the actual to the virtual.

5. In part two, Judy Barton reprises her earlier role mimicking Madeleine; but we have no original to compare her masquerade to, only the painting of a third — the portrait of Carlotta Valdes hanging in the museum — already a simulacrum with no necessary connection to the "real."

6. Derrida's comment on Nietzsche seems pertinent here: "All of Nietzsche's investigations, and in particular those which concern women, are coiled in the labyrinth of an ear." Jacques Derrida, *Spurs: Nietzsche's Styles*, trans. Barbara Harlow (Chicago: The University of Chicago Press, 1979), 43.

7. Madeleine says she prefers to call Scottie by his real name, John, because it is "a good, strong name," whereas Midge calls him Johnnie, and his acquaintances call him Scottie. In the opening scene, when Scottie asks Midge about the brassiere she is drawing, she replies: "You know about those things.

You're a big boy now."

8. "Hitchcock's humor informs every terrible situation he takes his 'bad' actors through. His settings are a vast simulacra built by an evil demiurge, and peopled with frozen automatons." Robert Smithson, "From Ivan the Terrible to Roger Corman or Paradoxes of Conduct in Mannerism as Reflected in the Cinema," in Nancy Holt, ed., *The Writings of Robert Smithson* (New York: New York University Press, 1979), 215.

9. Although perhaps an accident of billing and of the construction of the shot, in the credits James Stewart's name is superimposed over Kim Novak's mouth and Novak's name over her eyes.

10. "This simulacrum includes the differential point of view; and the observer becomes a part of the simulacrum itself, which is transformed by his point of view." Deleuze, "The Simulacrum and Ancient Philosophy," *The Logic of Sense*, 258.

11. Eric Rohmer and Claude Chabrol, *Hitchcock: The First Forty-Four Films*, 105.

12. Following on note 10 above, the Deleuze quotation continues: "In short, there is in the simulacrum a becoming-mad...."

13. Derrida, *Spurs: Nietzsche's Styles*, 53.

14. Ibid., 49, 51. "Truth, unveiling, illumination are no longer decided in the appropriation of the truth of being, but are cast into its bottomless abyss as non-truth, unveiling and dissimulation" (119).

15. Hitchcock devised elaborate traps for his characters. Scottie is condemned to witness the tower death of Madeleine in both parts. Some commentators have speculated that, like Sisyphus's or Prometheus's, this repetition is his infinite fate, and that a third part follows from the

second, and so on, in a vertiginous spiral, each one worse than the last.

16. The mutual dependency of parties in dissemblance — dissembler (Elster), dissembled (Madeleine), and dupe (Scottie) — has an uncanny resemblance to the Platonic triad of foundation, object aspired to, and pretender, or, otherwise expressed, the father, the daughter, and the suitor. According to the Platonic origins from which this model of rivalry and adjudication derives, the claims of rivals to the object aspired to are measured against the ground of the Idea or model. Either the rival resembles the Idea and is a true pretender or he dissembles resemblance and is a false pretender. This derived internal resemblance or dissemblance is either a true or false copy of the model. Problems arise not in the accordance of secondary copy to original model but in the confusion of copy and simulacra: "The model-copy distinction is there only in order to found and apply the copy-simulacra distinction The function of the notion of the model is not to oppose the world of images in its entirety but to select the good images, the icons which resemble from within, and eliminate the bad images or simulacra. Platonism as a whole is erected on the basis of this wish to hunt down the phantasms or simulacra which are identified with the Sophist himself, that devil, that insinuator or simulator, that always disguised and displaced false pretender." Deleuze, *Difference and Repetition*, 127. Grounding claims is a matter of separating icons from simulacra that arise from true and false pretenders. But what if the ground itself that measures the rivals' claim — not just the object aspired to (Madeleine) and one of the pretenders (Elster) — what if *all* are simulacra? The foundation that should establish the rivals' claims is itself a false ground, a

simulacrum, because one of the claimants (Elster) is not only a false pretender to the aspired (false) object, he has also, at the same time, laid the ground of this deception — he is impossibly both father *and* rivalrous pretender at once. (If we superimpose the mimetic triangle of husband-wife-rival onto the Platonic triad of father-daughter-suitor, we find that Elster impossibly occupies the two roles of husband/father and rival/suitor. Likewise, Gordon would be both father and daughter in this scheme.) In this process, Scottie emerges more as a dupe than as a rival. Rivalry between the males must dissipate because not only the object aspired to is a simulacrum but, more important, the foundation is a false ground. Participation in a simulacral ground would be madness. This would be Scottie's fate, which, however, he seems by the second half of *Vertigo* to escape, not through some fact of detectively deduction but because of a mistake by Judy, who has entered too believingly into her new masquerade: she has come to believe in Scottie's masquerade, not her own.

On simulacra, the ground, and the Platonic trinity, see Deleuze, *Difference and Repetition*, passim, and "The Simulacrum and Ancient Philosophy," 253–66.

17. Deleuze, *Difference and Repetition*, 67.

18. Derrida, *Spurs*, 111.

19. Freedom is a recurrent, though obliquely mentioned, topic in *Vertigo*. Elster laments the past of San Francisco when he could have lived with "colour, excitement, power, freedom." The Argosy Bookstore owner, who in part one relates Carlotta Valdes's story to Scottie, says of the rich man who abandoned her and took her child, "You know, men could do that in those days. They had the power and the freedom." In the concluding

moments of the film in the tower, Scottie says to Judy, "Did he ditch you? Oh, Judy, with all of his wife's money, and all that freedom and power, and he ditched you." (Note the no doubt intentional symmetrical mirroring of the dialogue in the two parts of the film — "power and freedom"/ "freedom and power" — which in rhetoric is called a chiasmus.) Freedom was not to be Scottie's, when, before ascending the tower a second fatal time, he says to Judy, "I need you to be Madeleine for a while, and when it's done, we'll both be free."

20. Lyotard, "Figure Foreclosed," 88.

21. "Now we know that sight is the sense of the oneiric scenario (*mise en scène*) and of phantasy in general, whereas in paranoia and even schizophrenia, hallucinations are addressed to the ear. Psychiatrists seem to be be agreed that the sense of hearing is more 'intellectual' and 'more closely bound up with mental processes' than vision; but psychoanalysis teaches us that the predominance of the ear bears witness to the fact that the ego has come under the sway of the id, and has taken the side of the inside against the outside. The advance in intellectuality is not an advance in truth." Ibid., 96. This last observation applies equally to Norman and Scottie.

22. Jacques Derrida, "History of the Lie: Prolegomena," *Without Alibi*, trans. Peggy Kamuf (Stanford: Stanford University Press, 2002), 28.

9.
Dead Awake
Déjà vu

1. Paul Schrader, "Notes on Film Noir," Alain Silver and James Ursini, eds. *Film Noir Reader* (New York: Limelight Editions, 1996), 59. Schrader's essay was

originally published in 1972.

2. Practically every character expresses some worry about time: Paula, Bigelow's secretary and girlfriend: "And here I was worrying I had lost my time"; Mrs. Philips, deceptively: "If only you had come sooner, Mr. Bigelow. My husband might be alive today"; crime boss Majak, thinking of the prospect of prison, which in order to avoid he would attempt to murder Bigelow, not knowing that Bigelow is already a dead man: "Ten years — that's the rest of my life."

3. Deleuze, *Cinema 2*, 78–79.

4. Ibid., 54–55.

5. Bergson, *Matter and Memory*, 138.

6. Ibid., 78. The progression through the LAPD hallway during the credits illustrates this driving force.

7. Ibid., 144–45.

8. As well as for his *Instructions*, Gordon has used the telephone in *Dead Line in Space* (1997) and *Untitled (I'm not sure this is working)* (1997).

9. Schrader, "Notes on Film Noir," 61. In 1995, in an exhibition of scannerchrome film images on canvas called *The End*, Gordon exhibited a series of end titles of various films.

Conclusion
Fate and Freedom

1. Willing an act through a flaw in character in film noir is not tragic precisely because the space of action of film noir is banal, especially the chance acts protagonists become subject to.

2. Even in the absence of a double image as in *24 Hour Psycho*, we should think of Gordon's projections as always already mirror images that carry a doubleness within them.

3. Gordon's reception of film is allegorical: "The cinema is young, it's only a hun-

dred years old, but for us, it's already dead. It must be because we grew up with the videorecorder." Interview with Stéphanie Moisdon, *Bloc Notes* 11 (Jan.–Feb. 1996), quoted in Raymond Bellour, "The Instant of Seeing," *Douglas Gordon* (Lisbon: Centro Cultural de Belém, 1999), 17.

Relying on the morality tales of film noir and his allegorical literary sources (Hogg and Stevenson), Gordon's enterprise is essentially allegorical. From the start, his appropriative act is allegorical. Like the Baroque *deus ex machina*, his interventions have the effect of allegorical "daemonic agency." Isolating a fatal flaw in the character and trapping him or her in an abstract repetition, his film interventions repeat allegory's constriction of meaning and progressive abstraction of action and character. His visual traps, with their "increase of daemonic control over the character amounts to an intensification of the allegory." Yet saying Gordon's work is allegorical should not make us overinterpret his fateful themes. To do so would retain us in the dilemmas Gordon constructs for his characters or maintain us merely as observers on the level of content and not deeply implicated as we know ourselves to be. On allegory, see "The Daemonic Agent," in Angus Fletcher, *Allegory: The Theory of a Symbolic Mode* (Ithaca: Cornell University Press, 1964), 25–69. (The relation of symbol to allegory would be equivalent to that of the relation of sixties experimental film to Gordon's projections.)

4. Compare Derrida on the cut: "This cut is not so much effected by the machine (even though the machine can in fact cut and repeat the cut in its turn) as it is the condition of production for a machine…. The machine is an *effect of the cut* as much as it is a *cause of the cut.*" Derrida, "Typewriter Ribbon: Limited Ink (2),"

Without Alibi, 133.

5. "No event without *experience* (and this is basically what 'experience' means), without experience, conscious or unconscious, human or not, of what happens to the living." Ibid. *72.*

Derrida would call the anomaly an apo-. ria. He asks whether the aporia can be experienced, a pertinent question for us since the aporia might have the same structure as the chiasm as a site of the event of the other. "Let us ask: *what takes place, what comes to pass* with the aporia? Is it possible to undergo or to experience the aporia, the aporia *as such*? Is it then a question of the aporia *as such*? Of a scandal arising to suspend a certain viability? Does one then pass through this aporia? Or is one immobilized before the threshold, to the point of having to turn around and seek out another way, the way without method or outlet of a *Holzweg* or a turning (*Kehre*) that could turn the aporia—all such possibilities of wandering? What takes place with the aporia? What we are apprehending here concerning what takes place also touches upon the event as that which arrives at the river's shore [*arrive à la rive*], approaches the shore [*aborde la rive*], or passes the edge [*passe le bord*] —another way of happening and coming to pass by surpassing [*outrepassant*]. All of these are possibilities of the 'coming to pass' when it meets a limit. Perhaps nothing ever comes to pass except on the line of a transgression, the death [*trépas*] of some 'trespassing' [in English in the original]." Jacques Derrida, *Aporias*, trans. Thomas Dutoit (Stanford: Stanford University Press, 1993), 32–33.

6. Derrida, "Typewriter Ribbon," 74. Elsewhere Derrida has identified the relation between anomalies and repetition: "All these disruptive 'anomalies' are engendered—and this is their common law,

the lot or site they share — by *repetition.*"
Derrida, "The Law of the Genre," *Acts of
Literature*, 226.

7. However, he makes this reservation:
"this new figure would resemble a mon-
ster. But can one resemble a monster?
No, of course not, resemblance and
monstrosity are mutually exclusive." Der-
rida, "Typewriter Ribbon," 73.

8. Derrida asks, "What if there were,
lodged within the heart of the law itself, a
law of impurity or a principle of contami-
nation? And suppose the condition for
the possibility of the law were the *a priori*
of a counter-law, an axiom of impossibil-
ity that would confound its sense, order
and reason?" Derrida, "The Law of the
Genre," 225.

9. Deleuze, *Difference and Repetition*,
119.

10. Disguised repetition is by definition
simulacral; as well, there seems no dis-
tinction between the dark precursor, as
the differentiator of difference, and sim-
ulacra: "Simulacra are those systems in
which different relates to different *by
means of* difference itself." Ibid., 299.

11. "The dark precursor is sufficient to
enable communication between differ-
ence as such, and to make the different
communicate with difference: the dark
precursor is not a friend." Ibid., 145.

12. On the *arrivant*, see Derrida, *Aporias*,
33–34.

13. On "sur-vival," see Derrida, "Type-
writer Ribbon," 133–35, as well as "Living
On/Borderlines," Harold Bloom, et al.,
Deconstruction & Criticism (New York:
Continuum, 1979), 75–176. On the ques-
tion of sur-vival in the context of the dis-
juncture of time or the "non-contempo-
raneity with itself of the living present,"
see Derrida, *Specters of Marx*, trans.
Peggy Kamuf (New York and London:
Routledge, 1994), xix–xx and passim.

14. "The visible itself has an invisible

inner framework (*membrure*), and the
in-visible is the secret counterpart of the
visible, it appears only within it, it is the
Nichturpräsentierbar which is presented
to me as such within the world — one
cannot see it there and every effort to
see it there makes it disappear, but it is *in
the line* of the visible, it is its virtual focus,
it is inscribed within it (in filigree)." Mau-
rice Merleau-Ponty, *The Visible and the
Invisible*, trans. Alphonso Lingis
(Evanston: Northwestern University Press,
1968), 215.

In his notes to his incomplete and
posthumously published book, Merleau-
Ponty writes of the relation of the invisible
within the visible, stemming from the chi-
asm, as being a union of incompossi-
bles: "the topological space and the time
in joints and members, in dis-junction
and dis-membering" (228). Embedded in
his existential-phenomenological histori-
cal context, Merleau-Ponty's observations
derive from the subject-object/other dyad
not the self-doppelgänger/other dyad of
Gordon's characters, but they are appli-
cable especially when he writes of the
chiasm: "the cleavage, in what regards
the essential, is not *for Itself for the
Other,* (subject-ob-ject) it is more exactly
that between someone who goes unto
the world and who, from the exterior,
seems to remain in his own 'dream'"
(214). "The 'among ourselves' (*entre-
nous*) (Michaux) of my body and
me — my duplication — which does not
prevent the passive-body and the active-
body from being welded together in
Leistung — from *overlapping*, being non-
different"(246). "The *touching itself, see-
ing itself* of the body ... is not an act....
To touch *oneself*, to see *oneself*, accord-
ingly, is not to apprehend oneself as an
ob-ject, it is to be open to oneself (nar-
cissism) — Nor, therefore, is it to reach
oneself, it is on the contrary to escape

oneself, to be ignorant of *oneself*, the self in question is by divergence…which consequently does not cease to be hidden or latent" (249).

15. Derrida, "Living On/Borderlines," 90–91.

16. The expression is Merleau-Ponty's, *The Visible and the Invisible*, 215.

17. "The passive decision, condition of the event, is always in me, structurally, another event, a rending decision as the decision of the other. Of the absolute other in me, the other as the absolute that decides on me in me. Absolutely singular in principle, according to its most traditional concept, the decision is not only always exceptional, *it makes an exception for/of me*. In me. I decide, I make up my mind in all sovereignity — this would mean: the other than myself, the me as other and other than myself, *he makes or I make* an exception of the same. This normal exception, the supposed norm of all decision, exonerates from no responsibility. Responsible for myself before the other, I am first of all and also *responsible for the other before the other*." Jacques Derrida, "This Mad 'Truth': The Just Name of Friendship," *Politics of Friendship*, trans. George Collins (London, New York: Verso, 1997), 68–69.

18. As if responding to the problem of post-war male alienation in American society (and after women had been convinced or compelled to return to domestic life from their wartime labour roles), in the end the moral of *D.O.A.* is: Men, accept what you have and what you are, be a family man.

In Bigelow's last telephone call to Paula, Bigelow confesses, "I'm sorry I left you. I never realized how much I love you, but I know it now"; and in the last scene he calls out her name in his final breath.

19. "Toward the end film noir was en-gaged in a life-and-death struggle with the materials it reflected; it tried to make America accept a moral vision based on style. That very contradiction — promoting style in a culture which values themes — forced film noir into artistically invigorating twists and turns." Paul Schrader, "Notes on Film Noir," 63.

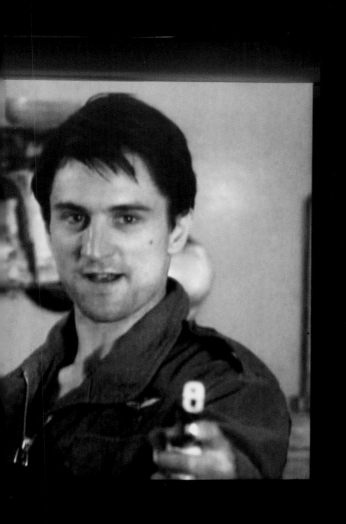

Kodak EPN 1271

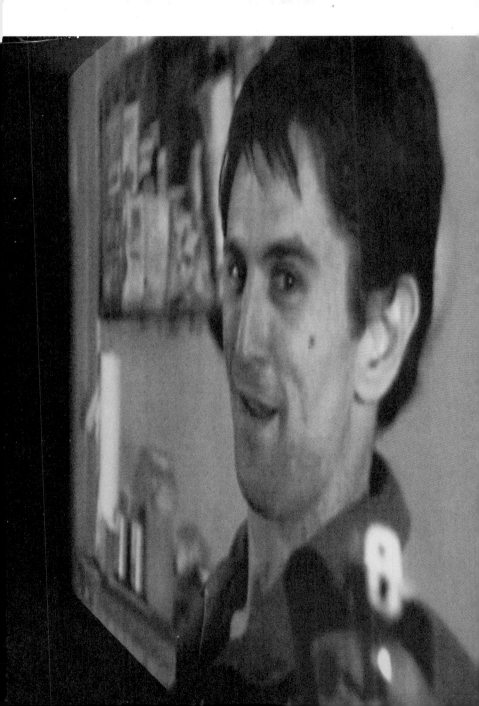

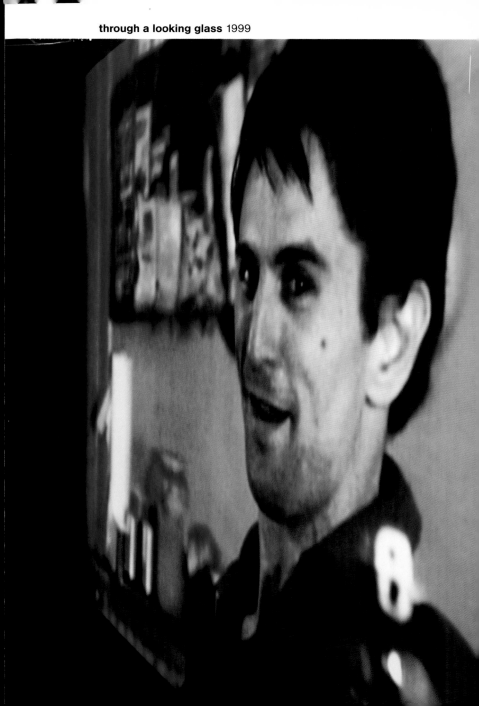

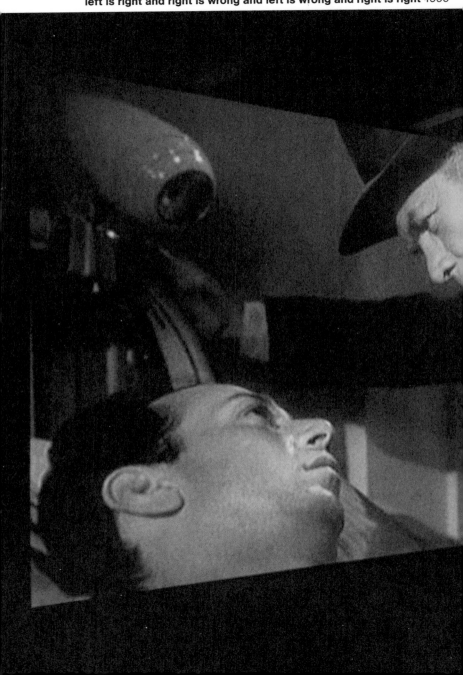

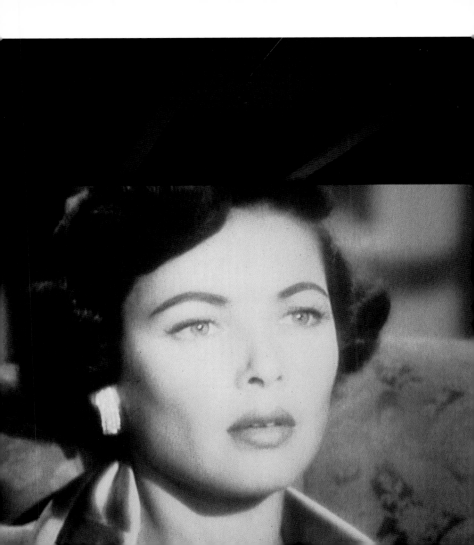

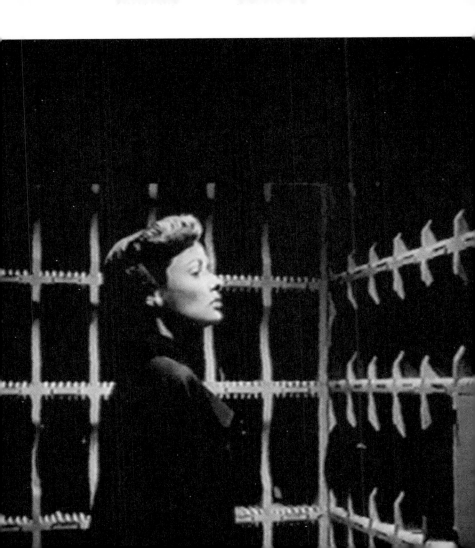

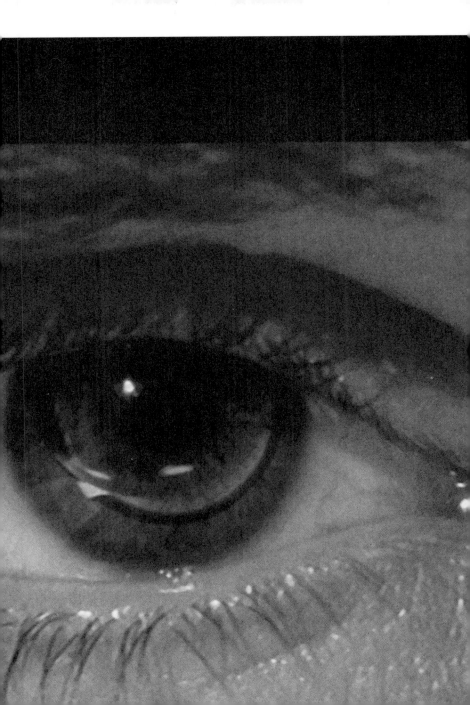

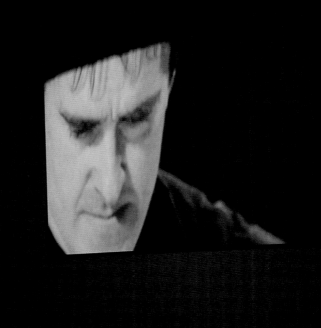

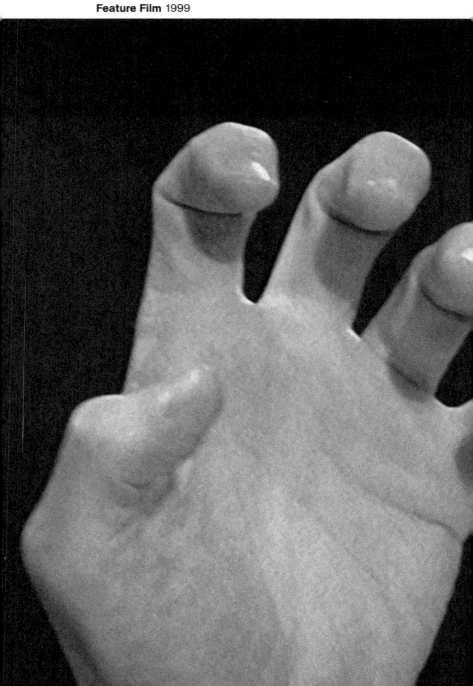

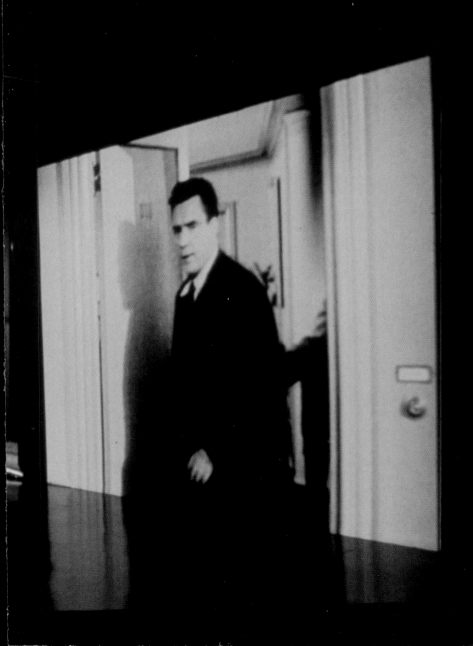

Photo Credits and Film Acknowledgements

24 Hour Psycho
installation at The Power Plant, 2000
photo: Cheryl O'Brien

Psycho, 1960, dir. Alfred Hitchcock
Universal Studios © Universal

5 Year Drive-By
Installation at Twentynine Palms, 2001
photo: Douglas Gordon

The Searchers, 1956, dir. John Ford
Warner Bros. Studios © Warner
Home Video

Confessions of a Justified Sinner
Courtesy Fondation Cartier pour
l'art contemporain, Paris

Dr. Jekyll and Mr. Hyde, 1931, dir.
Rouben Mamoulian
Paramount Pictures © Metro Goldwyn
Mayer/United Artists

Between Darkness and Light
installation at Skulptur. Projekte
Münster 1997
courtesy Westfälisches
Landesmuseum für Kunst und
Kulturgeschichte Münster
photo: Roman Mensing

The Song of Bernadette, 1943, dir.
Henry King
20th Century Fox © Criterion Films

The Exorcist, 1973, dir. William Friedkin
Warner Bros. Studios © Warner
Home Video

through a looking glass
installation at The Power Plant, 2000
photo: Cheryl O'Brien

Taxi Driver, 1976, dir. Martin Scorcese
© 1978 Columbia Pictures Industries
Inc. All rights reserved. Courtesy of
Columbia Pictures

**left is right and right is wrong and
left is wrong and right is right**
installation at DIA, New York
courtesy Lisson Gallery
photo: Stuart Tyson, courtesy DIA,
Gagosian Gallery, and Lisson Gallery

Whirlpool, 1949, dir. Otto Preminger
20th Century Fox © Criterion Films

Feature Film
installation at The Power Plant, 2000
photo: Cheryl O'Brien

Vertigo, 1958, dir. Alfred Hitchcock
Universal Studios © Universal

Déjà vu
installation at Musée d'Art Moderne
de la Ville de Paris, 2000
photo: Marc Domage, courtesy of
Lisson Gallery, Tate Liverpool

D.O.A., 1950, dir. Rudolf Maté
Cardinal Pictures © Reel Media
International